DATE DUE

DEMCO 38-296

Shadows and Enlightenment

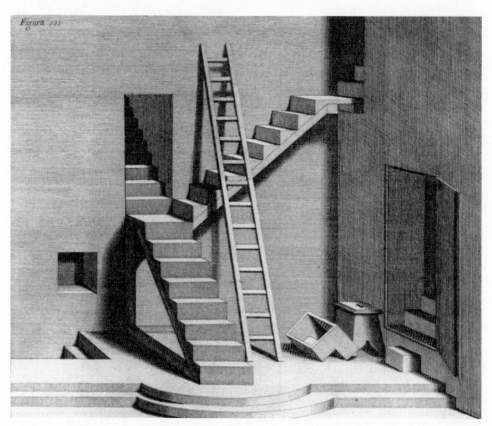

1 Steps. Detail from Andrea Pozzo, *Prospettiva de' Pittori e Architetti, Parte Seconda*
Rome: J.J. Komarek, 1700), pl. III.

SHADOWS
AND ENLIGHTENMENT

Michael Baxandall

Yale University Press
New Haven & London

Designed by Gillian Malpass
Set in Linotron Bembo by Best-set Typesetter Ltd., Hong Kong
Printed and bound in Great Britain
at The Bath Press, Bath

Library of Congress Cataloging-in-Publication Data

Baxandall, Michael.
Shadows and enlightenment / Michael Baxandall.
Includes bibliographical references and index.
ISBN 0-300-05979-5
1. Shades and shadows in art. 2. Visual perception. 3. Art.
Modern – 18th century. 4. Art. Modern – 20th century. I. Title.
N8243.S36838 1995
701'.8 – dc20
94-40132
CIP

A catalogue record for this book is available from
The British Library

PREFACE

This book is a discussion of shadows and their part in our visual experience. More particularly, it juxtaposes modern with eighteenth-century notions about shadows with a view to benefiting from a tension between them. Some other historical periods have also had interesting ideas about shadows, of course, but the book is not about these.

Chapter I is a short introduction on the physical constitution of shadows, and a preliminary differentiation of the physical types.

Chapter II sketches the eighteenth-century empiricist/nativist issue of the role of shadow in perception of shape. The story has already been well told by others, particularly Jean-Bernard Mérian [1770–80] and Michael J. Morgan (1977), but it is a base-line for the next three centuries' thought and must briefly be established here.

Chapter III looks at what seem to me the more interesting results of late twentieth-century research on shadow perception by cognitive scientists and machine vision workers. Its materials are rather discrete because shadow perception as such is not really an isolable functional domain in cognitive science.

Chapter IV deals in some detail with a previously neglected episode, the mid-eighteenth-century shadow observations of what I refer to (mainly for the convenience of a label) as Rococo Empiricism – some of the observers being artists, some scientists: these observations are quite different in their thrust from both the previously described bodies of thought, and I believe they are still interesting and valuable. The terms Rococo and Empiricism are used in the broadest sense.

Chapter V tries to set these three shadow universes in some relation to each other, partly by touching tangentially on the issue of visual attention to shadow through the special issue of

the status of shadows in painting. It is inconclusive, but the topic is shadow, and this chapter is not offered as art criticism.

An Appendix situates and summarises the shadow theory of Leonardo da Vinci, which had a strong though partly underground influence in the eighteenth century, as it still does.

The book was written out of an interest in looking at shadows and any reader will need the same, but it is coloured by being an offshoot of work-in-progress on problems of visual attention in eighteenth-century thought, in modern thought and in the art of painting. Attention is such a diffuse or tentacled concept that it touches most areas of visual perception, and shadow is certainly one of those areas: so much so that one may question whether attended and unattended shadows are the same thing; or (to put it another way) whether shadows survive attention.

A word about the Bibliography. Since the book involves itself with three distinct fields, the works cited are heterogeneous and must be highly selective. Books recommended for specific topics may be located by referring to the Notes by sections: sections may be located, if that is necessary, by referring to the Contents.

In the case of the cognitive science I obviously know that no items are included too technical for an art historian (say) to profit from. Most of the references are to handbooks, chosen partly for their good bibliographies, with further titles. For articles I have worked a great deal from such book-form collections as those of Horn and Brooks (1989) and Rock (1990). Not being a regular reader of the journals, I have gone to them only for specific items when pressed by special relevance, learned of through recommendation or citation in the other literature. This means two things: if a reference is to an article in a journal, as Lehky and Sejnowski (1988), it is essential; and secondly, given the nature of scientific publication, I am not up to date.

In the case of eighteenth-century books I have tried to use readily available modern editions, preferably in print, when adequate ones exist. These have references in which the date of original publication is given in square brackets – as Condillac [1754]: this means a modern edition is being used and cited. The original chapter and section numbers are then also often cited, for those using other editions. Modern facsimile reprints (cited as 'repr.') of books not available in modern editions are mentioned

when known; anyone working in such a field is much obliged to such reprint firms as Minkoff of Geneva and Olms of Hildesheim, to name only two.

In the case of the art history the referencing is deliberately minimal. In a field so choked with repetitious bibliographies, it seemed better to cite just the works with the specific material or ideas in hand – as Hills (1987) – and the works where the best general information and further bibliography is found – as, *Subleyras* (1987) – and leave it at that.

The draft of the book was written in summer and autumn 1991 in London, Sainte-Cécile-les-Vignes (Vaucluse), Vowchurch Common (Herefordshire) and Paris, localities and seasons named because in one way or another specific shadow landscapes from them enter the argument. During and for some time before this period I had the benefit of support from the John D. and Catherine T. MacArthur Foundation, to which I am much indebted; in particular, I should certainly not otherwise have had time for the dispersed kinds of reading involved in the book. The draft was revised in autumn 1992 at the start of a year at the Wissenschaftskolleg zu Berlin, to which I am also indebted, and I am particularly grateful to the librarians of this institution for their skill and determination in finding some previously elusive books. I am also grateful to James Griesemer and Eörs Szathmáry, colleagues in Berlin, for referring me to literature I had not known.

Before this, a graduate seminar on Rococo-Empiricist shadow theory, HA 262, in the spring of 1991 at the University of California, Berkeley, had turned out to have been a preparation for pulling a book together. I mention here those at Berkeley who responded most at that time: Svetlana Alpers, Harry Berger (at Santa Cruz), Evelyn Lincoln, Nina Lübbren, William MacGregor, Michael Podro, Patricia Reilly, Elizabeth Schott, Frances and Randolph Starn. And I am grateful to Tom Baxandall for the photograph reproduced as figure 9.

Finally, I owe a great deal to Gillian Malpass and John Nicoll of the Yale University Press in London for the good will, care and skill with which they took on and realized an awkward book.

CONTENTS

| I | INTRODUCTION: HOLES IN A FLUX | I |

1	Light. Energy and least action.	I
2	Shadow. A confusion of terms. Three kinds – projected shadow (some cast, some attached), self-shadow (also attached), shading from tilt and slant.	2
3	A short glossary for light behaviour: lights, illumination, and reflection from surfaces.	4
4	The retinal array. Luminance discontinuities and their several causes. The perceptual task.	8
5	Piazzetta, *A Man with a Staff*: kinds of shadow.	12

| II | ENLIGHTENMENT SHADOWS | 17 |

6	John Locke: experience of flat circles variously coloured. Settled habits of inference. Molyneux's Query: sphere and cube.	17
7	Leibniz and Berkeley: the epistemological resonances of shadow.	20
8	Cheselden's Case and the thickening of the Query.	22
9	The French extension. The sensational statue of Condillac.	25
10	Three Enlightenment shadows: Montesquieu, the Abbé Millot, Rousseau.	28

| III | SHADOW AND INFORMATION | 32 |

| 11 | Subleyras, *Charon*: three Queries. | 32 |
| 12 | Three questions. Machine vision and shadow. The recalcitrance of shadow. | 35 |

13 The issue of importance. Pro: counter-shading, and
 light-from-above hard-wiring. Con: overridden
 shadow, and confusing shadow. An agenda:
 relationality and the top-down. 36

14 Modular early vision. The supercontingency of
 shadow. Reducing the relations: 'shape-from-
 shading'. The attenuations of one-to-many. Serial and
 parallel. 41

15 Top-down perception. An impossible drawing by
 Tiepolo – the mannekin and the paper bag. Top-down
 versus bottom-up. 48

16 Middle perception: the predominance of shadow edges.
 Some active properties of the retina – mobility and the
 registration of change; variable thresholds; plotting
 discontinuity. 52

17 The parabolic lines of Koenderink and van Doorn. 56

18 Cast shadow: shadow in need of support. Inferred
 source or seen surface. Waltz's illuminated block-world.
 Shadow as constraint, as line, and as surface. 60

19 Illumination and reflected luminance: sliding scales and
 differentials. The passivity of fields. The logic of
 lighting. Gilchrist's rooms. 66

20 Summary. 70

21 Introspection. 72

IV ROCOCO-EMPIRICIST SHADOW 76

22 Two kinds of chiaroscuro: prescriptive-compositional
 and analytical. Compositional chiaroscuro epitomised:
 ten points from D'André-Bardon. 76

23 Analytical chiaroscuro: a shadow agenda from Jombert-
 Cochin: (a) edges of shadows, (b) form of shadows, (c)
 light conditions and shadow, (d) relative intensity of
 shadows, (e) colour in shadow, (f) colour of shadow. 77

24 (a) *Edges of shadows*: Conceptions of light – particles
 and fluids. Two relevant behaviours: reflection and
 diffraction. Grimaldi and diffraction. The prospect
 for edges. . 80

25 (b) *Form of shadows*: Sciography. Mathematical truth and
 physical truth. The appeal and limitations of
 sciographical shadow. Its postulates and product.
 Testimony of 'sGravesande. 84

26 The observational alternative of Maraldi. A flame-like
 form with a structure. The fluid model. 88

27 (c) *Light conditions*: Directed light and diffused
 light. Gautier D'Agoty and Oudry. Some
 reflections. An idea adapted by Diderot? 91

28 The photometers. Lambert and diffused
 shadow. Light through a doorway. Shadow on a
 cloudy day. Horizon, and angle of incidence. 99

29 (d) *Intensity*: Cochin's wall (i): shadow as object. The
 ballistics of reflection. The darkness of cast shadow.
 Three kinds of light in one complex. 104

30 Cochin's wall (ii): shadow from a point of view. Two
 counter-scales and a variable point of balance. 108

31 (e) *Colours within shadow*: Attenuation of colour. The
 persistence of hue as opposed to tone. Reflected hues:
 an exhortation from Diderot. 110

32 (f) *Coloured shadow*: Buffon's observation. Physical
 explanation: Bouguer on differential scattering, and
 Léonard de Vince. 112

33 Subjective explanation: Otto von Guericke's
 candle. Simultaneous contrast versus colour constancy. 115

V PAINTING AND ATTENTION TO SHADOWS 119

34 Summary. Systematic shadow and syllogistic
 shadow. (A list of some possible shadow perceptions.) 119

35 Thomas Reid and the perceptual transparency of shadow. 124

36 Attention and the painter. 127

37 Oudry, *Hare, Sheldrake, Bottles, Bread and Cheese*. 130

38 The ecological validity of painting. A market in
 attention. 134

39 Largillierre and pseudo-opticism. Pictures as
 performances of representation. 136

40 Chardin, *The Young Draughtsman*. 139

41 Conclusion. 143

 APPENDIX: THREE NOTES ON LEONARDO
 AND EARLY RENAISSANCE SHADOW 146

I The renaissance of rilievo. 146

CONTENTS

2 The analytic of drawing: second derivatives on a
 zero-ground. 149
3 Leonardo da Vinci on shadow in 1490–93. 151

NOTES AND TEXTS 156

BIBLIOGRAPHY 180

INDEX 189

PHOTOGRAPH CREDITS 193

I

INTRODUCTION:
HOLES IN A FLUX

1 Shadow originates in a local and relative deficiency of visible light.

Light is the flux of mass-energy units emitted by a source of radiation, the sun or a candle-flame. The mass-energy units, or photons, are surplus energy, the surplus product of smaller particles combining together to become larger particles, and some of these photons are more energetic than others. *Visible* light consists only of photons in the middle of that energy range, which is plotted in terms of the pulse of electrical disturbance, or wavelength. These moderately energetic photons are visible in that cells on the retina of the eye have evolved to react to them, as they do not to those of very low energy; those of very high energy are not admitted into the inner eye. If even a fairly full visible range is present, from blue-inducing photons at the high-energy or low-wavelength end of the visible gamut to red-inducing photons at the low-energy or high-wavelength end, we see white light.

The behaviour of any particular photon is notoriously unpredictable. Even to determine probabilities or make statistical predictions about the behaviour of multiples of photons involves the highly counter-intuitive calculations of quantum electrodynamics – no part of the present enterprise. When photons meet opaque surfaces, when they address transparent substances like glass and water, when they pass through holes, when they go past sharp edges, their behaviour is complex and strange because it is involved in intricate interchange with local electrons, not the simple bounce or trajectory of a commonsense-world projectile. And this strangeness does indeed bear on the forms of shadow. However, for initial purposes a fairly broad sense of the

old principle of least action is adequate: photons can be considered as tending to take the route most economical in time. In consistent media such as clear air or water this route is often a fairly straight line; complications arise both within complex media like the atmosphere and at such interfaces between media as the bent-stick transition from air to water.

Some finer points of photon behaviour will, in fact, work themselves out as one proceeds into the morphology and behaviour of shadow – phenomena of reflection and diffraction, in particular – but for the moment two coarse points are the most important. First, photons often favour travel in straight lines. But, second, there are many molecular structures through which their energy is not transmitted as visible light. This means that in real mundane places with things standing about in them there are unevennesses, interruptions to the flux, almost 'holes in the light', as an eighteenth-century scientist called them. These are shadow.

2 Shadow, then, is in the first instance a local, relative deficiency in the quantity of light meeting a surface, and is objective. And in the second instance it is a local, relative variation in the quantity of light reflected from the surface to the eye. There are three distinct kinds of deficiency, and they emerge clearly in a sixteenth-century diagram drawn after Leonardo da Vinci (fig. 2) – who, as will presently appear, played a recurrent part in eighteenth-century thinking about shadow and vision.

A is the source of light radiating to the man's face, with angles marked from B to M. The light source is, of course, abnormally close and schematically concentrated; and the face is conveniently heavy-featured. In two sectors, I–K on the lower nose and L–M on the chin, light meets obstructing solids. The tip of the nose prevents light from reaching the upper lip, and the chin prevents it from reaching the neck, even though the upper lip and neck are themselves angled to receive some light. These are one sort of shadow.

But the under part of the man's nose and the underneath of his chin would also be without direct light from A, not because of obstruction by some other form but because they face away from the light. This is a second sort of shadow, even though it merges, in these cases, into the first.

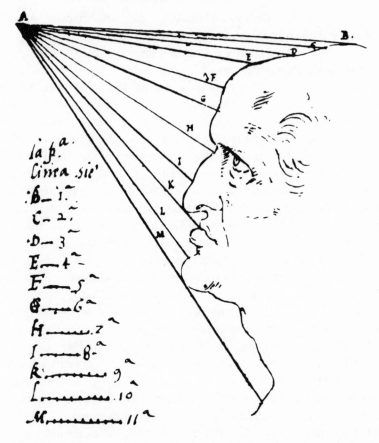

2 After Leonardo da Vinci. Light falling on a face. Vatican Library, Rome, Codex Urbinas Latinus, fol. 219 recto.

A third sort of deficiency or shadow is only partial. A surface facing the source of light directly will, clearly, receive more intense light than a surface sharply angled in its relation to the light. It will receive more photons to the square millimetre. So the bridge of the man's nose at H–I will take more light than the receding part of his head at D–E. Even within H–I and D–E there are slight curves which will slightly modify incidence of light. The less light received, the less available to reflect, and so the less reflected.

One reason for labouring these distinctions is that there are slight but systematically confusing vaguenesses of differentiation in the current ordinary terms for shadow. The three sorts of

shadow just distinguished are usually called *cast* shadow, *attached* shadow and *shading* respectively: these are normal terms. But the trouble with *cast* is that we tend to think of a cast shadow as something thrown from an object on to a separate surface, like our own shadow on the ground when we are in the sun. We are less likely to think of the shadow on the far side of a concave like the Leonardo man's neck as *cast*, partly because it is phenomenally almost continuous with the other sort of shadow under his chin. Indeed, we might think of the whole shadowed concave from chin to neck as *attached* shadow, for the good reason that it is on the object, not thrown (or detached) on to some other surface. So *attached* is not the ideal word for the second sort of shadow either. As for *shading*, the possibilities of confusion in this case seem to come from the association with the graphic act or fact of 'shading' in the sense of representational toning. We might take it to include representation of other sorts of shadow on the surface of an object, including the shadowing under the man's chin.

It would be destructive to coin a new set of terms to replace the vernacular words, and in any case much of what needs to be said will refer to shadow and shading in general. But sometimes it will be necessary to understand people making points specific to one sort of shadow, since some matters of shadow edge, shadow colour, shadow reflection, shadow value and so on are specific to shadow kinds. For this occasional purpose it will be best to qualify the vernacular terms. In the case of the first sort of shadow, that which is caused by a solid intervening between a surface and the light source (as by a nose preventing light from reaching an upper lip (fig. 2)) the term *projected* shadow will be used; and when a projected shadow is thrown on a differentiable surface, it may still surely be described as *cast*. In the case of the second sort of shadow, on surfaces which face away from the light (like the under part of the nose), the best term will be *self-shadow*, which is the term used in computer vision studies. As for *shading*, the word is much too generally current not to use, and if there is danger of ambiguity it can be qualified as *slant/tilt shading*, slant being angle on the vertical axis and tilt being angle on the horizontal axis.

3 Occasionally it will also be necessary to distinguish in quite simple ways between different forms of light source, different

qualities of lighting, and different qualities of surface struck by light. The full apparatus of light physics would be unwieldy, but the physically based conceptualisation of lighting and shadowing developed for the purpose of computer graphics will serve instead. Though most of the equations or algorithms it uses for application are too medium-specific to the pixel-grids of the computers' screens to be relevant here, the terms of the equations have the right degree of respectful simplification of the physics and also the right degree of bias towards the visually phenomenal. From them one can extract the following glossary.

Light sources vary in *extension*, from sources that may be considered *point* sources through various levels of *extended* source to a notionally quite non-directional source – assuming infinite reflections of light from ambient surfaces – called *ambient* light. Point-like sources produce the sharpest-edged shadow, perfect ambient light would produce none. Extended sources produce softer-edged shadows with a divide between *umbra*, the part masked from the whole area of the light source, and *penumbra*, the border zone masked from only a proportion of it. (A particular penumbra, we shall find, is likely to be complicated by such other factors as diffusion and diffraction too.)

Light sources also vary in what is loosely but often adequately called *intensity* – which is sometimes further broken down into *flux*, the emitted energy measurable in watts; *radiance*, the amount of flux arriving in a given flux-perpendicular sector of an object; and *irradiance*, the actual amount of incident radiance on an area of surface of an object given its angle to the light source. The visible brightness of radiance/irradiance is commonly called *luminance/illuminance*. Light sources also vary in *hue*. Light sources also vary in their degree of directionality of emittance, some tending to be *diffuse* and some tending to be directed or focused. Finally, light sources are subject to *attenuation* with distance, radiance diminishing as the inverse square of the distance travelled.

Illumination, or the lighting of a seen scene, is primarily determined by light source but introduces three more main factors. First, the *medium* of transmission of light to the reflecting surfaces of the scene – normally atmosphere – may modify its intensity, its hue, and above all its diffuseness. Second, if the scene is taken as viewer-dependent, the medium of transmission of light from the reflecting surfaces to the eye may do the

same, and besides there will be additional, and very differential, attenuations by distance: these modifications much interested some eighteenth-century shadow-observers. Third, there is *global illumination*. This is modification of the primary lighting by the complex of secondary interactions between light and surfaces in the local environment – reflections (with tinges of acquired hue), continuing re-reflections, local denied reflections (from shadowed surfaces), incursions into shadowed surfaces by alien-hued reflections, and occasional complications from light's twisting negotiation of transparent surfaces.

Surface is what reflects light, both to the eye and on to other objects, and here simplification is necessarily at its most radical. Since it is not practicable to treat surface reflection behaviour as it physically really is – in short, as a variably selective (and not fully predictable) photon-exchange between incident light and the varying electron clouds associated with those nuclei that make up the different substances of surfaces – the applied physics borrowed by computer graphics has modelled surface as something microfacetted: that is, it is treated as being covered by microscopic perfectly reflecting planes, variably angled and arranged. (In fact, this is a reversion to the eighteenth-century model developed by Pierre Bouguer (1760), who will be discussed in chapter IV) Both the intensity and the direction of reflection from a given light source are closely approximated by such a model. For instance, the arrangement of facets may posit a sort of sub-microshadow (fig. 3) by which peaks between facets produce both self-shadow and projected shadow, not to mention the shading effects of slant and tilt. At coarser, non-microscopic, levels of scale an analogous landscape produces visual *texture*.

Two of the distinctions employed in all this are worth taking on. The first and more important refers to how fully direction and angle of reflection is distributed. *Lambertian* surfaces, such as chalk or indeed the moon, reflect diffusely in such a way that they seem equally bright from any angle; they are powerful factors in the production of ambient light. (The term Lambertian is from the eighteenth-century student of light Johann Heinrich Lambert [1760], also discussed in chapter IV; the perfectly diffusing surface is described by Lambert's law – the quantity of light reflected by a unit area of surface is proportional to the cosine of the angle between line of sight (direction of viewer to the surface) and the normal (or line perpendicular to the surface).

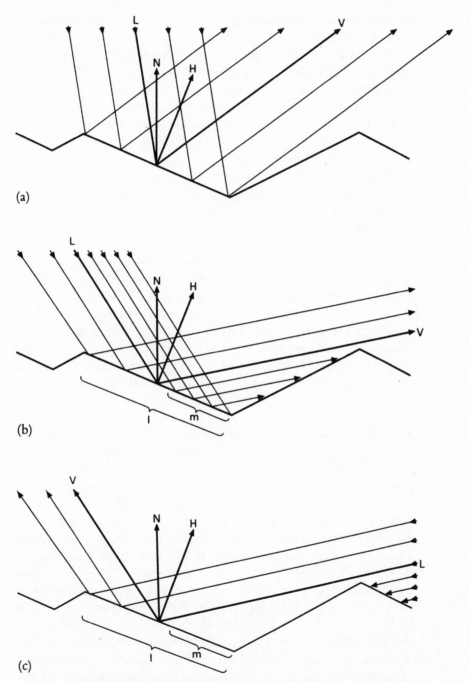

(a)

(b)

(c)

3 A microfacet model of surface reflection: L is direction of incident light rays, N is the average surface normal, H is the local facet normal, V is direction of reflected light rays. (a) involves no obstruction of light, but various angles of incidence and reflection; (b) involves obstruction of reflected rays *from* section *m* of the facet; (c) involves obstruction of incident rays *to* the facet and so a projected microshadow *m* on it (simplified after Blinn (1977) and Foley (1990)).

In other words, the surface appears equally bright from all angles because the apparent size of the unit area is likewise proportional to the cosine of the angle between line of sight and normal.) *Specular* surfaces like shiny polished metal, by contrast, reflect light preferentially at an angle equal to the angle of incidence, and straight. One product of this is a lustre highlight that is concentrated, is mobile on the surface according to position of viewer, and tends to retain the hue of the light source as against the hue of the reflecting object. Another is onward reflection of light in a still beamed, focused or at any rate little modified form – sometimes onward into primary shadows or on to objects that will make secondary shadows. Perfect Lambertian-diffusing or specular surfaces are notional: but real surfaces can be characterized as tending to one or the other.

The second distinction refers to how far direction of reflection is selective in orientation. *Isotropic* surfaces reflect equally all round. *Anisotropic* surfaces – hair and horses' coats, some woven fabrics, many leaves, in some circumstances human skin – have small-scale structures which reflect more light in some orientations than in others. They are a special case of microshadow, and may have a special optical and pictorial interest which they will lose in proportion to their being in larger-scale shadow.

4 We do not see the world directly, but through the two-dimensional pattern of light that falls on the retina of the eye. This light is not a simple transparent witness of the world (figs 1 and 4). It is compromised by varied experience, not all of this equipping it to tell a plain tale of the shapes of the tables and trees and people it has reflected off. Part of the battering it has received is represented in those discontinuities of luminance on the retinal array that we are calling shadow. It will be noticed that even this far the retinal array is a complex document to interpret, since a dark patch may register any one of three kinds of circumstance. And while the first of these, projected shadow, is extrinsic or due to the character of a neighbouring shape, the other two, self-shadow and slant/tilt shading, are intrinsic, or due to the shape of the surface itself. It will also be noticed that if we *can* locate the cause of a dark patch, identify it both as a shadow and as a shadow caused by a particular one of the possible three circumstances, then this carries some information about the shape of the world.

But the testimony of the two-dimensional pattern of light on the retina is further complicated by that light's experience of other circumstances that allow more or less of it to reflect from a surface. One is the microstructure and reflective character of that surface (fig. 3). The other is more microscopic yet, the different reflecting properties of different chemical substances making up different surfaces – in other words, whether a surface is 'light' or 'dark' or pied. A surface may or may not be substantially selective also about the wavelengths of light it either reflects or absorbs, and so may or may not impart a hue to the light. It is often helpful if it does, since hue can offer a basis for distinguishing between surface tone and shadow.

To see, to derive from the two-dimensional retinal array of stimulations some knowledge of the three-dimensional world of tables, trees and people, we must above all interpret luminance discontinuities. These discontinuities are not identical or isomorphic with the edges of the tables and other physical objects that are one cause of them (fig. 4). The light array that arrives at the back of the eye is not a naive witness or a plain map of physical reality. The light is as objective as the table in the sense that it is as fully physical stuff, but it has been shaped by its own complex experience and peculiar dispositions as well as by encountering a table. Shadows are a product of this shaping, and are a principal intricacy in interpretation of the retinal array. But, because they have been caused by physical realities, they also carry information about the three-dimensional world, if we make it out.

The role of shadow as an object of perception, then, is bound to be regarded sometimes through issues of good or bad: help or hindrance? Or better, perhaps, since shadows are a fact, which properties carry information, which are artefacts of the visual act, which are stable and which fickle, which are used in perception and which are ignored – in fact, how do shadows work, not just in the physical world but in our minds? It is noticeable that answers have varied widely according to people's projects and historical epistemes. The eighteenth-century people on whom chapters II and IV will centre, who were predominantly cognitive psychologists, light physicists and contemplative painters, not only acknowledged shadows as important to perception and painting but were fascinated by them. In fact, their episode was one of sheer 'sciophilia' not quite in tune with our own day. But before addressing them it may be useful to finish by establishing

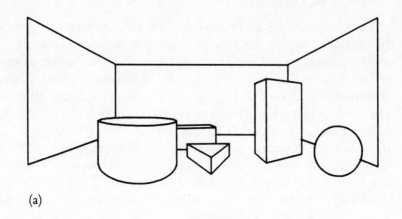

(a)

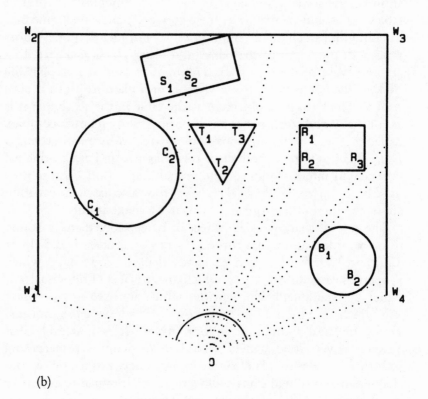

(b)

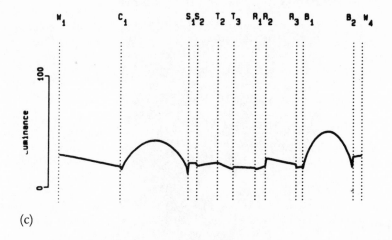

(c)

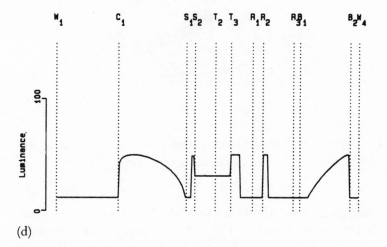

(d)

4(above and facing page) Shadow and luminance: (a) diagram of a 150-degree scene; (b) ground plan of the scene, with lines of sight from observer at O.; (c) luminance profile if observed from O., *supposing a point source of light at O itself, eliminating seen shadow*; (d) luminance profile if observed from O, *with parallel illumination inwards, introducing seen shadow* (from Roger Watt, *Visual Processing: Computational, Psychophysical and Cognitive Research* (Hove and Hillsdale, NJ: Lawrence Erlbaum, 1988), figs 1.14, 1.1, 1.3 and 1.5).

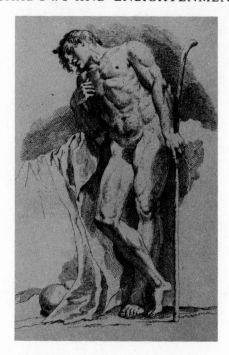

5 Francesco
Bartolozzi after
Giovanni Battista
Piazzetta (1683–
1754). Figure
study. Engraving,
31 × 22 cm, from
Studi di Pittura
(Venice: Teodoro
Viero, 1760), pl.
XXXVII.

how the three kinds of shadow combine and distinguish them-
selves on something less schematic than Leonardo's profile head.

5 One good object on which to study shadow is a thoroughly
crumpled and buckled paper bag, set in a window or near some
other source of directed light – an old drawing exercise. But here
it will be best to use an eighteenth-century demonstration-piece,
a figure engraved after a design by the Venetian painter Giovanni
Battista Piazzetta (figs 5–6). The figure appears in two versions.
The first (fig. 5), engraved by Francesco Bartolozzi, shows the
edges of things crisply, with outlines, and registers shadow
and shading schematically, with forthright and usefully visible
hatching. The second (fig. 6), engraved by Marco Pitteri, is
taken much further as a shadow demonstration, both more finely
and more strongly modelled, without linear edges. In this case
Piazzetta's drawing survives too (pl. II).
 The motif is a standing man with a staff in his left hand, lower
legs crossed, leaning with his right elbow on something covered

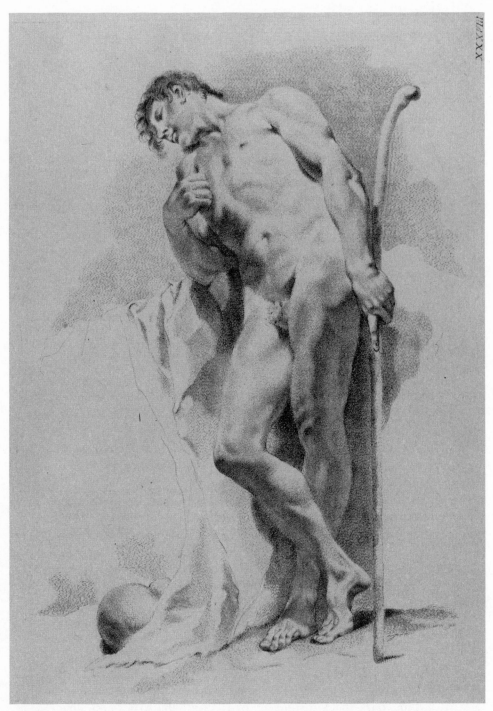

6 Marco Pitteri after Giovanni Battista Piazzetta (1683–1754). Figure study.
Engraving, 31 × 22 cm, from *Studi di Pittura* (Venice: Teodoro Viero, 1760), pl.
XXXVIII.

by folds of a light-toned fabric, and apparently looking down at a spherical form on the ground, possibly a boulder. The light must be taken to come from a quite high source at about 1 o'clock (perhaps: there are local inconsistencies, as the shading of the staff suggests), and the man's pose seems calculated to produce a good demonstration of shadow in such lighting. It is unashamedly academic.

(Once again, there are *projected* shadows caused by the occlusion of light from surfaces by intervening solids, these being sometimes *cast* or thrown on the surfaces of quite distinct objects; *self-* shadows caused on the further sides of objects by the intervention of the objects themselves; and differential *shading* on other sides of objects caused by the *slant* and *tilt* of each plane to the dominant angle of the light incident upon it.)

Slant/tilt shading is exemplified on, among other places, the bent left leg – the inside of the thigh and the back of the calf, both of which are angled to catch light. The swell of muscles on the upper inner thigh, to the right of the knee, and behind on the upper calf causes slanting and, even more, tilting at an angle from the light greater than that of the larger surfaces from which the muscles swell: thus the darker tone. The arm holding the staff is another demonstration of shading, but the torso and chest are less so, since the light is thrown rather more directly on them. The detail dourly registered in Bartolozzi's edgier version (fig. 5) does not assert itself in the Pitteri engraving (fig. 6), or in Piazzetta's drawing for it. It is characteristic of Piazzetta to posit a light powerful enough to bleach out directly facing surfaces into a near-featurelessness.

Self-shadow is most obviously represented by the lower half of the right, leaning arm, and particularly by the outer side of the straightly braced left leg. However, Piazzetta has arranged for light activity within these shadows and this allows representation of some detail. His device is the light-toned fabric, which justifies much animation of the self-shadow by reflected light. Consider the shadow down the side of the straight leg: much the darkest part is along the left edge, a sort of terminator, the form of which carries information about the contour of the surface facing the viewer, the front of the thigh. To the centre it lightens with reflected light, to allow low-toned shading. The right edge is lightest of all, picking out a profile against a dark background.

This dark background is **projected shadow**, cast shadow

derived from the figure itself. Nearly all the projected shadow
here is cast on other objects or surfaces, for various reasons. One
reason is the viewer's own position, which is not so far from the
quarter of the light source and not well placed for an angle of
view into concavities beyond the terminator. Another is, again,
reflected light. Down the flank of the straight leg there is a
depression, the further side of which would be at least near to
bearing attached projected shadow, but the reflected light invades
this. Another is the form of the human body: if its different
members are considered distinct elements, cases like the neck
under the chin of Leonardo's diagram are limited. Take the fine
section of shadow along the meeting of left upper arm and chest:
along the biceps' swell is self-shadow, edged by a delineating
reflection of light from somewhere, probably from the highlit
trunk; next to this is a small projected shadow, darker than the
self-shadow, on the body. Whether one considers it cast or not is
a matter of whether or not one reckons the body as membered or
as unitary, and this is unimportant. What is important is that it is
projected shadow.

That is important because projected shadows are, as Leonardo
had realised, often darker than self-shadows because they are less
likely to face illuminated reflecting surfaces; indeed, what they
are likely to face is self-shadow on the back of the solid they
derive from. Piazzetta and Patteri knew this. They made their
projected shadows – cast from the leaning arm on the fabric,
from the other arm on the staff, from the left foot on the ground,
from the whole figure on its background – dark shadows.

The spherical object the man is looking at sums much of this
up. It has clearly distinct shading in the upper left quarter, self-
shadow animated by reflected light in the lower third, and a
sharp dark projected shadow cast on the ground. An accidental
merit of this print as an example of shadow is its unconscious
emblematic weight: the man looking at the sphere can represent
John Locke and the Enlightenment, with whom this book now
begins.

Demonstration d'vnité d'objet.

Fig. 1.

Clair obscur dans un seul objet.

Fig. 2.

Clair obscur dans vn grouppe d'objets

Fig. 3.

Clair obscur dispersé, et par consequent sans effet

Fig. 4.

De Rochefort sc.

7 Flat circles variously shadowed. Roger de Piles, *Cours de peinture par principes* (Paris: Esteve, 1708), pl. [2].

II

ENLIGHTENMENT SHADOW

6 Locke comes at the beginning not so much because he offered the eighteenth century a powerful theory of visual perception, though he did this too, as because, in the course of stating his theory in *An Essay Concerning Human Understanding* (1690), he framed in a particularly gripping way the issue of how we achieve a perception of the three-dimensional world from the two-dimensional array of stimulations on the retina. The form in which he first established the issue was: on what basis do we perceive that what the eye receives as a specifically shadowed circle (fig. 7) is really a solid sphere? His answer was that we have learned by *experience* that what we receive as a sensation of a circle shadowed in a certain way is in substance a sphere.

This answer (an 'empiricist' answer as opposed to the 'nativist' answer, which is that our capacity to read the shadowed circle as a sphere is somehow innate) much exercized eighteenth-century thinking about our knowledge of the world, and is what gives Locke's particular form of the issue its intellectual charge. But it is the particular issue – how do we perceive a shaded circle to be a sphere? – that is the starting point here.

> When we set before our Eyes a round Globe, of any uniform colour, *v.g.* Gold, Alabaster, or Jet, 'tis certain, that the *Idea* thereby imprinted in our Mind, is of a flat Circle variously shadowed, with several degrees of Light and Brightness coming to our Eyes. But we having by use been accustomed to perceive, what kind of appearance convex Bodies are wont to make in us; what alterations are made in the reflections of Light, by the difference of the sensible Figures of Bodies, the Judgment presently, by an habitual custom, alters the Appearances into their Causes: So that from that, which truly is variety of shadow or colour, collecting the Figure, it makes

it pass for a mark of Figure, and frames to it self the perception of a convex Figure, and an uniform Colour; when the *Idea* we receive from thence, is only a Plain variously colour'd, as is evident in Painting. (II. ix. 8)

So experience of shadowed circles in association with spheres touched and found to be solids, and no doubt also in association with spheres seen all round and found to be solids, leads us to judge shadowed circles to be *caused* by solid spheres: as, says Locke, is evident in painting. We perceive by making educated inferences about cause. Locke accepts the fact that we are not aware of ratiocinating away when we perceive the sphere, and he immediately addresses this point:

> . . . this is not, I think, usual in any of our *Ideas*, but those received by *Sight*: Because Sight, the most comprehensive of all our Senses, conveying to our Minds the *Ideas* of Light and Colours, which are peculiar only to that Sense; and also the far different *Ideas* of Space, Figure, and Motion, the several varieties whereof change the appearances of its proper Object, *viz*. Light and Colours, we bring our selves by use, to judge of the one by the other. This in many cases, by a settled habit, in things whereof we have frequent experience, is performed so constantly, and so quick, that we take that for the Perception of our Sensation, which is an *Idea* formed by our Judgment; so that one, *viz*. that of Sensation, serves only to excite the other, and is scarce taken notice of it self; as a Man who reads or hears with attention or understanding, takes little notice of the Characters, or Sounds, but of the *Ideas*, that are excited in him by them. (II. ix. 9)

The first and peculiar material of visual perception is light, then, from which we can derive information about shapes and situations by making inferences about the causes of the modification of its appearance. Use, experience of relating the appearance of reflected light to shapes and situations, enables us to do this. And if it is unconscious, if we are not aware of going through such a process of inference, that is because long experience has led us to go through it so habitually and swiftly that we no longer notice the operation. In perceiving an object, we attend no more to the particulars of the conformation of the light than, in listening to someone talk, we attend to the detail of

the noises he is making, as noises (an analogy that is, in fact, discussible). Nevertheless, causal inference, from light to substance, is what we are at; and we have had to learn by experience that such and such a pattern of light is associated with such and such shape and situation of substance – for instance, that a circle shadowed in a certain way is associated with a sphere. We did not enter the world with this ability to relate shadowed circles to spheres already inborn; what we do seem to have entered the world with (Locke would have agreed) is some innate capacity and disposition to make inferences, and utilize experience, in this kind of way.

Locke's new empiricist account of perception was radical and racy as it stood. But in the second edition of his book he further dramatized the issue by inserting, between the two passages cited above, a new passage, in which he reported a letter he had recently received from a correspondent in Dublin, William Molyneux:

> ... I shall here insert a Problem of that very Ingenious and Studious promoter of real Knowledge, the Learned and Worthy Mr. *Molineux*, which he was pleased to send me in a Letter some Months since; and it is this: *Suppose a Man born blind, and now adult, and taught by his touch to distinguish between a Cube, and a Sphere of the same metal, and nighly of the same bigness, so as to tell, when he felt one and t'other, which is the Cube, which the Sphere. Suppose then the Cube and Sphere placed on a Table, and the Blind Man to be made to see. Quaere, Whether by his sight, before he touch'd them, he could now distinguish, and tell, which is the Globe, which the Cube?* To which the acute and judicious Proposer answers: *Not. For though he has obtain'd the experience of, how a Globe, how a Cube affects his touch; yet he has not yet attained the Experience, that what affects his touch so or so, must affect his sight so or so; Or that a protruberant angle in the Cube, that pressed his hand unequally, shall appear to his eye, as it does in the cube.* I agree with this thinking Gent. whom I am proud to call my Friend, in his answer to this his Problem ... (2nd edition, 1694, II. ix. 8)

Molyneux's Problem, or Molyneux's Question, or Molyneux's Query, which seems neatly to encapsulate the issue set by Locke, was to have extraordinary allure for eighteenth-century Europe. It is a brilliant literary device, in fact, to insert it at this point in

the argument: here was a puzzle, an anecdotal glimpse of the discourse of two friends, a frankly rather grotesque scene of blind man and sphere and cube, and also a tantalising implication that actual experimental determination of the issue might be possible. Molyneux's Problem probably took Locke's empiricist case to many people who had never read Locke himself.

It also took to them an emblem of the power of shadow, the shadowed circle, which we can, through experience which we have long had, perceive as a sphere, whereas Molyneux's long blind man could not. Or could he?

7 The array of opinion on that question was wide and also very nuanced, since opinions on the particular issue were likely to be projections of complex and diverse general positions in psychology and sometimes metaphysics too.

Leibniz, for example, in his *Nouveaux Essais sur l'entendement humain* (II. ix. 8.), a critique of Locke's empiricist psychology written between 1703 and 1705 (though not published until 1765), disagreed with Molyneux: shape is accessible to both sight and touch, and the formerly blind man would be able to reason his way to a correct distinction between sphere and cube on the basis of such properties as pointed corners or the absence of pointed corners. But Leibniz's disagreement came out of a nativist psychology idiosyncratically modified in the light of a very idiosyncratic general philosophy of mind: the human being is seen as arriving in the world with a complete set of ideas and a complete equipment for handling them; however, the ideas are confused and must be sorted out and indeed discovered – rather (Leibniz says) as the pattern of veins on a piece of marble must be uncovered by working that marble. So for Leibniz the blind man would be able to distinguish between the sphere and the cube with his newly acquired faculty of vision, but only on two conditions: first, he would need a moment to sort out any general confusion in his new state; second, he would need to have perceived by touch, previous to acquiring vision, that sphere and cube were present.

Berkeley, by contrast, agreed emphatically with Molyneux in his early work of 1709, *An Essay towards a New Theory of Vision* (CXXXII–CXXXVI):

'Cube', 'sphere', 'table', are words he [the formerly blind man] has known applied to things perceivable by touch, but to things perfectly intangible he never knew them applied. Those words, in their wonted application, always marked out to his mind bodies or solid things which were perceived by the resistance they gave. But there is no solidity, no resistance or protrusion, perceived by sight. In short, the ideas of sight are all new perceptions to which there be no names annexed in his mind; he cannot therefore understand what is said to him concerning them. And to ask of the two bodies he saw placed on the table which was the sphere, which the cube, were to him a question downright bantering and unintelligible... (CXXXV)

But Berkeley's stance on the Molyneux Problem, commonsensically presented and intended, responds to the demands of the less commonsensical metaphysic (he disavowed this term) that he was already developing, though had not yet made public. His position on the Problem is already a covertly or perhaps preliminarily immaterialist position. This, put crudely, is that there is nothing but God, spirits or minds, and ideas: cubes and spheres – and tables – must be taken to be ideas presented by God, not permanent material substance; to exist just means to be perceived. Ideas of sight and ideas of touch have no common objects; they are the product of signs in distinct languages used by God. Light and colours, including the colour or tone of shadows, are signs in the vision language, not the touch language. What happens is that we learn by long experience of certain constancies of relation between vision signs and touch signs, on the one hand, and constancies of relation between signs and 'things', on the other, 'to confound... signs with the things signified' (CXLIV). Of course the formerly blind man would not read cube and sphere visually: he had not had occasion to learn the visual language, either in relation to the tactile language, or in relation to things.

To follow the history of the Problem through the eighteenth century properly would be to retrace the history of eighteenth-century epistemology, which is not the project. The point of the two examples just sketched is to suggest how, from the start of the century, the Problem was established as a crux. If one had a view of the workings of the human mind, particularly a view of

how the human mind perceives the world, it was necessary to address oneself to shaded circles and the question of how the human mind is able to process them for information. The answers were diverse and often elaborately circumstanced, like those of Leibniz and Berkeley, but the issue itself was simply posed. And it is remarkable that, every generation, when it might have been expected that discussion would move on to new issues framed to accommodate more neatly new configurations of argument, something happens to refresh and enrich Molyneux's Problem. The first such development is the publication in 1728 in the Royal Society's *Philosophical Transactions* of Cheselden's Case.

8 William Cheselden was a surgeon and anatomist with artistic interests: he was painted by his friend Jonathan Richardson, sculpted by Roubilliac, had a part in designing Fulham Bridge and Surgeons' Hall in London, and in the early 1720s attended the St Martin's Lane Academy, to draw. Cheselden's Case was an operation for cataract on a thirteen-year-old boy, and the well-written short report on it was called 'An Account of some Observations made by a young Gentlemen, who was born blind, or lost his Sight so early, that he had no Remembrance of ever having seen . . .'(fig. 8).

The boy had not been totally blind: he had been able to distinguish black, white and scarlet in a strong light, but faintly and refractedly from the periphery of the eye, and without shape. Nor did Cheselden have the nerve, it seems, to test him with cube and sphere immediately after his gaining fuller sight. Indeed, the report is some way from providing rigorous experimental determination of Molyneux's Query – as, to be fair, are the modern observations of newly sighted persons – but it both kept alive the teasing possibility of such determination and provided an amount of striking anecdotal matter. On the whole the boy is presented as a good Lockean:

When he first saw, he was so far from making any Judgment about Distances, that [1] he thought all Objects whatever touch'd his Eyes, (as he express'd it) as what he felt, did his Skin; and [2] thought no Objects so agreeable as those which were smooth and regular, tho' he could form no Judgment of

VII. *An Account of some Observations made by a young Gentleman, who was born blind, or lost his Sight so early, that he had no Remembrance of ever having seen, and was couch'd between 13 and 14 Years of Age. By Mr. Will. Cheselden, F. R. S. Surgeon to Her Majesty, and to St. Thomas's Hospital.*

THO' we say of the Gentleman that he was blind, as we do of all People who have Ripe Cataracts, yet they are never so blind from that Cause, but that they can discern Day from Night ; and for the most Part in a strong Light, distinguish Black, White, and Scarlet; but they cannot perceive the Shape of any thing ; for the Light by which these Perceptions are made, being let in obliquely thro' the aqueous Humour, or the anterior Surface of the Chrystalline (by which the Rays cannot be brought into a *Focus* upon the *Retina*) they can discern in no other Manner, than a sound Eye can thro' a Glass of broken Jelly, where a great Variety of Surfaces so differently refract the Light, that the several distinct Pencils of Rays cannot be collected by the Eye into their proper *Foci*; wherefore the Shape of an Object in such a Case, cannot be at all discern'd, tho' the Colour may : And thus it was with this young Gentleman, who though he knew these Colours asunder in a good Light; yet when he saw them

O o o after

after he was couch'd, the faint Ideas he had of them before, were not sufficient for him to know them by afterwards ; and therefore he did not think them the same, which he had before known by those Names. Now Scarlet he thought the most beautiful of all Colours, and of others the most gay were the most pleasing, whereas the first Time he saw Black, it gave him great Uneasiness, yet after a little Time he was reconcil'd to it ; but some Months after, seeing by Accident a Negroe Woman, he was struck with great Horror at the Sight.

When he first saw, he was so far from making any Judgment about Distances, that he thought all Objects whatever touch'd his Eyes, (as he expres'd it) as what he felt, did his Skin; and thought no Objects so agreeable as those which were smooth and regular, tho' he could form no Judgment of their Shape, or guess what it was in any Object that was pleasing to him : He knew not the Shape of any Thing, nor any one Thing from another, however different in Shape, or Magnitude ; but upon being told what Things were, whose Form he before knew from feeling, he would carefully observe, that he might know them again; but having too many Objects to learn at once, he forgot many of them ; and (as he said) at first he learn'd to know, and again forgot a thousand Things in a Day. One Particular only (tho' it may appear trifling) I will relate ; Having often forgot which was the Cat, and which the Dog, he was asham'd to ask; but catching the Cat (which he knew by feeling) he was observ'd to look at her stedfastly, and then setting her down, said, So Puss ! I shall know you another Time. He was very much surpriz'd, that those Things which he had lik'd best,

best, did not appear most agreeable to his Eyes, expecting those Persons would appear most beautiful that he lov'd most, and such Things to be most agreeable to his Sight that were so to his Taste. We thought he soon knew what Pictures represented, which were shew'd to him, but we found afterwards we were mistaken; for about two Months after he was couch'd, he discovered at once, they represented solid Bodies; when to that Time he consider'd them only as Party-colour'd Planes, or Surfaces diversified with Variety of Paint ; but even then he was no less surpriz'd, expecting the Pictures would feel like the Things they represented, and was amaz'd when he found those Parts, which by their Light and Shadow appear'd now round and uneven, felt only flat like the rest; and ask'd which was the lying Sense, Feeling, or Seeing?

Being shewn his Father's Picture in a Locket at his Mother's Watch, and told what it was, he acknowledged a Likeness, but was vastly surpriz'd; asking, how it could be, that a large Face could be expres'd in so little Room, saying, It should have seem'd as impossible to him, as to put a Bushel of any thing into a Pint.

At first, he could bear but very little Sight, and the Things he saw, he thought extreamly large; but upon seeing Things larger, those first seen he conceiv'd less, never being able to imagine any Lines beyond the Bounds he saw ; the Room he was in he said, he knew to be but Part of the House, yet he could not conceive that the whole House could look bigger. Before he was couch'd, he expected little Advantage from Seeing, worth undergoing an Operation for, except reading and writing ; for he said, He thought he could have no more Plea-

O o o 2 sure

sure in walking abroad than he had in the Garden, which he could do safely and readily. And even Blindness he observ'd, had this Advantage, that he could go any where in the Dark much better than those who can see ; and after he had seen, he did not soon lose this Quality, nor desire a Light to go about the House in the Night. He said, every new Object was a new Delight, and the Pleasure was so great, that he wanted Ways to express it; but his Gratitude to his Operator he could not conceal, never seeing him for some Time without Tears of Joy in his Eyes, and other Marks of Affection : And if he did not happen to come at any Time when he was expected, he would be so griev'd, that he could not forbear crying at his Disappointment. A Year after first Seeing, being carried upon *Epsom Downs*, and observing a large Prospect, he was exceedingly delighted with it, and call'd it a new Kind of Seeing. And now being lately couch'd of his other Eye, he says, that Objects at first appear'd large to this Eye, but not so large as they did at first to the other; and looking upon the same Object with both Eyes, he thought it look'd about twice as large as with the first couch'd Eye only, but not Double, that we can any Ways discover.

VIII. *An*

8 William Cheselden, 'An Account of some Observations made by a young Gentleman, who was born blind. . . .', *Philosophical Transactions of the Royal Society*, XXXIV, 1728, pp. 447–50.

their Shape, or guess what it was in any Object that was pleasing to him: [3] He knew not the Shape of any Thing, nor any one Thing from another, however different in Shape, or Magnitude; but [4] upon being told what Things were, whose Form he before knew from feeling, he would carefully observe, that he might know them again; but [5] having too many Objects to learn at once, he forgot many of them; and (as he said) at first he learn'd to know, and again forgot a thousand Things in a Day. One Particular only (tho' it may appear trifling) I will relate; [6] Having often forgot which was the Cat, and which the Dog, he was asham'd to ask; but catching the Cat (which he knew by feeling) he was observ'd to look at her stedfastly, and then setting her down, said, So Puss! I shall know you another Time.

Points explicit or implicit in this passage seem these: (1) the near-Lockean boy had to learn a general property of his new sense – that it is not, at least in as simple a way, an immediate contact sense like touch – before he could use it at all effectively; (2) he may also have carried over from his old sense of touch a specific habit of aesthetic valuation, a liking for the smooth and regular; (3) he could not discriminate or distinguish objects just on the basis of seen shape or size; (4) he could learn to do so if allowed to match tactile sensation with visual sensation; (5) this was laborious learning; (6) let cat be globe, dog cube (as the echo in Cheselden of the rhythm of Molyneux's 'which is the globe, which the cube' prompts us to allow) – then here is surely an approximation, though hardly more, to the original blind man of Molyneux.

Cheselden thickened and coloured the issue, then: he did not settle it. Indeed, the contribution of the Case was to problematize the Problem, particularly by admitting and, in effect, insisting on the role of contingencies that Molyneux's pure form of the question cut off. This is very much so in the matter of shadow, which appears in the special form of shadow in painting:

We thought he soon knew what Pictures represented, but we found afterwards we were mistaken; for about two Months after he was couch'd, he discovered at once, they represented solid Bodies; when to that Time he consider'd them only as Party-colour'd Planes, or Surfaces diversified with Variety of Paint; but even then he was no less surpriz'd, expecting the

Pictures would feel like the Things they represented, and was amaz'd when he found those Parts, which by their Light and Shadow appear'd now round and uneven, felt only flat like the rest; and ask'd which was the lying Sense, Feeling, or Seeing?

This is impure as data since, apart from anything else, the boy was obviously led, but it is also rich in implication. At this point the cataract of only one of his eyes had been couched: the boy therefore had no stereopsy to hinder the eventual effect of the pictures. What he had to learn in order to perceive them as representational was first that coloured plane surfaces – which he would perceive to be planes not through stereopsy but through his own movement in relation to them and perhaps also their movement in relation to him – could be representations of a three-dimensional world. And he also had to adjust to other peculiarities of the institution of pictorial representation, that pictures are not necessarily life-scale, for instance, or that pictures have a more limited range of tone (or reflected luminance) than a real visual array. The report is not about shadow perception as such, then, but firstly about the need to learn the institution of pictures in order to perceive pictures, and secondly about the effectiveness of modelling with light and shadow in pictures.

9 The next episode is the appropriation of Molyneux's Problem by the French, and this prolonged the discussion through the middle of the century. The immediate agent of transmission was probably less Locke, who had been translated into French in 1700, than Voltaire, who picked up Cheselden's compact narrative and translated much of it in his *Eléments de la philosophie de Newton* of 1738. It was certainly from Voltaire that the French learned of Cheselden. For the next generation Molyneux's Problem and Cheselden's Case were focus for a discussion that seems rather more resonant, bearing rather more often on the whole matter of human knowledge, than had been usual in England.

Between 1770 and 1780 Jean-Bernard Mérian, a Swiss philosopher, wrote a series of papers for the Prussian Academy in Berlin in which he set out to tell and analyse the whole tale. As he said: 'Il a été le germe de découvertes importantes, qui ont produites des changements considérables dans la science de

l'Esprit humain . . .' In addition to Locke, Leibniz, Berkeley and the Newtonian Englishman James Jurin – who had argued that the uniform continuity of the sphere, sensible to both touch and vision, would have allowed the former blind man to distinguish it from the discontinuities of the cube – his protagonists included the 'sensationalist' or radical empiricist philosopher Condillac and Denis Diderot. He might also have included with them the more moderately empiricist scientist Buffon, author of the great *Histoire naturelle, générale et particulière*, who was particularly productive as an irritant to Condillac. Again, the arguments of these men have been well studied and need not be rehearsed here, though we shall have occasion to return to all three on specific shadow matters. But it is pointed out that, whereas Locke and most of the English were arguing about whether the blind man would be able to distinguish between sphere and cube by name and thus as concepts, the French went further and were questioning how far he would *see* them, at all. And this had massive implications for ideas of human nature, its plasticity to culture, the Perfectibility of Man.

It will emerge that a high proportion of the most interesting French texts on shadow – the technical observations of scientists, artists and lay shadow-analysts – originate in the period or generation-span 1740–60, and this is also the high noon of the French Molyneux debate. The core episode is marked out by the two primary books of Condillac, the *Essai sur l'origine des connaissances humaines* of 1746 and the *Traité des sensations* of 1754; both Diderot's *Lettre sur les aveugles* and the second and third volumes of Buffon's *Histoire naturelle*, containing the 'Histoire naturelle de l'homme', were published in 1749.

Condillac was worried about Locke's insistence on unconscious inference, on the mind achieving a perception by locating the *causes* of sensations, and being so intellectual while doing so; he argued for a more direct perception, for a mind that learns to work immediately from visual sensations that have, however, been educated by association with an active sense of touch, the mobile hand. It is the hand, which unlike the eye can get outside the mind, that conditions the eye to construct perception of the external world, actively and direct from optical sensation; the hand, says Condillac, who liked analogies from painting, holds the brush that organizes the colours in or on the eye. Condillac's account of all this is refined and strangely modern, but it is

beginning to outgrow Molyneux's Problem and the Cheselden Case. He addresses both. He reverses himself on Molyneux, in fact, disagreeing in 1746, agreeing rather absently in 1754; he is unusually aware of the impurities of the Cheselden case, the previous partial vision, and accommodates to it delicately.

In the letter to Locke of 2 March 1693, in which he stated his Query, Molyneux had described it as 'jocose'. The joke lay, perhaps, in the question being a snare, unanswerable because, simple though it may look, it is really a compound tangle of many entailed questions and unascertained contingencies. Condillac evaded some of these traps by inventing a story of his own, the developmental myth of Condillac's statue. He imagines a statue that is successively endowed with different combinations of the five senses, but the principal episodes are on the relation of sight and touch. When limited to sight alone the statue has a life of a sort but has no conception of either the existence or the form of things outside itself; limited to touch alone it has such conceptions, but they are very limited, not least in range. But with sight and touch in tandem full perception is possible. Shadow makes it so:

The statue learns to see a sphere

The first time it brings its vision to bear on a sphere, the impression it gets of it stands for nothing but a flat circle, with shadow and light mixed. It does not, therefore, yet see a sphere: for its eye has not learned to assess the relief on a surface where shadow and light are distributed in a particular proportion. But it has touch now, and because it is learning to come to the same judgements with vision as it comes to with touch, the statue takes under its eyes the relief that it has under its hands.

It repeats this experiment, and comes to the same judgement again. In this way it connects the ideas of roundness and convexity with the impression that a certain mix of shadow and light make upon it. It then tries to recognize a sphere that it has not yet touched. At first it doubtless finds itself in difficulty here: but touch removes uncertainty; and with practice it comes to recognize that it sees a sphere, forms this judgement with such quickness and sureness, and connects the idea of this shape so strongly with a surface on which shadow and light are in a certain proportion, that in the end

it sees each time only that which it has so often told itself that it must be seeing.

The statue goes on to do the same with cubes, and learns to distinguish spheres from cubes. Finally, vision is trained by touch to be a more powerful and far-ranging sense than touch itself, all by a process of associated sensations, quite without such intellectual operations as inference.

Mid-century radical empiricism has a complex further history and many shades. As well as Condillac's 'sensationalism', in which the main point is that *all* knowledge is derived from sense experience, there were currents of 'associationism' – which posited a consciousness in which such operations as memory, valuing and inferring were the product of a history of ideas coinciding, or succeeding or resembling each other, and so sympathetically vibrating – and 'materialism' – which means here a notion of the mind as a purely physical organism that reacts to physical stimulations in a style determined by the individual's physical organisation. But for the moment the point has been more than fully enough made. Shadowed circles were an emblematic object of perception, and newly sighted persons or statues were the thought-experimental subject.

10 It would mean very little to say that the eighteenth century was particularly interested in shadow: there is no way to validate such remarks; and in any case, at a guess, Enlightenment people were no more conspicuously interested in shadow than, say, seventeenth-century people. What one might be able to claim is that eighteenth-century attention to shadow has certain identifiable characteristics and points of focus, and also a distinctive tone. One of these characteristics is an implication of shadow in the basic matter of human knowledge: the shaded circle and what we do with it, and how we are able to do what we do, is always there in the background. This may colour the tone of attention to shadow, which is serious and pertinacious to a degree that is sometimes hard to understand. Perhaps some sense of this can be given in a preliminary way by citing two or three examples spanning the golden age of French shadow discourse.

In 1729 Montesquieu, the political philosopher, who had published the *Lettres persanes* eight years before and was already

at work on *De l'Esprit des lois*, was in Rome in the course of a long European tour. He was keeping a journal, and on the day he had been to see the *Stanze* in the Vatican he reflected:

> Raphael is admirable . . . Say one part of a picture is in light: shadow is next to it; and then there is light reflected by something nearby; and it is easy to see that: [1] the places lit by direct light *and* reflected light will be illuminated more than those lit only by the direct light; [2] that things in shadow caused by some obstruction to direct light are lit by reflected light from opposite, and [3] are so lit in proportion to the distance from the beginning of the shadow, which becomes less dark the further it is from its beginning: [4] the most intense darkness being the closest to the light.
>
> [5] *Lo sbattimento*, the shadow on the ground caused by the feet and legs of figures, is the larger the nearer it is to the body, since it is seen then at a greater angle. When the figure is not on the ground but up in the air, *lo sbattimento* is detached from the figure, as in real life.
>
> [6] When light is coming from inside a room, because of a light source there, the brightest lit things will be those furthest from the eye; and the darker things are, the closer they will look: for the eye judges as it is used to judge. The case is precisely the contrary of what happens ordinarily – that is, light coming from the sun. There is a fine example in the *Stanze*, where Raphael painted St Peter delivered from his bonds: the prison bars seem nearer for being blacker, and very removed from the angels who illuminate the whole. The gradual reduction of light is admirably observed here. Four lights: that from the angel; that from the other angel at the side; that of the moon; that of a torch. Yet there is no error.

Montesquieu, who seems to have been getting very normative ideas about painting from an aesthetician met in Vienna, Hildebrand Jacob, looks at Raphael with a specialized attention.

In 1754–5 the Abbé Millot of Lyon wrote to the scientist Buffon:

> . . . I must outline the topography of my room: it is on the third floor, the window rather at an angle to the west, the door almost opposite it. This door gives on to a gallery, at the end of which – two paces along – there is a window facing south.

When the door is open, light from both these two windows
meets and unites on one of the walls of my room: and it is on
that wall that I have seen coloured shadows at almost every
hour of the day, but above all around ten o'clock in the
morning. The sunlight that comes to the gallery window, even
if still obliquely, is not falling at all through the window of my
room, on to the wall I have just mentioned. Now, some inches
from this wall I set some wooden chairs with pierced backs.
The shadows from these are sometimes very brightly coloured
at this time. I have seen some such where one was dark green,
another a fine sky-blue, even though both were cast from the
same side. When the light is trained in such a way that the
shadows lit from both sides are equally perceptible, the one
opposite the room's window is either blue or violet, the other
now green, now yellowish. The latter is accompanied by a
strongly coloured sort of penumbra, which takes the form of a
double blue border on one side, and a green or red or yellow
one on the other, according to the brightness of the light. If I
close the shutters of my window, the colours of this penumbra
often have even more brilliance, not less. They disappear if I
half-close the door. I should add that the phenomenon is not
nearly as noticeable in winter. My window looks to the
summer setting sun, and it is in summer I made my first
experiments, at a time when the rays of the sun were falling
obliquely on the wall that is at an angle to that with the
coloured shadows.

The Abbé Millot is a rather wild example of a widely spread
interest in both the colour of shadows and the edges of shadows:
both these were studied by others, and will concern us.

In *Emile, ou de l'éducation* [1762] Rousseau (sometime friend of
both Condillac and Diderot) was much concerned with the
proper education of the senses. At the end of the second book,
when Emile is pre-adolescent, he writes of appropriate modes of
testing progress and tells this story:

I once heard the late Lord Hyde tell of one of his friends who,
returning from Italy after three years of absence, wanted to
examine the progress of his son, then nine or ten years old.
They went one evening to walk with him and his tutor on an
open space, where schoolchildren were playing at flying kites.
The father said to his son, casually: 'Where is the kite making

that shadow there?' Without hesitating, without raising his head, the child said: 'On the main road.' And indeed, Lord Hyde said, the main road was between us and the sun. When he heard his son's reply, the father embraced him and, leaving off his examination, went away without saying anything more. The next day he sent the tutor notice of a life pension, in addition to his stipend.

What a man was that father! And what a son he was like to have!

III

SHADOW AND INFORMATION

11 The conviction common to all Enlightenment parties –
nativist, empiricist, sensationalist, materialist, associationist –
that shadow must somehow be quite central to our perception of
the world, whatever the means and basis of our interpreting it, is
so firm and compelling that effort is needed to disengage. It will
help, at this point, to look at a picture.

Pierre Subleyras's *Charon* (pl. 1) is a study in figure and in
drapery, and may even have been a student piece; but Subleyras
himself liked it enough to include it among pictures on the wall
of his studio when he painted this in 1746. Charon is poling his
ferry towards the fiery hell in the background, with a shrouded
soul each side of him. Apart from fire and smoke, hell contains a
bat, barely discernible, to the left; human figures being submitted
to torment on a wheel in the centre; and more shrouded dead
standing waiting on the right. Hell is quietly painted, however,
and its pictorial function seems to be partly as manipulable
background – there is, for example, a convenient break in the
smoke permitting the silhouette of Charon's head – and partly as
a potential source of secondary lighting distinguishable from the
primary lighting by its reddish hue. The primary lighting on
Charon and the two souls is this world's light and comes from
the front upper right. (An example of *shading* is much of the
centre of Charon's back; of *self-shadow* the left side of his back,
relieved on its edge by secondary light from hell; and of *projected
shadow* the darker shadow thrown by his head on the left
shoulder).

Within an overall diagonal grid Subleyras has set up his three
figures as a neat problem of contrasts at various levels of struc-
ture. At the lowest level, the level of texture or microshadow,
there is play between the different light-reflecting surfaces of
Charon's skin and the shrouds' fabric. The skin is less pure

white, less dead white, on the one hand, but more finely textured, on the other: it responds more finely and emphatically to light and shade, with even a suggestion of lustre on a tendon of the lower leg. This is accented by the dust-covered, and so un-specular, sole of his other foot.

Then, at a higher level, there is an opposition between two morphologies of local surface structure. The passivity of the shrouds' fabric, its lack of resilience towards tension or com-pression, is realized in a landscape of kinked folds and slack expanses, often falling into an angled moment of surrender in the lower half. Against this there are the taut and continuous local forms involved in the flesh and muscle of Charon, even though his attitude may be more that of a model sustaining the pose of a man with a pole than that of someone vigorously poling: firm elasticity is registered both in the modelled surfaces facing us and in the controlled and urgent bounce of the figure's silhouette. This is very much part of the picture's tale of life and death.

Then again, restating in a further register both the opposition within the micro-morphology of texture and colour, and the opposition in the middle order between local fold or muscle forms, there is at a higher, third level still some contradiction between the general form of the figures as perceptible structures: Charon is obviously immediately accessible as a representation of a man in a certain position, whereas the two dead souls are, at the least, less immediately accessible. They are perceptually that much more elusive. It is here that the picture helps us begin to question some of the Enlightenment confidence in the shadow.

We could recognize Charon as a man, and a man in a certain attitude, from his outline alone. We may have to work a little harder to gauge exactly what has happened to his left arm and perhaps also his left leg, but the general position is quickly perceptible. The two souls are not quite as transparent just from their outlines: presumably we postulate that within the fabric are human figures, and from the forms of fabric represented by the pictorial modelling, and also out of our knowledge of likely and possible attitudes of human figures, we come to an adequate sense of how the two are sitting. In their case, shadow and shading seem helpful to our perception of form, and must certainly be part of the basis for any perception of the fabric's detail topography.

But with the figure of Charon shadow is less positively a

contributing element. Once we have identified him as a man, in an attitude, the shadows on his legs are surely a complication we could do without, particularly that on the left leg: if we teased out our perception into a Lockean sequence of unconscious telescoped causal inference, the main product would seem likely to be the possibility to *discount* these black forms as false edges, not object edges. This would stand in some relation to the sense of lighting direction we derive from the picture as a whole. As for the shadow and shading on Charon's back, this certainly carries information about form, position and implicit movement. But it must be suggested too that the information, considered purely as information, is distorted. One could chart, one could even name, the anatomical features signified by the dark marks on the left upper back, but the total composed pattern of the marks is, in fact, a marvellous evidence of the period feeling for form – as pure rococo design as some stucco wall moulding. It is not necessary to be a fluffy painter to be a rococo painter.

Now, most of this is at a tangent to the painter's pictorial project. But it points to a number of issues in visual perception to which eighteenth-century discussion of perception in general and shadow perception in particular was systematically insensitive. Three of these will need opening out in the next chapter; they are listed here in the eighteenth-century form of leading Queries.

Query 1: Does not our experience of Subleyras's picture suggest that we perceive, not by assembling primitives like spheres (however shadowed) and cylinders into compounds such as human bodies, but by recognizing, *whole*, known compound entities like human bodies? and do we not work from our sense of these wholes to hypothesize the forms of their parts – in so far as we take interest in these primitives at all? (This seems so of Charon himself; in a more complicated way the known form of the human body was also essential to construing the souls and their shrouds.)

Query 2: Does it not also suggest that we perceive first and, in normal cases, adequately on the basis of outlines of known types of object, without need of shadow? (Shrouded souls are not a normal case.) And does not the ability of outline perception to accommodate extreme three-dimensional facts like foreshortened arms suggest that it is very agile and evolved indeed?

Query 3: Is not shadow likely to be a deceptive hindrance, first,

and only very secondarily, supplementarily and occasionally a useful source of information? Is not the complaisance with which we accept Charon's rococo musculature, or perhaps overlook a number of anomalies in the shadow-modelling of the shrouds, even in this very carefully lit picture, an indication that we perceive no more shadow than we need to recognize and locate objects? (And is this not one condition of style in painting?)

12 Questions about shadow perception are special questions within the problem of visual perception in general, as Molyneux's Question demonstrated, and the three questions just asked about Subleyras's *Charon* have a context in issues of what has come to be called cognitive science.

The first question leads straight into the bottom-up/top-down issue, the issue of how far we build up a perception of an object by charting the array of visual primitives – intensity values, discontinuities, blobs, groups, linear repetitions and so on – into progressively higher-order structures; and how far, conversely, we impose order on the array by bringing down from our experience of the world such templates for the primitives to fall into as our knowledge of the human figure.

The second question leads into the issue of how predominantly our visual perception of the world is a matter of locating and interpreting edges, of working from the luminance discontinuities available to the subject towards the physical contours of an object; and, then, how complete is the information that can be carried by the edges – and also, by an extension important to art, how complete is the information carried by lines or linear coding.

The third question, which entails much of the first two, is a very broad one about the contribution of shadows to our knowledge of the world. It also prefigures the problem of attention and non-attention.

If one is going to draw on modern thinking about vision, it must first be clear that the newly sighted man of Molyneux has been displaced from his central part in the thought experiment. The exemplary figure addressing the cubes and spheres now is often an array of electronic sensors, feeding light measurements into one or another conformation of circuitry controlled by such-and-such a program. There is no necessary implication that the computer could be elaborated either to see or to paint like

Subleyras, but it is a medium in which perceptual processes can be modelled for study. A criterion of intelligent cognition is still that it should be human-like, therefore, and there is an interest in how far the circuitry used might be assimilated to what is known about the circuitry of the human brain. One is not involved in the issue of whether the computer could attain human consciousness or understanding.

However, for the parochial purposes of this study of shadow perception, the displacement of Molyneux's newly sighted man by a machine has at least two important consequences. The first is that the effective angle of issue changes. The modern question is not whether cube and sphere would be discriminated on the basis of figure and shadow; it is, rather, what information about an object could in principle be derived from shadow. A secondary question is often, which processing program derives this information in the best and also most human-like way, though this is outside our scope. The other consequence is an almost accidental projection of the first. Much of the circuitry and programming chosen for machine vision has found it difficult to cope with shadow. Worse, its recalcitrance seems sometimes to have led to it being dismissed as a weak and/or obstructive element in vision. Worse still, 'shadow' as a category of perceptual object that ranges from cast shadow to slant/tilt shading does not fit very well into the schematization of things.

13 There is little to be gained by framing the problem as one about whether or not shadow perception is important or powerful or positive since, even apart from the difficulty of knowing against what to gauge importance, the materials one might draw on tend to answer rather different questions more satisfactorily.

For instance, it has long been usual to point to the frequency of animal countershading as an indication of an importance of shadow in nature. Many mammals, reptiles, birds and fish have evolved in such a way as to have a dark-pigmented upper side and a light underside; this counters the self-shadow they would have in the strongest light, from above, and gives them protection against being given away to prey or predator by that shadow. Some creatures, such as the north American male bobolink, have apparently refined this to the point of also

9a Sand 1.

temporarily reversing their shading tonality in the breeding season, to counterfeit a noticeable and impressive self-shadow for a time. This suggests shadow perception, of a sort, as a means of animal survival. But an argument to specifically human perception from a tendency of general animal nature seems to lead to nothing very specific; and in any case the perception involved might be little more than alertness to tonal discontinuities, particularly moving ones, rather than some construction of a three-dimensional object.

A more suggestive kind of point is the demonstration that the human visual apparatus has an expectation that light should come

from above, physically hard-wired into it: the expectation is not acquired, not even cognitive, but built into the retina. Figure 9(a) is the sort of image that can reverse its relief in response to different assumptions about the direction of lighting: it can be smooth ridges and rough valleys, or rough ridges and smooth valley-bottoms. The dominant take is affected by which way up the picture is, because we tend (other things being equal) to take the light notionally causing the shading to be at the top; if the image is inverted (fig. 9(b)) the relief is liable to reverse, though it may be necessary to give it a little time to do so. But if one looks at it with one's own head upside down – as lying on a bed with one's head hanging backwards over the end – then the relief will respond to our tendency to assume lighting from the top of our heads more than from the top of our ambience. The wiring of the retina overrides any awareness of actual top or even actual direction of light. We are physically built to have an expectation of light coming from above rather than below the level of the eye, and so too an expectation of and about shadow.

However, such things seem less suited to arguing for the positive importance of shadow in perception than for suggesting that some elements in shadow perception are likely to be primitive, in the sense of being developed rather early in the evolutionary process. But the demonstrations supporting arguments against the positive importance of shadow are also at tangents to the issue.

Figure 10, for instance, might seem to demonstrate that shadow is a weak element in three-dimensional vision. The line-drawn object is one of those reversible figures that seem to switch in and out like the Necker cube. One might expect that to add shadow to it, self-shadow and the darker projected shadow, conceived as for one of the two perceptions and not the other, might at least reduce the reversibility. But it hardly does: and in the alternate perception the shadow tone is quite easily accommodated as parti-colouring of the object.

Figure 11, a photograph degraded to render relative lights and darks as simply positive and negative, has been used to suggest among other things that shadow is a perceptual nuisance. It dramatizes the fact, which is complicating for shadow perception, that lights and darks may register object edges, object colour or illumination effects. Shadow makes it difficult to see Dalmatian dogs in sun-dappled parks.

9b Sand 2.

However, these cases do not really diminish the shadow. The first, figure 10, has its interest mainly in its original function, to illustrate a powerful and still not fully explained instability in linear edge perception. It says little about the actual impression of shadow, being a diagram, oddly combining two discrete graphic modes moreover, and being without a context of lighting. The second, the Dalmatian of figure 11, was originally designed to illustrate top-down perception, the importance of concepts or imagery, like 'dog', brought down to help order sensory data. This is one point it makes, but in the present context its effect is to remind one that shadow perception would be easier here with

10 A reversible figure
with shadow. The
shadow does not exclude
reversal. The tone of the
shading subjectively
lightens when perceived
as shadow rather than
body colour. (From
Richard Gregory, 'Space
of Pictures', in *Perception
and Pictorial
Representation*, ed. Calvin
F. Nodine and Dennis F.
Fisher (New York: 1979),
fig. 12.1, o. 233.)

the additional ordering element of hue: even green grass would
help one see the dog.

So where a first question as to the importance of shadow takes
one is not to an answer but to part of an agenda for situating the
shadow in a context, or frame. Shadow perception, it seems
from the bobolink and from looking at figure 9 with one's head
upside down, is evolutionarily primitive, at least in some respects,
and may belong partly to very early stages or low levels of
perception; that suggests a long-term question about its acces-
sibility to attention. Shadow perception, figure 10 suggests,
might well be considered as a systematic activity in the sense that
any one shadow needs to be established within a larger pattern to
signify with any force: a solitary, unco-ordinated, uncaused
shadow may be just a dark patch. The Dalmatian picture, finally,
not only asks for shadow perception to be considered as sensitive
to top-down suggestion: its reticences about such things as hue,
texture, tonal gradation – that is, again, the larger pattern of
lighting – reinforce the question about shadow signifying only in

11 A degraded photograph conflating reflectance and illumination. (Photograph by R.C. James, in J. Thurstone and R.G. Carraher (1966), *Optical Illusions and the Visual Arts* (New York: Litton). Copyright Van Nostrand Reinhold Co.)

a larger system. These – the issue of the independence of shadow perception; the character of top-down intervention; the power and intricacy of relationality – will be matters that recur in the next sections.

14 I have been using the word 'shadow' to include all of self-shadow, projected shadow, and slant/tilt shading. What self-shadow, projected shadow and slant/tilt shading have in common is, in the first instance, a locally relative deficiency in their photon counts – a physical thing. These deficiencies are differently caused. All may become 'shadow' when seen, but, if the goal is direct information about object form, the three kinds not only offer different kinds and degrees of information but demand different processing.

Shadow has its origin in a first relation between the flow of light and opaque matter. The gross form of any particular shadow is due to a particular relation between either two or three principal terms – a positioned light source, a positioned and shaped solid and, in the case of projected shadow, a positioned and shaped support or receiving surface too. The gross form will be modified by a number of additional lesser terms: the concentration and extension of the light source, the consistency of the medium through which the light passes to the solid, the position and shape of adjacent reflecting surfaces, the texture and hue both of these and of the solid (and, in the case of projected shadow, of the receiving surface also). A perceived shadow involves yet a further principal term, the positioned perceiver.

The causal factors involved in the appearance of a shadow involve a complex equation, then, and it is not surprising that it has been difficult to develop the sort of procedure that will make it accessible to artificial intelligence, or suggest models of how it is handled by our own minds. For good computational reasons and on more debateable neuropsychological and neurophysiological grounds much of the current schematisation of the early stages of vision is highly 'modular': that is, various modes of perception – edge perception, stereopsy, colour, what is referred to as 'shape from shading', and others – are treated as separate processes, studiable as such and in greater or lesser degree supposed to operate as such. The problems of their integration into what we would normally reckon a visual perception of an object are postponed until quite late in the process. Meanwhile they are expected to earn their keep by providing direct information about object form.

The machine vision enterprise has principally approached shadow through slant/tilt shading, 'shape from shading', partly because this offers information about the total relief of surfaces; there has been limited accommodation of self-shadow and some avoidance of projected shadow, both of which offer relief information only about individual contours, if treated as direct form indicators in isolation. The problem of developing linear procedures for serially processing shading into form has been vigorously attacked in the last twenty years, most conspicuously by Berthold Horn (1989) and his associates. The techniques are complex (figs 12(a)–(c)) and do not lend themselves to summary, but the strategy has been first to dispose of all variables except

the one essential to their task, slant/tilt, and then to attack this last with an overwhelming battery of differential equations and differential geometry.

Consider the basic unit of vision, one of a hundred million retinal cells in the case of humans or one of a grid of electronic receptors in the case of machine. Addressing the real array of objects reflecting light, it registers any one point in the visual array with a response that is quickly processed into a relative value: *one* value. Yet the value is the product of the many variables of solid matter, of light and of medium; and these are far too many and too variable for intelligence of any kind to compute the cause of that single light value. It is not possible to work simply from one known value to the values of many variables.

For this reason, in machine vision some of these, such as atmosphere, are ignored and others, such as any perspective complications caused by distance of viewer or of light source, may be either ignored or processed out of the problem. Any other inequalities between the actual reflected light from the object scene and the received reflected light from the object scene and the received reflected light of the subject's image are resolved, sometimes by equating the object scene luminance array with the received image array. Another group, the various complications of surface textures, is simplified away with an eighteenth-century tool: as has been mentioned, in his *Photometria* of 1760 Johann Heinrich Lambert described what is known as the Lambertian surface or ideal diffuser, which appears equally bright from all directions. Machine vision and the simpler computer graphics often take all surfaces to be Lambertian – a sort of chalk or blotting-paper universe – though programs can be elaborated to take account of differential reflection too. What is left, after much preliminary computation, is finally just the one thing needed for shape from shading, the inclination of surface. Yet it is at this point that the real problem begins.

The basic problem is that inclination of surface may be one thing but still involves two variables, since the angles of inclination, considered against the visual axis or the direction of light or any external coordinates, have two dimensions: slant (on the vertical axis) and tilt (on the horizontal). The single value of the light measurement cannot apportion itself between these two, in other words has no meaning, unless it is set in a larger frame-

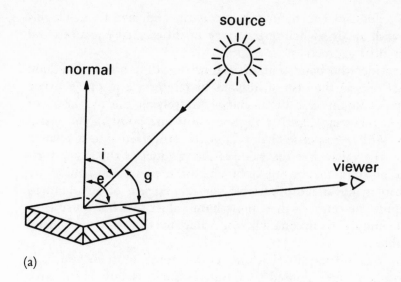

(a)

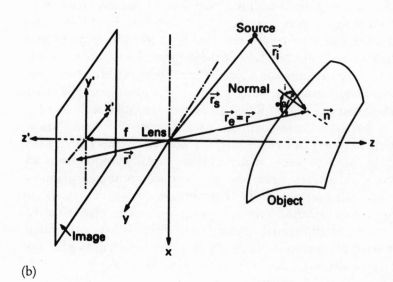

(b)

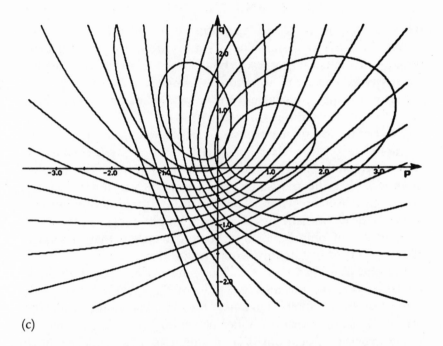

(c)

12 Some basic elements in serial shape-from-shading procedures. (a) The incident angle i, emittance angle e and phase angle g. The reflectivity of a surface in relation to the actual intensity of incident light is treated as a function of these: $\phi(i,e,g)$. (b) The object/image relationship. The detail in the angle Source/Normal/Lens repeats the angles i, e, and g of the first figure. z,z' can be thought of as a representation of the optic axis, and x and y with z are the three dimensional axes. Points \mathbf{r} and \mathbf{r}' are a point on the object and on the image respectively; and f is the distance from image plane to lens. Let t be the relation of image illumination to object luminance, a the incident light intensity at x,y,z, and let ta be A. Let I, E, and G be the cosines of i, e, and g; and let b be the brightness measured at the image point x',y'. Then there is a first image brightness equation: $A(\mathbf{r})\,\phi\,(I,E,G) = b(\mathbf{r}')$, from which others are generated. (c) Reflectance maps. A simple Lambertian surface feature is represented here in *two* superimposed reflectance maps corresponding to two light sources separated by 90 degrees in azimuth with respect to the viewer. The curving lines are iso-brightness contours, contours of constant scene radiance. The co-ordinates p and q, which are partial derivatives of the x, y and z of the second fig. b., are gradient co-ordinates registering gradient slant and tilt in relation to a viewer. (From Berthold K.P. Horn, 'Obtaining Shape from Shading Information', in *The Psychology of Computer Vision*, ed. P.H. Winston (New York: McGraw Hill, 1975), pp. 115–55, figs 1 and 4, and Robert J. Woodham, 'Photometric Method for Determining Surface Orientation from Multiple Images', in *Optical Engineering*, 19.1, 1980, pp. 139–44, fig. 8; both reprinted in Horn and Brooks (1989), pp. 124, 132 and 529.)

work of relation with adjacent values that will offer some constraint. In machine vision this is usually done by positing continuities that entail hypotheses about shape – smoothness usually, convexity or sphericity sometimes – which can be modelled for patterns of related light values and tested for match: this is where the differential equations can come in.

The results for such purposes as aerial and astronomical cartography (and also electron microscopy) are extraordinarily impressive. Indeed, the machine vision scientist is the first to point out that the machines can have higher quantitative precision than human vision. The bearing of these computational feats on how human vision actually might work is therefore problematic, if only because a perceptual system that processed all in its view so elaborately would be not just neurally expensive, as the phrase is, but wasteful. There are various possibilities. It might be that the modular isolation of the shape-from-shading enterprise from other elements of early vision and from the organising suggestions of higher perception is, in human terms, at the expense of economy. Or it might be that while we have some such faculty for use in focused local cases, our global perception of shading is different – not just not taken to such lengths, but differently conducted. This last possibility is urged by more recent developments in parallel processing techniques.

The systems used by Horn and others for the shape-from-shading feats just described were serial systems with finished rule-directed procedures. Serial or linear processing uses a language of symbols, generally, to apply a prescribed, specific-purposeful, sequential transformation procedure to specific sorts of data in order to render a specific sort of information, to solve a problem. A human caricature of such a processor in shadow perception would be an astronomer calculating the size of the earth from its shadow on the moon; a sundial is an algorithm for shadow processing, or rather the gnomonic formulae for its design and placing are.

But a system used for shape-from-shading by Lehky and Sejnowski (1988) (figs 13(a) and (b)) was a parallel distributed processor (or neural network or connectionist system) with a learning algorithm, not a serial symbolic system with a processing algorithm like Horn's. In neural networks – a term that does claim a degree of analogy with actual brain structures – interaction between simultaneous quantitative inputs is itself the process

Outputs

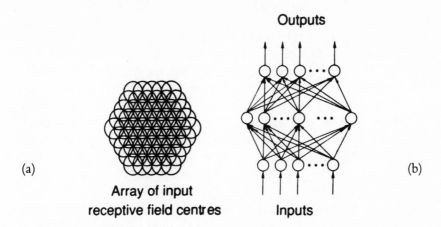

(a)

(b)

Array of input
receptive field centres

Inputs

13 Shape from shading by neural network. (a) The array of 122 receptors, on-centre and off-centre overlapping. (b) The processing principle: the receptors at the first level project to all of 27 units (3 × 9) at the second level which project to all of 24 output units (4 × 6) giving output in two dimensions, on positive/negative curvature magnitude across 4 rows and on curvature orientation down 6 columns. (From Sidney R. Lehky and Terrence J. Sejnowski, 'Network model of shape-from-shading', in *Nature*, 333, 2 June 1988, pp. 452–4, fig. 1 c. and a.)

leading to output. There is no symbolic language, no pre-set procedure except the network structure itself, and no unit has any particular identity except that acquired through particular sets of relationships with other units, of which it can have many. This is the 'distribution'. The immediate input into Lehky and Sejnowski's network was brightness measures located in a matrix. The output was decisions between surfaces being convex or concave and assessments of the orientation and magnitude of curvature. After experience of pictures of shaded objects and after learning of its errors through feedback, it had so adjusted itself as to respond to similar but new pictures with an accuracy of 88 per cent, at which level it stuck. (A little more detail about this is given in the Notes.)

Two principles, therefore, have proved capable of being a basis for converting into solid form the field of light values shading first offers the eye. The one is active, purposefully sequential, specialised, with its supplied intelligence lying in a fixed routine.

The other is re-active, plastic, global, with its supplied intel-
ligence lying in a disposition to improve the performance asked
of it with experience. They are computational principles more
than models of faculties, and how they might both be implicated
in perception is a complex issue beyond the scope of this book.
An intuitive sense that they feel a little like attentive and inatten-
tive experience is no more than that, but they do not discourage
a description of how we see a scene that admits both local focus
and global awareness – a description that is urged by such other
things as the structure of the eye.

15 A field of light values is at one end of perception, if it is
considered as a process, and a located and identified object is at
the other. But, in fact, the process is not all in one direction,
since knowledge of the world of objects moves 'from top down'
to play some part in the process of integrating the light values
into things. It is well established that shadow perception is sen-
sitive to this. Most obviously it yields to the high-level element
of imagery, the stock of known object-types: people, trees, tables
and so on. Our expectations of human beings, for instance, are
powerful and override any disposition to expect top lighting, for
instance. So, as has been abundantly shown, hollow-mould
masks of faces are perceived as solid faces, almost whatever is
done with the lighting.

Rather than document yet again the priority of imagery in
such open-and-shut situations it seems more interesting to spend
a moment surveying and complicating, slightly, the lines of the
frontier between top-down imagery and bottom-up processing
of an array of light values, and this can be done while looking at
an eighteenth-century drawing. A drawing is not evidence for
how we see in the real world – in which we move about, with
two eyes, among solids, with input from other senses – but its
isolation of certain faculties can sharpen thinking about how we
might see in the real world.

Figure 14, better reproduced in plate III, is a drawing in which
the Venetian painter Tiepolo – working first with a few lines of
black chalk, then more broadly with red chalk and then washing
over the red chalk with water – was developing ideas for figures
of Roman-type soldiers, to stand as prominent onlookers
(probably) in the foreground of some scene of Roman history.

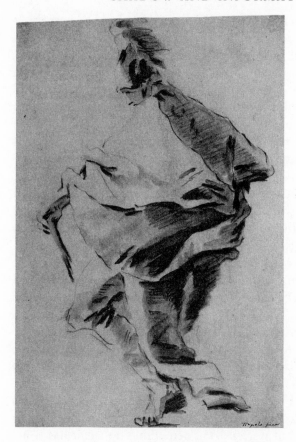

14 After a
drawing by
Tiepolo. *A Roman
Soldier*. The
original drawing
is reproduced in
pl. III.

Many of Tiepolo's pictorial ideas came from the patterns that
emerged from the action and the educated accidents of athletic
drawing, and he did not always bother to push the patterns all
the way to literal-minded human detail. There is no problem
here about taking the drawing as a human figure in helmet and
drapery, holding a stick, but it is not fully resolved; in fact, it is
almost an eighteenth-century version of an impossible figure.
The imagery of the human figure is in odd relation to the shadow
perception.

What is the attitude of the figure? Some people will have
initially taken it, for a moment, as tripping thoughtfully along
leftwords, holding its stick in the *right* hand. This reading comes
from taking the spiral of drapery lower right for a leg: that it
cannot be this – at least in one commonsense dimension – is

shown by the one clear foot at the bottom, whose toes make it clearly a *left* foot, though Tiepolo is sometimes casual about this kind of thing. What leads to misprision is presumably the expectation of two legs and the quick trial matching that follows: in the absence of any other conspicuous leg, the drapery spiral passes for one until the difficulties in higher-order coherence become more pressing. A hidden leg the other side of the figure has to be posited then, and may be inconclusively tried out against the dark patches under the heel of the foot and at top right of the drapery spiral. Awkwardnesses still remain, though, since the angle of the left knee and leg is in an extreme relation to that of, say, the right elbow. One can feel that the ghost of the leftwards tripping figure still hangs about, long after it has been discounted, indeed even if it has never been knowingly perceived, and this remains part of the rich irresolution of the drawing.

Meanwhile the modelling of the drawing, the shadow and shading, leads a fairly independent life. It is, of course, in the first instance a lozenge or rhomboid pattern of red chalk marks, muscularly displaying craft and touch; we enter a contract to take this as a Roman soldier within early eighteenth-century graphic conventions for such types. But we then apply dispositions of shadow perception that are adaptations from real vision and are not conventional. Light is from upper left. Left leg and hand apart, the object is mainly areas of fabric almost arbitrarily swathing a posited but not in detail penetrable figure; it has some of the quality of the crumpled paper bag.

We do bring organizing principles from above but they seem more generalized than the image of the human figure, middle-down rather than top-down. It will be quickest to list some suggested tendencies of perception, derived from introspection, which can be tried out on the drawing, if wished. Most of them are commonplace. (1) We hypothesize continuity of object tone, like the machines. (2) But we adapt to variations when at all clearly cued, as by the big triangle of thrown-back light-toned lining of cloak, imagery-licensed but also urged by the extreme paleness of some of the modelling. (3) On the other hand, smaller tonal marks we tend to read as modelling rather than surface colouring, even when Tiepolo does not shape them in detail to suggest either. (4) We use any information of edges as a useful constraint in parsing fold structures and moreover (4 *bis*), Tiepolo usually locates fold complexes in edge-defined zones. (5) But

within edges the main urgency seems about discrimination between convex and concave in the middle range. (6) We work more with local, immediate tonal contrast than with total tonal structure – a number of strong anomalies in which do not worry us. (7) In our perceptual satisfaction, imagery-aided recognition, as of hand and foot, seems an alternate not a companion to shading-based security of modelling: the relative solidity of topography of the almost imagery-less zone below the right elbow is in a balance of satisfaction with the sparsely registered left hand. (8) The modelling has no intrinsic scale: cover head, hand and foot, and the structure could be any size, particularly smaller, like paper round a bouquet, another image. (9) Covering them also clarifies the structure, presumably by removing interference from imagery, or from the attempt to reconcile them with problematic imagery.

What blocks our final resolution of this drawing is basically the fact that it contains two modes of perception in incomplete relation. There is the phenomenal crumpled paper aspect of which we happily read the shadow-modelling as a robot maps Mars from space, shape-from-shading, and there is the schematic mental mannekin aspect represented by positioned head, hand and leg. The former can be read independently of imagery of the mannekin kind, though it can be disrupted by it; the templates are middle-order, almost abstract, Euclidean-like, and have little to suggest directly, as opposed to aggregationally, about the total structure. They are about surface topography and seem to await some internal armature. The hierarchized mental mannekin that would normally provide this fails to deliver on this occasion because we fail to extrapolate a fully satisfying pattern within the constraints of his range of possible dispositions – whether through inadequate or contradictory cues: in particular, perhaps, we fail to fix the alignment of axis. Thus the persisting element of flicker between readings. These react back on the shadow perception, introducing uncertainties that can be removed by covering the human details and pretending the shadow structure is a more autonomous paper bag. But it is partly certainties of the shadow perception that inhibit projection of a satisfying mannekin. That is to say, the bind is reciprocal: if the middle-order data of shadow perception sometimes yield to higher-order imagery, they also constrain its range of possibilities.

15 Generalized cone: 'the surface created by moving a cross section along a given smooth axis. The cross section may vary smoothly in size [as may the axis turn smoothly in orientation], but its shape remains constant.' (From David Marr (1980), *Vision* (San Francisco: W.H. Freeman), p. 224.)

16 Let us accept that shadow will often be resolved and sometimes even overridden by imagery of the high-order kind the human body represents. If we are positing some dialectic between shaping forces top-down and agglutinating patterns of light values bottom-up, the problematic field of action for shadow is likely to be somewhere in the middle. There is, at the very least, an upper middle somewhere around the level of the cube and sphere, and a lower middle somewhere around the problem of edges. Rather than working up through the levels of process posited by most current models of perception – that is: (1) light values on the retina, (2) organized into such features as discontinuities and groups, (3) then organized into a sketch of planes with orientation and distance in relation to the eye, and (4) then into emancipated solids like cubes and spheres (or, nowadays,

Human

Arm

Forearm

Hand

16 A viewer-centred diagram of an object-centred representation of generalized cones in a complex object. Each box is a description of both an overall axis (*left*) and an arrangement of next-order axes (*right*). Each is associable (*overlap*) with other more local and detailed descriptions that may be called up if necessary. The spatial relations of even remote details, such as toe and finger, are retained and available. (From David Marr and H.K. Nishihara, 'Representation and recognition of the spatial organisation of three-dimensional shapes', *Proceedings of the Royal Society*, B 200 (1978), pp. 269–94.)

'generalised cones' (fig. 15)) which (5) can be assembled into (6) such perceived objects as tables and human beings (fig. 16) – what follows here will move around in the middle, somewhere around (3) and (4).

But, as a preliminary, it may be a useful constraint to keep in mind some limits of what (1), the retina, offers. The retina has not only receptor cells but various kinds of processing cell. It delivers its data to the cortex through the bottleneck of the optic nerve and is active in pre-processing and editing, which it does with a compact four-tier organisation of cells and synapses (fig. 17). The receptor cells register change, not stable condition: given a stable scene and a stable light array from it, the eye sees by keeping on the move, producing its own stimulation by providing its own change. The various kinds of processing cells and connections between them begin the reduction of this temporal change into spatial change, and the product has a number of characteristics relevant to shadow perception.

KEY

RT	receptor terminals
H	horizontal cells
B	bipolar cells
A	amacrine cells
G	ganglion cells

17 The synaptic system in the vertebrate retina. Horizontal cells react both to and on receptors and bipolars, and amacrines react both to and on bipolars and ganglions, which report through the optic nerve on specific sizes and placings of light in specific receptive fields. (From J.E. Dowling, 'Synaptic Organization of the Frog Retina: An Electron Microscopic Analysis Comparing the Retinas of Frogs and Primates', *Proceedings of the Royal Society of London*, B 170 (1968), p. 223, fig. 16.)

First, the data is about discontinuities, not fields but the edges of fields. The actual operations of the system are complex, but an emblem of the tendency is the concentric receptive field of many ganglion cells. These cells report difference of luminance between the field's centre and periphery, and may report on the degree of that difference through their rate of fire.

Second, the data is about relativities, not absolute values but differences between local values. The thresholds at which cells respond are not only adaptable but locally variable. The horizontal cells (fig. 17) on the first tier after the receptors are one means of lateral connection within the system, and there are others, but while these give coherence within the system, some

of the coherence is local to regions rather than unitary over the whole retina.

Third, the data about any zone in the visual array comes in a range of scales of fineness. Different cells and synaptic networks respond to stimuli of different scales, finer or coarser. While cells on the periphery of the retina both receive and process more coarsely than the cones at the centre of acuity, the centre produces both fine and coarse information. Early vision does not merge these but sustains distinct channels for information from the same point in the visual field at distinct scales of detail: that

18 Brightness discontinuities delineated: (a) is a detail from a photograph of a sculpture by Henry Moore; (b), (c) and (d) are zero-crossings of the second derivative of its light values reduced by filters of three different spatial frequencies. The range of blurring by these filters is designed to correspond with the range of blurring by different zones of the fovea. (From David Marr and E. Hildreth, 'Theory of edge detection', *Proceedings of the Royal Society*, B 207 (1980), pp. 187–217.)

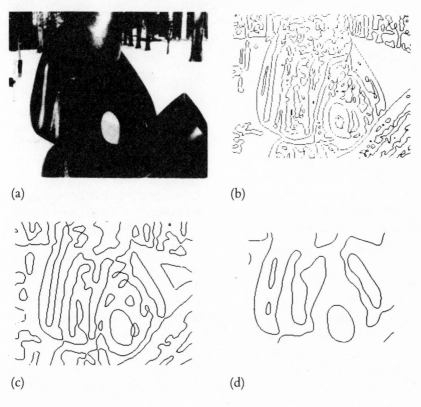

(a) (b)

(c) (d)

is, it seems that visual perception has a use for both fine infor-
mation and coarse information about the same area of the visual
array. This was one of the things that encouraged machine vision
to take the basic productive step of using not just the one fine
registration of a luminance array but some combination of fine
and coarse registrations (figs 18–19). (This practice is sketched in
the Notes, p. 162.)

What the cortex has to work with, then, is a plot of luminance
discontinuities, not calibrated to some external absolute value but
internally relational on more than one level, available in more
than one scale of detail. This is likely to be the material or
medium for shadow construction and it has a certain feel.
There are obvious problems about moving from a physiological
universe to a perceptual universe, but very early vision does seem
more friendly to some aspects of shadow – the quality and
location of shadow edges, for example – than to others – such as
the form of shadow fields.

17 Locke, Condillac and the shape-from-shading programs
differ among themselves about means. But Locke and inferential
serial programs, on the one hand, and Condillac and sensationalist/
associationist parallel programs, on the other, agree about the
immediate end of shadow perception being perception of shape.
The means may be intricate, but the mission is simple, perhaps
too simple in that a question arises about that immediacy. Can an
animal organism be so modularly single-minded? The three
pieces of work to be mentioned now entail less simple courses
for shadow perception. They are discrete – a topological study of
shading, a computational application of projected shadow and a
psychophysical experiment on relationality in all shadow – and
will not add up to anything coherent, but they will open up the
landscape.

★

Koenderink and van Doorn (1980) were interested in the pos-
sibility of there being structural invariants to the different shading
patterns a given form will present under different lighting.
Crudely put, the question that interested them was whether there
is an underlying pattern beneath all the patterns the shading of a
given object can take. They made a topological analysis of some

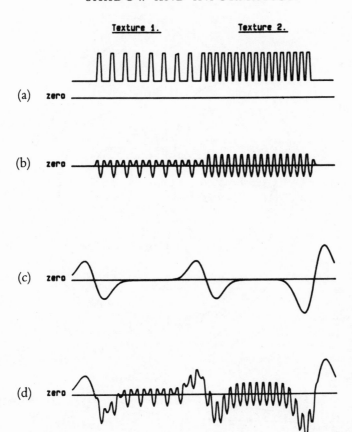

19 Combining filters: (a) a luminance profile of two textures; (b) its fine-filter second derivative; (c) its coarse-filter second derivative; (d) the sum of both. (From Roger Watt, *Visual Processing: Computational, Psychophysical and Cognitive Research* (Hove and Hillsdale, NJ: Lawrence Erlbaum, 1988), fig. 2.4.)

basic forms (figs 20–21). The forms were: the 'furrow', a hyperbolic notch in an elliptical area, whose negative is the 'ridge'; and three kinds of 'hump' – one like a hat with its brim turned down, another like a hat with its brim turned up, the third like a hat with the brim turned up at front and back but down at the sides – whose negatives are three kinds of 'dimple'. All these except the first type of hump and dimple have cusps, intersections of curve. These basic forms cover most morphologies in principle: 'More complex surfaces (such as statues) yield essen-

20 Isophote field for a
hump like a hat with
its brim turned down
(as a spherical Gauss
map). (From Jan J.
Koenderink and
Andrea J. van Doorn
(1980), 'Photometric
Invariants related to
Solid Shape', *Optica
Acta*, xxvii.2, pp.
981–6, fig. 4, reprinted
in Horn and Brooks
(1989), pp. 301–21.)

21 Isophote field at a
cusp-point (as a
spherical Gauss map).
A cusp-point is at the
centre, and a saddle is
upper right. The
broken line is the
parabolic line. The
dotted lines are
asymptotes of the
curves of the isophote
'families', approaching
and never meeting
them. Parabolic line
and asymptotes all
meet at the saddle-
point. The isophote
that cuts the parabolic
line twice does so at
the same angle both
times. (From Jan J.
Koenderink and
Andrea J. van Doorn
(1980), 'Photometric
Invariants related to
Solid Shape', *Optica
Acta*, xxvii.2, pp.
981–6, fig. 10,
reprinted in Horn
and Brooks (1989),
pp. 301–21.)

tially nothing new, they can be considered to consist of combinations of humps, dimples, furrows and ridges (set besides each other or contained within each other), possibly complicated with extra cusp pairs'.

Treating these forms as Lambertian ideal-diffusing in surface quality, and excluding projected shadow and reflections of light within the object, they then plotted their *isophote* fields and their *singularities*. Isophotes are the contours of equal luminance on an object. Singularities are such features as local maxima and minima of luminance. It emerged that, whatever the illumination, all isophotes and certain singularities tend to preserve a close relation to the *parabolic lines* of the surface, moving along or being created or dying out on such lines, or crossing them at fixed angles (fig. 21). The parabola is that conic section of which the cutting plane is parallel with one of the lines of the cone, so that a parabolic line is a curve of which one of the radii is infinite. Part of its significance here is that it is the curve that marks the juncture between an elliptic region and a hyperbolic or saddle-shaped region. Figure 20 represents the isophote field for a hump of the first, simplest kind, the hat with the brim turned down. The dotted lines are the two parabolic lines, and the solid lines plot the isophotes and such singularities as extrema (the ovoids on the inner parabolic line) and saddle-points (the crossing on the outer line).

As Koenderink and van Doorn (who are noticeably sensitive to the history of art-technical interest in shading and shadow) themselves put it: 'a large class of singularities of the *chiaroscuro* stands in an invariant relationship to the surface *rilievo*; they cling to the parabolic curves.' The implication is strongly that, whatever the illumination, the shading of shapes has a deep stability of a kind that would permit perception of shape without determination of the source or other variables of illumination. Moreover, it would point to shadow perception operating not at the level of charting single light values up into inclined planes, as in most machine vision models, but at some intermediate level of constituent units, 'humps' and the rest. Moreover, such perception would accommodate considerable tolerance of inaccuracies and inattentions, the general probabilistic and corner-cutting way of proceeding that economy seems to demand.

★

18 Projected shadow has so far played almost no part, it will be noticed. It is excluded from the shape-from-shading procedures partly because it would need discrete computation, a complication that can certainly be done without. It is excluded from it also because the form of the shadow would bring information about only one contour, that of the projected silhouette, instead of many contours, as shading can: hardly worthwhile. Though one might expect it to be used as an obvious and economical indicator of the light source, at least, this is not normally the case; shape-from-shading procedures usually either locate light sources for themselves or are independent of the sources' location. So projected shadow's role in the universe of machine vision sometimes seems to be just to complicate perception, a sort of large-scale noise.

For most people projected shadow, and particularly cast shadow, represents shadow. If we consciously notice a shadow, it is usually a cast one with a striking form or a striking relation to the shape that is projecting it. The art of picture-making itself has its myth of origins in this relation: Pliny the Elder told of the woman who invented the art by outlining the cast shadow of her lover on a wall. The story is worth mentioning because it embodies so plainly the idea that the information-value of cast shadow lies in the projected silhouette's rendering of a contour. Perhaps this is a misconception.

The main specific of projected shadow, as against shading and self-shadow, is that it is not self-supporting. It is *on* some surface distinct from that which is causing the privation of light. The morphology of this alien surface interferes with its form. The complication introduced by this additional term is precisely what makes projected shadow too much of a computational nuisance to be worthwhile in procedures for machine recovery of shape from shading. But complications encode information, and let us suppose the task to be different. In normal vulgar experience we often know what is casting the cast shadow and often already have a sense of where the light is coming from: we do not need to learn these things. Suppose what we want to learn about is, rather, the surface on which the shadow is cast.

This is not a matter of indirection. It is true that the theoretical urge has historically been to work from the cast shadow and a known object towards locating a light source (gnomonics or sundial design) or from a known object and light source towards

working out the plane form of a cast shadow (sciography or shadow projection). Both these are concerned to relate the projected shadow to causes outside itself, the intellectually interesting operation, particularly for its geometrical purity. To attend to a surface for the modifications of generic cast shadow and for what those modifications tell one about that surface, is somehow less vigorous; but it is more continuous with other modes of shadow perception, like shape from shading.

When we scan shaded surfaces it is the shape and character of those surfaces themselves we perceive, not something off to the side. When we scan surfaces bearing projected shadows, we may well make inferences about things off to the side that are causing them, but the direct thing may be simply to look at what we are looking at. In that case, we would read the interference with a more or less known quantity – a shadow projected by such-and-such from thereabouts – as an indication that the receiving surface has a certain shape and character. The two are reciprocal, of course, like so much else in perception. It is a question of where the information value lies.

There is a piece of interesting thinking that bears on this. David Waltz (1975) was one of several people who worked at one time towards a special sort of analysis of 'block-worlds'. The purpose was to facilitate machine vision of arrangements of blocks; and the problem was to work out a two-dimensional representation which would mediate that three-dimensional world, a language with which to describe block-worlds. The analysis was therefore of a language of lines that signified edges, but these edges could be any one of several kinds of edge – in Waltz's early version a line could mean convex, concave, obscuring edges, cracks between two meeting blocks, or two or three blocks meeting in a concave edge. The blocks were rectilinear, made up of straight edges and flat planes, but could otherwise have any form; they were not confined to the rectangular. The problem was to produce a catalogue of possible and impossible readings of various solid conformations from the two-dimensional drawings; with this, the idea was, a computer would be programmed to interpret the three-dimensional block-world. It proved difficult simply because most schemes of line/edge language contained too many ambiguities. Even when the impossible combinations had been marked as such in the catalogue, a line could still mean too many possible things for

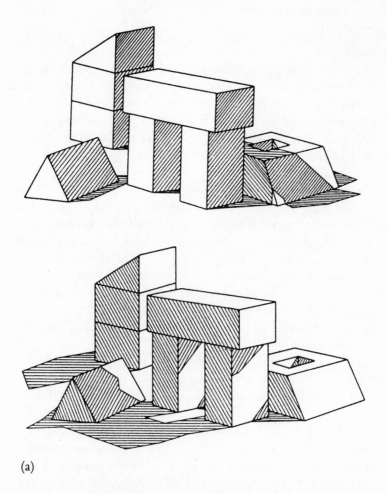

(a)

22 (above and following pages) Shadows in a block world. (From
David Waltz (1975), 'Understanding line drawings of scenes with
shadows', in *The Psychology of Computer Vision*, ed. P.H. Winston (New
York: McGraw-Hill), pp. 19–91.) (a) Projected shadow and self-
shadow: the shadow edges introduce the additional variable of light
source position and must be distinguished from object feature edges;
but they can also (i) resolve ambiguities between convex and concave,
(ii) carry information about hidden features facing away from the eye,
(iii) carry information about spatial relations. (b) Waltz's categorisation
of edges. (c) Examples of analysis with these terms. Discrimination
between projected shadow, SP, and self-shadow, SS, is inherent. I =
'Illuminated'; T = 'Table' or base plane. (d) One kind of product of the
analysis: visible regions assigned orientation values in relation to 'Table'
base plane and point of view.

─────⁺─────	1	*Convex edge*
──────→	2	*Obscuring edges* (Obscuring body lies to right of arrow's direction.)
←──────	3	
────_c→	4	*Cracks* (Obscuring body lies to right of arrow's direction.)
_c←────	5	
────┼────	6	*Shadows* (Arrows point to shadowed region.)
────┼────	7	
─────[−]─────	8	*Concave edge*
───[−]──→	9	*Separable concave edges* (Obscuring body lies to right of arrow's direction; double arrow indicates that three bodies meet along the line.)
←──[−]────	10	
──✳────	11	

(b)

(g)

(h)

(i)

(c)

① Table (TA)
② Horizontal
③ FRV (front right vertical)
④ FLV (front left vertical)

1 TA
4 FLV
⑤ FRU (front right up)
⑥ BLU (back left up)

1 TA
3 FRV
⑦ FLU (front left up)
⑧ BRU (back right up)

1 TA
⑨ LU (left up)
⑩ RU (right up)
⑪ FU (front up)
⑫ BU (back up)

(d)

one configuration of lines to register only one form, with no alternative readings.

What Waltz took advantage of was that the blocks, which were matte white and set in front of a black background, were illuminated (fig. 22(a)): there was shadow, consequently, both self-shadow and projected shadow. He added the edges of these shadows to the signification of the lines (fig. 22(b)). As well as the various kinds of block edge, a line could now also signify two kinds of shadow edge, since the shadow could be on either side of it. The effect was to introduce a new set of constraints on interpretation that went far towards excluding ambiguous lines and alternative kinds of possible edge. As was noted, the effect of complicating the signification of lines and edges a little was to simplify perception a great deal (figs. 22(c) and (d)). The shadows more than paid their way by ruling out false or ambiguous readings, and cast shadows were particularly pro-ductive of exclusions because they were, in a sense, out-of-system and intrusive, and ranged across more than one plane at a time.

Block-world machine vision had limitations that apparently led people to lose interest in it. But Waltz's result seems to have various implications for the possible workings of projected shadow perception, and three of them will be important to us here. First, the presence of the shadows was as shadow edges: lines, in a sense. Secondly, they contributed to information less by direct and positive means than by excluding false interpre-tation. Thirdly, the information they contributed to was about the surfaces they fell on as well as about the object causing them; they were more informative about the shape and position of the surfaces which they lay on, and which one was looking at, than about the objects that threw, or caused them.

19 One problem for the visual system is the vast range of possible illumination of the world, between a dark night and a bright day; this is literally millions of times greater than the range of reflectance of light from the blackest and whitest of objects in any consistently lit array, which is variously assessed at figures of the order of 20:1 or 30:1. Even within a single array the illumination may vary widely, because of shadow: the luminance contrast across a border from sunlit to shadow on the

same surface can be something like 9:1. Responsive to the first, general illumination, is the general variability of the threshold. Responsive to the second, local illumination, is the threshold's local variability. Clearly it would be impossible for a nervous system to operate finely with an absolute scale of many millions of degrees of light; it must relativize itself and operate with stable contrast ratios of reflected luminance set against sliding scales of illumination. It does so.

This means that there are no absolutes in the perception of tone: the same tone can look different within the same array. It also means that the system is very casual about what is happening between contrast edges. What does happen within the edges? In machine vision models what follows on the discontinuity-finding process (known as convolution) is deconvolution, a sort of filling-in by extrapolation, not observation. Some analogous kind of integration is likely in human vision. The Mach bands (fig. 23) and many other contrast illusions are in the first instance a product of the visual system's concentration on the discontinuity edges: the fields between them exist less as wholes with values of their own than as little-known and unstable border country characterized by difference from its neighbours.

What we use to control the instabilities of this retinal bottom-up early processing is top-down censorship and construction, from various perceptual levels. From fairly low comes such a check as the expectation that the light source should be consistent. From fairly high comes knowledge of objects; for instance, we know that canonical paper and coal are white and black, and paper in shadow, reflecting less light than a lit black object near it, is still perceived as white. But as is often the case, the more elusive and intriguing checks come out of a class of more general constructive dispositions from somewhere in between.

Some neat psychophysical investigation of these was made by Alan Gilchrist (1979). Gilchrist and his colleague Jacobsen built two miniature rooms, identically furnished. One room and its contents was painted uniformly matte white, the other matte black: by painting both uniformly matte they ensured that the pattern of stimulations on the retina was caused by different local illumination within each room, not by different local quality of reflecting surface, colour or texture. The rooms were worlds of pure shadow and shading. They were viewed through holes in one wall, designed to prevent the electric light sources from

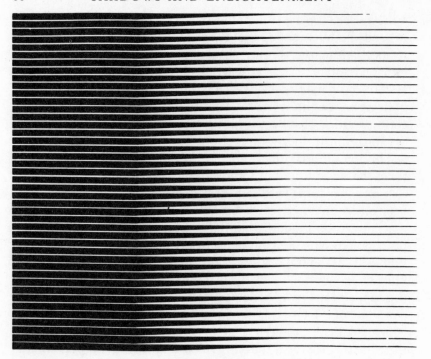

23 Mach bands. The evenly dark area left and evenly light area right
are separated by a third area centre which is a gradual transition from
the dark to the light, a 'luminance ramp'. To each side of this ramp
there can be an illusion of a vertical band, a dark band on its left, a light
band on its right. The illusion is the product of retinal enhancement
of luminance edges or discontinuities within the stimulus. This and
analogous contrast effects may offer an illusion of shading and so of
shape. They may also appear at the edges of projected shadows – see
p. 91 below. (From Nicholas J. Wade and Michael Swanston, *Visual
Perception* (London: Routledge, 1991), p. 77, fig. 3.26.)

being seen. People had little difficulty either in recognizing that
each room was uniform in tone of surface or in concluding that
one was white and the other black (or perhaps dark grey). But
of course the white room was brighter than the black room,
reflecting a greater total of light: that might well be enabling.
Gilchrist and Jacobsen therefore 'lowered the intensity of the
light source in the white room and raised the intensity of that in
the black room until every point in the black room reflected
more light than the corresponding point in the white room'. Yet

people still saw the white room as white, the black as black, even though the black presented a brighter stimulus, both overall and in each part.

What basis had they for doing so? The white surfaces of the white room, while darker under the dim illumination, reflected a higher *proportion* of received light within the room than the black surfaces did in the black room: stated as about 90 per cent against 3 per cent (fig. 24). This meant that indirect lighting played a larger role in the white room, and this meant that there was less variation of intensity and also less sharpness in contrast: the

24 Intensity profiles of reflected light from Gilchrist's rooms: painted white (top), painted black (middle) and painted white but with reduced illumination (bottom). (From Alan L. Gilchrist (1979), 'The Perception of Surface Blacks and Whites', *Scientific American*, ccxl.3, March, pp. 88–97.)

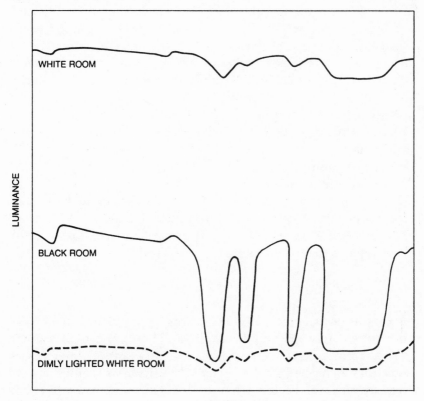

LUMINANCE

WHITE ROOM

BLACK ROOM

DIMLY LIGHTED WHITE ROOM

POSITION

shadow and shading were softer in the white room than in the black because they were more modified by reflections. With the qualification that the set-up of the experiment cued subjects to work comparatively, it does seem that from comparative intensity profiles of luminance they were able to determine which was the white, which the black, independent of and even counter to the suggestions of total brightness.

20 As has been said, the research of Koenderink and van Doorn, Waltz, and Gilchrist is heterogeneous and no attempt will be made to fit them together into a pattern of shadow perception. But each makes robust suggestions eccentric to the main line, which has been to work out how shape can be directly derived from an array of atomic light values treated as the product of slant and tilt of surface. Koenderink and van Doorn in effect raise the possibility of a much broader handling. Parabolizing extreme lights and darks and tonal continuities tell of basic component humps and holes. Waltz brings projected shadow and even the poor relation self-shadow into play. In particular, he locates a powerful function for projected shadow other than the silhouette imitative of just one object section: it resolves the convex/concave ambiguities it falls across. Gilchrist points to the high capacity of vision to derive information from relative differential patterns. Three terms – object form, lighting intensity, object brightness – in relation produce an informative pattern of luminance differences which enables us, given one (not two) of the three, to determine the other two: object form + the relative internal luminance differentials enable us to know, reciprocally, object brightness and lighting intensity. At least one gets a sense of a shadow world richer than the rather bleak landscape of shape-from-shading.

<p style="text-align:center">*</p>

To sum up schematically: The sensory elements in shadow perception are values of reflected light. These come to us through the receptor cells of the retina, an outstation of the brain, which pre-edits them, and so also the physical shadows, before onward transmission to the inner brain. The retina (1) is interested in luminance discontinuities, not in what comes between them; (2)

its standards for significance are both generally and locally variable in response to prevailing luminance levels; (3) it transmits separately to the cortex both fine and coarse takes of the same regions of the luminance array.

This is what the visual cortex has to work with. At this point it becomes difficult to continue thinking about the process within the neurophysiological universe, though striking particular localisations of function potentially relevant to shadow perception have been made. In particular, neurons responsive to quite complex and differentiated particular conformations of luminance gradation, which is to say areas of shading, have now been identified.

In the computational universe of machine vision it has been shown that it is possible to derive the shape of surfaces from their shading either serially or by a reactive parallel system, though the former is very laborious. This perhaps raises a question about whether there may not be both focused and unfocused faculties of shading perception.

In any case, the data from the retina interacts with constructive dispositions in the cortex. This is difficult to think about for many reasons, including problems of category. The interaction would be work at least germane to a perceptual task of sorting out luminance edges from reflectance edges and object edges – which means identifying shadows as shadows. There might be productive work with informative proportions of luminance value patterns, as in Gilchrist's rooms (§19). There might be work with deep patterns of forms' brightness invariance, of the kind located by Koenderink and van Doorn, underlying the changing luminance caused by changing illumination (§17). There might be work with shadow-caused luminance edges acting as constraints on misprision of object-caused luminance edges, as in Waltz's block world (§18).

All this would be work with, so to speak, abstract tools, undedicated templates, general constructive dispositions – an interest in significant proportionalities, eloquent invariances and contradictions and unities of system. At some point, also, hints or cues or suggestions of table or tree or human figure must somehow offer themselves for matching (§15). There is something bathetic about this moment, and there are notorious problems about the form this 'imagery' appears in – analogue and picture-like, or propositional and specification-like, or two-

dimensionally analogue and three-dimensionally propositional, or whatever. They are in any case unlikely to arrive with shadows.

21 I am sitting writing out-of-doors and intend introspection about shadow. For good discipline-historical reasons introspection is disreputable as a source of psychophysical data; but the taboo cannot stop outsiders reflecting informally on how far the models attained by more rigorous means seem to be covering ordinary experience, as it were, and these reflections are sometimes better explicit.

I am on a roughly paved terrace, on a windless day of very strong sun, but under the shade of a lime tree. I am at an angle to the south wall of the house, which is long, two-storeyed, buff-plastered but half-covered by vines of several different varieties, with three sun-bleached green stable doors and the one house door, nearest me, which opens into the kitchen. Looking along the house, from kitchen door towards the various stable doors, there are successively a compact oleander, an untrained domestic fig, and a massive plane tree, each of them five or eight times bigger than the last. Here and there are a score of pots and tubs, half of them earthenware, half of them zinc, with flowers and herbs. The table I sit at is large, round, and has a top of shiny white plastic, half of which is in sun. On the ground are a few small beetles and ants, and on the house wall are occasional lizards. There are no birds.

Looking about now I can see plenty of things that seem compatible with the thinking of these last two chapters. One of the pots, holding basil, is practically a Lockean shadowed disk: I hardly go through a process of inference to the sphere, or convex regular, and may now read it as an immediately transparent sign, but I will accept that I may long ago have learned the sign by making something like inferences; and even that in cases with less top-down assurance than this pot embodies might still resort to some ratiomorphic process. I follow the smaller lizards on the wall more from their shadow than from their own figure, which is close to the colour of the wall itself, and I lose them when they run into the shadow cast on the wall by the oleander, where they shed their shadows. The sharply grooved and scarified bark of the trunk of the lime tree is, if I wish, very precisely readable in

what may involve some shape-from-shading style, though the fact that the diffuse-lit side seems almost as legible as the direct-lit side suggests other factors are in play. If I did not know that the wall of the house was vertical, the bending of cast shadows when they meet it could tell me. I see brightness features on the parabolic lines of every pot that has parabolic lines: that has become obsessional since reading Koenderink and van Doorn. But at this moment I cannot see anything whose shape I am conscious of really learning from the shadow it casts, not even trees or tubs. Object edges, stereopsy, colour discontinuities, texture gradients and, above all, previous knowledge of objects seem more important.

On the other hand, at some level I must be doing a great deal of discounting of brightness discontinuities, as being due to illumination rather than reflectance or object shape. The forthright light conditions demand this, the shadows cast by the trees being strong and elaborate, and they also facilitate it. This raises a worry that can be put briefly as an appeal to the parsimony of natural selection. It would be uncharacteristically wasteful for the organism not to make full use of shadow, so unavoidably present and to be dealt with, as a means of perceiving its environment. Since brightness discontinuities must anyway be distinguished into reflectance discontinuities and illumination discontinuities if the shape of objects is to be accurately perceived, it would be particularly wasteful of the neuronal energy spent on this discrimination to discard identified illumination discontinuities as, simply, discountable, without making something further of them. Biological nature is not usually like this. Perhaps the trouble is partly that to frame the task of visual cognition just as perception of object shape is too simple.

For instance, earlier this morning I did see informative cast shadows indoors, but they did not directly inform me of shape. There is a small sitting-room off the kitchen in which I tend to sit and drink coffee in the early morning: through its open door one looks to the kitchen table and chairs and these cast a complex pattern of shadow on the tile floor. It is complex partly because light is coming from two directions, directly through the doorway from the garden, less directly but strongly through a single large window, quite deep-set in the same wall; this window opening has returns at the sides, set at an angle and painted white, so that they act as focusing reflectors and redirect a flux of

light into the kitchen, different in both quality and direction from that of the doorway. At the time I tend to sit, each of up to sixteen chair-legs throws two long diverging shadows into a beautiful criss-cross pattern. Moreover, while the set projected by the direct light from the doorway are parallel, those thrown from the window radiate from the window. It is a common effect.

It would be an absurdly complicated basis for learning about the chairs, which I know about anyway, but it is a manifestation of the lighting conditions in the kitchen. It tells me first about the two directions of light source and secondly that the redirected window light is weaker but of the same order of strength as the direct doorway light, but it also tells me a little more. As each shadow gets further from the edge casting it, its own edge gets softer; but those from the redirected window light start softer and degenerate less than those from the doorway, which start very sharp and quickly soften. The shadows carry clear information about two different kinds of photon deployment. The progressive blurring also constitutes a potential scale of spatial information, though I do not think this is active in this case. I consider that when I get up and go into the kitchen I am a little the perceptually sharper, rather better tuned, through exposure to these shadows. I have not perceived shape from them but would maintain that I am better calibrated for perceiving shape there, by having acquired a more secure light-space frame within which to do so.

Looking about here now, outside, I see phenomena analogous to those of the chair leg complex. At the edge of the shade cast on the table top by the lime, where it begins to become fragmented, I can distinguish between bits cast by nearer and further leaves on the basis of the degree of blur at the shadow edge. The flat shadow-picture on the table is three-dimensional within its own code. Though cast shadows are less long now than earlier in the kitchen, I can still make a direct sunlight shadow with my arm that blurs progressively from my elbow on the table to my hand in the air.

With all the reflection of light going on here in the shade under the tree – reflection from house wall, paving, and table-top – the lighting ambience is intricate and quite violent. Yet I cannot see the structure of cross-fire and ricochet in the photon flux I am sitting within, or at least I cannot see it directly as light in the air,

only as the cause of surface illuminations here and there. Because the light is not direct there is little specular reflection, or lustre: I depend on the degrees of surface brightness of differently facing surfaces to tell me of the direction and force of the different currents and cross-currents of light. I can experimentally hold a piece of my paper up at different angles and try to compare degrees of brightness, but my memory for light values is very insecure. It is better to crumple the paper into a buckled ball and throw it on the table top for inspection, since the different brightnesses of its different facets then offer a simultaneous map of the light activity here. Properly, I ought to be reading the shape of the paper ball from its shadow and shading, as no doubt in a fairly coarse way I am: shadow certainly opts for concave rather than convex here and there, and warns of irregularities on some facing planes. But I am also 'reading' the ambient light structure here from the shadow and shading on a paper ball the shape of which I know from edges and (this close) stereopsy too.

This is a first uneasiness, then: the demand that shadow perception, like all perception, should inform directly of shape seems too constricting. There is also a second uneasiness – which will have to wait – marked by the inverted commas round the word 'reading' in the last sentence but one. The metaphor was reasonable there because the reference was to the attentive inspection of signs, in a freak situation, but how often is our shadow perception attentive in such a way? Indeed, am I destroying shadows, as normal objects of perception, by submitting them to something as abnormal to them as attention?

To write up an edited version of thoughts had under a tree is obviously an artifice, but it is an artifice with a good heredity and easily identifiable intentions. The only suppression that needs to be declared now is that one of the sources of the thinking was a reading of mid-eighteenth-century studies of shadow, which I believe are profitably matched against the modern study of shadow perception sketched in this last chapter. The next chapter will be a survey of this eighteenth-century shadow study.

IV

ROCOCO-EMPIRICIST SHADOW

22 The term *chiaroscuro* or *clair-obscur* was used in two distinct senses in the eighteenth century, as people pointed out at the time. One is the working of light and shade in the world in general, a phenomenal thing. The other is the artistic arrangement of light and shade in pictures, an aesthetic and often normative thing (fig. 7). Present business is with the first, actual light and shade, but many of the most perceptive observers of this were visual artists, which is hardly surprising, and for some of them there could be tension and interference between the two. So it is worth sketching the leading ideas and terms of academic pictorial chiaroscuro in mid-century, which can be done very perfunctorily indeed since the general tenets of pictorial chiaroscuro are really quite simple. The complexities lay in practice.

The classic account of pictorial chiaroscuro for the eighteenth century had been that of Roger de Piles in his *Cours de peinture par principes* [1708], which exerted an influence on western Europe for half a century or more, but for various reasons the following summary will be based on the later, less creative and more representative, thoroughly useful *Traité de peinture* (1765) of the academician Michel-François Dandré-Bardon.

(1) The 'general' chiaroscuro is directed to establishing the priority of one group in a picture. The placing of this group is a matter of judgement, though a usual location is the centre of the picture, for reasons of balance (and also, in de Piles's account, for reasons of conformity with the centralized acuity of the retinal array). (2) The chiaroscuro is analysed in terms of three-dimensional *groups* of objects, people and things, and two-dimensional *masses* of light and dark. (3) Groups are ideally conical or pyramidal, like a bunch of grapes, and the compositional matrix is in general diagonal, in three dimensions. (4) Masses, correspondingly triangular in form, compose local light

and dark into coherence, preventing bitty fragmentation; and they exist in the structure at all levels, from the individual head to the whole picture. (De Piles sees the painter as manipulating three kinds of constituent within the masses: actual objects, adjustable object colours and contrived 'accidents' such as special light sources and light-obstructing objects, in or out of the frame.) (5) Masses of light and shade are analysed in three degrees, *lights, half-tones* and *shadows*, the half-tones corresponding to indirectly lit surfaces. (6) A rule: The area of shadow should be not less than the area of lights and half-tones combined. (7) The shadows should offer masses that are soft, flat, uniformly coloured even if subtly differentiated in tone (*tout est relatif*), and of course triangular. Much attention was paid to the dominant hue of the shadow, huelessness being hard to achieve. (8) The tonal differentiation of shadow is relative to (a) the nature of the light, (b) distance and (c) the rule (which is a simplification of remarks by Leonardo da Vinci) that cast shadow is stronger than attached shadow. (9) A fourth kind of mass, that of *reflections* or reflected lights, overlays the other three, being necessary to illusion, grace and harmony. (10) 'Above all, avoid those dark masses, those exaggerated blanks, those trivial affectations called *repoussoirs . . .*', these being impenetrable dark masses typically in the foreground, once supposed to set off a light middleground effectively.

Such a doctrine of chiaroscuro offers itself as a system, and both its analytic concepts and its sense of where the complexity of shadow lies could sometimes be a resource for, and so an influence on, eighteenth-century thinking about shadows. The three-value scale of lights, half-tones and shadows, for instance, and attention to the importance and intricacy of reflected light, and so of the penetrability of shadow, are both very much of the observational culture.

23 To find one's bearings in the period's shadow problematic, it helps to get a sense of how the various problems come together. In 1755 Charles-Antoine Jombert, a third-generation publisher with a fine technical list, and Libraire du Roy pour l'Artillerie et le Génie, published under his own name as author a handbook on painting called *Méthode pour apprendre le dessein*. It was a revised and expanded version of a book he had

anonymously published in 1740, *Nouvelle Méthode pour apprendre à dessiner sans maître*, and one of the additions was a long footnote in the section on colour. For reasons that need not be rehearsed here, this footnote can confidently be attributed to Jombert's close friend Charles-Nicolas Cochin the Younger, fourth-generation engraver, art critic and theorist, academician and art administrator, obsessional observer of shadow. Cochin will be important to this study. The footnote is a summary essay on shadow, in fact, and touches on most of the main areas of preoccupation. Though the reader may wish to defer working through the note – which is given in full among the Texts – it embodies a sort of agenda for this chapter.

One preoccupation (¶1, for example) is with the relative darkness or intensity of differently situated shadows.

> . . . objects close to the eye are reflected to it more strongly than those distant from the eye, and their colours are more lively, not just in the lights (or illuminated surfaces) but in the shadows also, because, being reflected more, they lose less of their colour than do distant objects: these latter lose their colour altogether in the shadows, and it weakens and greys a great deal in the lights. Also, when the air has no vapour in it, these shadows are very dark, it being impossible to tell what colour they are . . .

Another preoccupation (¶¶2, 7, 8, 10), very prominent, is about colour both of shadow and in shadow. Colour of shadow:

> In the morning, about sunrise, the colour of the vapour in the air makes shadows seem bluish, often even violet; towards sunset the shadows again have a bluish quality. It is not that these shadows are really this colour, since all shadows are grey, in themselves – that is to say, their colour is extinguished by privation of light; what makes them seem bluish is contrast, with gold or red or other tints, making the grey seem blue.

Colour within shadow:

> . . . in the transitions of light towards shadow, which are called half-tones, local object colours remain intact, or at any rate, if they are broken, it is in a way that is not noticeable; and they seem to suffer no more breaking of their colour than is caused by their distance from the beholder. So one can lay down as

principle: that the lights have a general shade they share which
does not destroy their real colour but just blends with it; that
the half-tones have the proper colour of their objects; and
that colours grey and lose their force in proportion to their
darkening [through privation of light]; and that when they
receive some reflected light they become a blend of their own
proper colour, which this light makes reappear, and of the
colour of the object that sent them the reflected light.

A third (¶3) is about the internal variation or structure of
shadows:

Shadows cast by bodies are always stronger than the shadows
on the shadowed parts of those bodies; the strongest shadows
and strongest handling are always near the brightest lights –
this nevertheless depending on the light from reflections which,
if it is both bright and close, can destroy part of that strength
and let it persist only in those places reflected light cannot
penetrate . . .

A fourth (¶¶5–6) raises the subject of visual phenomena deriving
from diffraction of light:

It seems that the rays of light that carry the image of the light
background past and near the edges have a kind of aberration
and are broken a little while passing close by the objects, and
that through a sort of vibration they carry these edges in a
blurred form.

There is a fifth preoccupation (¶¶4 and 6–11 *passim*), particular
to the frame of reference, with necessary or permissible adjust-
ments of natural shadow in paintings. And a sixth preoccupation
is very conspicuous by absence: there is no mention at all of the
form of shadow, not even of the much studied projection of
cast shadows.

The eighteenth-century issues emerging from Jombert-
Cochin's footnote can be generalized as follows: What can be said
about the outline form of shadows? And how rigorously can it
be said? How do light's complex ways of operating, particularly
reflection and diffraction, bear on the character of shadow? What
determines the different intensities of different shadows in the
same array? What about different kinds of lighting, focused and
diffused? What happens to object colours within shadow? And

why do shadows sometimes themselves appear coloured? These are the main questions that will arise in this chapter, roughly in this order.

24 Shadow is the product of behaviour by light. In eighteenth-century discussions one or other of two main classes of assumption was usual about the nature of light: the one posited a light that is constituted of distinct particles projected through space, and subject to physical forces like attraction and repulsion; the other posited a light which, whatever its material constitution, was matter in flux, rather like a fluid. There were other rarer notions, particularly those in the line of Christian Huygens that posited a light behaving in waves, rather like sound, but they tended to stay reclusively in high science and will hardly appear here. The particle theories were often but by no means generally Newtonian in character, though Newton himself was more cautious on the question than some of his followers, whereas the fluid theories were often more traditional and popular – less scientific, to be crude, in that they were not very seriously worked out in the medium of the new physics.

It is disconcerting to find how little difference it makes to Enlightenment observers of shadow, usually, whether they have a particle conception or a fluid conception of light; both, by the way, are liable to talk of light as made up of 'corpuscles'. The main difference is that the particle people were able to mathematicize light more, which is impressive but was also depopularizing. And the fluid theory had the partly compensating characteristic, from the present point of view, of accommodating people who were just single-minded visual observers of shadow: some of the particle mathematicians – certainly again excepting Newton himself – can seem visually incurious and obtuse. But it has to be admitted that much of the richest Enlightenment shadow-watching is quite pre-mathematical.

Whatever the notion of the matter of light, eighteenth-century observers were familiar with four operational modes of light's movement: *direct* from the light source, by *refraction* (the bending that appears when light passes from one sort of physical medium to another), by *reflection* from a surface, and – a new and glamorous arrival – by *diffraction*. It is the last two, reflection and

diffraction, that had and have the most interesting implications for shadow.

Reflection is a pervasive factor. It is determining for shadow intensity, to an extent that stimulated Privé Formey, the author of the article 'Ombre' in the *Encyclopédie*, almost to eloquence:

Unvarying laws as ancient as the world itself make the light of one body spring back on to another body, and from this successively on to a third, and then continuously on others, like as many cascades; though always with progressive reductions in strength, from one stage of falling to another. Without the aid of these wise laws, all that is not immediately and without obstruction under the sun would be in total night. To pass from the illuminated side of objects to the side the sun does not reach would be like passing beyond the surface of the earth into the interior of caves and caverns. But, by an operation of the powerful springiness that God puts into every portion [*parcelle*] of this nimble substance, light, it pushes against every body upon which it arrives and is pushed back again, as much by its own bounce as by the resistance it meets.

Reflection also plays a large and various role in shadow colour; it will be recurrent in what follows.

But it is diffraction that needs establishing first, since this is determining for the eighteenth-century sense of shadow form. In an airy way Jombert-Cochin refers (¶5) to rays of light suffering 'a kind of aberration' when near edges and being 'broken a little when passing close by objects'. He does not develop a point about shadow, in particular, but there is certainly some remote and indirect derivation here from Francesco-Maria Grimaldi's description of diffraction. Grimaldi's *Physico-Mathesis de Lumine, Coloribus, et Iride* had been published posthumously in Bologna in 1665, and prominently printed on the first dozen pages is the treatment of his first Proposition: 'Lumen propagatur seu diffunditur non solum Directe, Refracte, ac Reflexe, sed etiam alio quodam quarto modo, Diffracte' ('Light is propagated or diffused not only directly, and by refraction, and by reflection, but also in a certain other, fourth way: by diffraction'). Other investigators had been working in the area, notably Robert Hooke in England, but it was Grimaldi who first described and named it.

The relevant points can be quickly covered by looking at four of Grimaldi's excellent diagrams. He was experimenting with the behaviour of light when it passes either by sharp edges or through small apertures. In one experiment (fig. 25(a)) he passed light through a small hole, AB, and found it diffused into a cone when it arrived on a surface, obliquely set. He then placed an opaque body, FE, in the cone of light, well away from the hole, and observed the shadow. If all the light from the hole had been travelling in a straight line, the shadow should have consisted of a true shadow, GH, and a penumbra, IL, the latter due to neither the light source nor the hole AB being a true point. However, it was not thus confined; it extended out to the dotted lines, MN. This was the first result: shadows are liable to be more diffused than they should be, if all light were travelling straight.

The second phenomenon was that there were multicoloured fringes associated with the shadow edges. Figure 25(b) is a schematic diagram of such a fringe: X marks the shadow, and to the right of it are three successively fainter and narrower streaks of white light – M, P and S – each of which has a blue left side – N, Q and T – nearest the shadow, and a red right side – O, R and V. Grimaldi went on to study the behaviour of this fringe at the corners of the shadow of an angled object. Figure 25(c) shows how it curved round outside corners but ran into inside angles. More important, he found that if the intervening object causing a shadow was a thin, narrow plate, he could produce similar streaks within the shadow. Figure 25(d) shows the shadow of an L-shaped, round-topped section of plate with streaks behaving in ways broadly analogous with those outside the shadow in figure 25(c). But the important thing about there being streaks within the shadow was the indication that light inflected inwards while passing an edge, as well as away from the object.

The scientific fortune of Grimaldi's diffraction is complex and outside the range of this study. He was often known not directly but through other books' references to him: for some years even Newton's knowledge of Grimaldi's diffraction was indirect. Then there was the problem that Grimaldi seems to have had a fluid/wave concept of light, and specifically spoke against particles. It took some time for Newton, among others, to accept that diffraction – which he later reformulated as 'inflection', with aspects of 'dispersion' – was not just refraction in ether or

(a)

(b)

(c)

(d)

atmosphere; but by the time of the *Opticks* [1704] he had, of course, not only accepted it but developed it in startling new directions, in effect appropriating it. In France too there was resistance. In 1679 the great Edme Mariotte did to Grimaldi what he also did to Newton: repeated the experiment incompetently and reported with his immense authority that the phenomena claimed did not exist. But though Grimaldi was not quite a household name for all eighteenth-century amateurs of the shadow, diffraction had become established, in one guise or another, as a fact.

So light could suffer diffraction – or inflection, or even just 'a kind of aberration' – when it passed edges. Therefore shadows were more diffused, larger and more blurred, than if the light's track were, refraction and reflection apart, consistently straight. And this meant that the status of the old mathematical discipline of sciography, the geometrical projection of cast shadow, became very odd.

25 Sciography, a sub-branch of linear perspective, is the representation in two dimensions of the calculated forms of (almost exclusively) projected shadows. Figure 26 is from Edme-Sébastien Jeaurat's *Traité de perspective à l'usage des artistes*, a book published by Jombert in 1750 that taught a fairly standard technique of perspective and finished, not unusually, with sections on shadow from sunlight (parallel rays from infinity) and from a candle (located point-source).

If this chapter were proportioned to the actual number of eighteenth-century pages devoted to different aspects of shadow, at least half of it would be given to sciography. This belongs to an important and highly institutionalised element in French technical culture. At the great new state schools of bridge and highway engineering, of mines, of naval architecture, of military science, and also at the proliferating craftsmen's schools and free drawing schools, highly sophisticated modes of technical draughtsmanship were being taught, and they included very precise methods of shadow projection. Edme-Sébastien Jeaurat himself became a teacher at the new Ecole Royale Militaire in Paris in 1755.

There were classes of activity for which serious sciography was necessary and productive: astronomy, particularly the obser-

vation of eclipses, some branches of optics and probably gno-
monics. For surveying and for registering spatial relations in
technical drawing of various kinds, precise shadow projection
was a convenient resource. As a sort of compound geometrical
exercise – first project your cast shadow, then represent this
projection in perspective on a plane – the interest of sciography
had long been partly that it called for new geometrical skills
people valued and enjoyed, and which, moreover, had very
important alternative applications in such fields as engineering
and military science. Much of the energy that developed the
sciography also seems to derive from interest in the geometrical
enterprise itself, at a moment between Girard Desargues's pro-
jective geometry and Gaspard Monge's descriptive geometry
in the later eighteenth century. Sometimes the approach to
shadow – for instance, a preoccupation with projected shadows
as conic sections – comes near being an artefact of its medium of
enquiry.

The reason why little attention will be paid to sciography
here is that it has little specific to offer either on the physical
determinants of shadow or on the nature of shadow perception;
and the shadow forms it describes are conventional. This point
can be made by Formey of the *Encyclopédie* again, who, after
giving a fair summary of basic geometric shadow projection, has
a qualification to make that sets the case of shadow within a
general Enlightenment tension or dilemma:

> . . . while everything one is demonstrating here about the
> shadows of objects, whether in optics or in perspective, is in
> full accordance with truth seen from the mathematical side,
> when one treats the matter physically, things become very
> different. Explanation of the operations of nature almost always
> depends on such complicated geometry that it is rare for those
> operations to fit what our calculations have led us to expect.
> So it is necessary in physical matters, and consequently with
> the subject of shadow now being treated, to join experiment
> [*l'expérience*] to speculation – whether to confirm the latter,
> as does sometimes happen, or to see how far it is astray . . .

Sciography failed to cover the phenomena.

As its prestige in the culture cannot be wholly ignored, the
question here must be: did sciography postulate things about
shadow that have an interesting implication for the physical or

LEÇON CVI.

La lumiere étant un point determiné, trouver les marches qui doivent être ombrées ou éclairées.

PLANCH.
XCVIII. Soit la lumiere en T C; du pied du flambeau C on menera une parallele C B, & élevant la perpendiculaire L K en A, on verra, par le plan B du flambeau, que la lumiere se trouve derriere les deux premieres marches, & devant la troisiéme. Du point C, pied du flambeau, & par le point de vûe, on menera la ligne C E. Du point E on abaissera la perpendiculaire E F. Du point F on tirera au point de vûe la ligne F G jusqu'à la rencontre de la perpendiculaire du flambeau. Du point G, plan de ce flambeau, on menera la ligne G H S terminée par le rayon I S. Du point S on menera une parallele S Z, & l'on tirera S Q au point de vûe. Du point Q au point I on tirera la ligne Q P. Du point P on tirera P N au point de vûe; du point N au point A la ligne N M; du point M la ligne M *b* tirée au point de vûe, & du point *b* la ligne *b* Y. Si cette opération est exactement faite, les lignes Q P, N M, *b* Y seront dirigées à des points de transposition de la lumiere V T *d*.

LEÇON CVII.

Ombre d'un parallelepipede sur un cylindre couché horisontalement.

Du pied de la lumiere, & par les plans de l'objet, on menera les lignes Y L, X N, V P. Des points quelconques, comme T, S, on abaissera des perpendiculaires. Du point plan R Q on tirera des lignes au point de vûe. Des sections P O, N M, L K, on élevera des perpendiculaires qui seront coupées par les lignes T B, S A, & qui donneront le moyen de décrire les courbes B A C, D E F, G H I, qui, déterminées par les rayons, donneront l'ombre proposée.

LEÇON CVIII.

Ombre d'un cone sur un plan incliné.

PLANCH.
XCVIII. Du point P plan de la pointe de la piramide, & par le pied R du flambeau, on menera la ligne P K terminée par le rayon A K. Du point K on menera deux tangentes au cercle qui donneront l'ombre D K E pour l'ombre de la piramide, en faisant abstraction du plan incliné. Du point F on menera F I, parallele à l'inclinaison I, M; & des points H, G on tirera au point I les droites G I, H I. Du point X on menera la parallele X V; des points Z, Y on menera les lignes Z V, Y V, ce qui donnera l'ombre demandée.

Quant à l'ombre L T, elle sera menée du point Q, qui sera trouvé sur la parallele K Q passant par le pied R du flambeau, en menant S Q parallele aux profils O N, M L au talud O N L M.

26 (above and facing page) Sciography exercises. (Facing page) top: shadow thrown by side-wall on steps. Middle: shadow thrown by rectangular block on a cylinder. Bottom: shadow thrown by cone on an irregular surface. (From Edme-Sébastien Jeaurat, *Traité de perspective à l'usage des artistes* . . . (Paris: C.-A. Jombert, 1750), pp. 220–22 with pl. XCVIII.)

perhaps even perceptual character of shadow? At least, what sort of physical shadow did sciography assume? In the first place, by the eighteenth century advanced sciography had long addressed the problem of shadows cast by the sun, not just from some local candle-flame deemed a point, and was able to accommodate the three main conditions of solar projection: that the sun is extended, not a point; that its rays fall on the object in parallel; that, except in astronomical applications, the sun's distance must be treated as infinite. Most of this was due to Desargues. In the second place, it was a shadow caused by light which, whether fluid or particle, moved entirely in straight lines: reflection was scarcely addressed and diffraction not accommodated at all. In the third place, consequently, the product involved a sharp distinction between 'total' shadow and an idealized penumbra.

Leçon CVI.

Leçon CVII.

Leçon CVIII.

S Q *parallele* à ON, *ou* ML.
T L *dirigeé au point* Q.

The shadow world of sciography was narrow. Perception of shadow only exists in the form of its distortion by perspective. And the shadow covered is limited to projected shadow and incidentally self-shadow from direct sun. Also, only the outer limits of extension of these, not the relative intensity or internal structure, is addressed. It is interesting that those mathematicians who worked both on the nature of light and on the linear perspective of which sciography is an extension and part, were those least likely to urge people like painters to apply a rigorous geometric method to shadow. The Dutch scientist 'sGravesande, still a great value in mid-eighteenth-century France, had worked on diffraction. When he comes to shadow in the seventh chapter, 'On Shadows', of his treatise on perspective he is quite curtly dismissive of the pictorial, which is the phenomenal, viability of perspective, his present subject, for chiaroscuro, in the sense of phenomenal light and shadow:

> . . . a painter would do better to notice the shadows he constantly sees . . . than to have recourse to rules that cannot cover all cases. I shall therefore pass over the matter of chiaroscuro in silence; a little attention to what can be seen every day will clarify this subject better than any long discourse, the more so in that it is not only impossible to provide general rules on the subject but the infinite number of forms does not allow one to examine each as a particular: not to mention that, if he is going to really catch the chiaroscuro, a painter has to attend not just to the forms of the objects but to their colour and material character too.

We shall find Johann Friedrich Lambert, a great mathematician of light, taking a similar line. Sciography remained a playground.

26 In his *Encyclopédie* article Formey gave Grimaldi only two sentences. He put much greater weight on the work of Giacomo Filippo Maraldi (1665–1729), an Italian working in France, who had produced interesting observations of shadow structure in the early 1720s. Maraldi was informed about the work of Grimaldi and Newton, but he was more an experimental observer than a physicist of the new difficult type, and his descriptions of the forms of shadow were intellectually accessible to a general readership. They were partly stimulated by popular problems

like that of why the occulted or eclipsed moon is still faintly visible when, 'mathematically', the earth's shadow should be complete.

In 1723 Maraldi had reported in the *Mémoires* of the Académie Royale des Sciences observations of an experiment designed to match this problem. He put cylinders in full sunlight, and mapped and measured the morphologies of the shadows they cast. Mathematically, given the size of sun and earth and the distance between them, he was reckoning that the full shadows should stretch to a distance equal to a hundred and ten diameters of the shadow-casting object. They did not. Formey summarizes:

> He found that the shadow, which ought to have stretched to a distance of about 110 diameters of the cylinder ... only extended, in the sense of still being equally black all over, to a distance of about 41 diameters. (The distance increases when the sun is less luminous.) Beyond a distance of 41 diameters the middle degenerates into [a false] penumbra, and total shadow only survives in two very black and narrow streaks that bound this penumbra on both sides, lengthways. These two streaks are of the blackness proper to the true shadow; and the space that this false penumbra and the two streaks occupy would be proper to the true shadow, since it is of the breadth this would fit. The breadth of the false penumbra diminishes and it becomes lighter in proportion to increasing distance, and the two black streaks always stay the same width. Finally, at the distance of about 110 diameters, the false penumbra disappears, the two black streaks join into one, after which the true shadow disappears entirely and nothing more than penumbra is seen. It is to be noted that the true penumbra, which should theoretically surround and enclose the true shadow, accompanies the two black streaks of the shadow on both sides.
>
> Where the shadow falls quite near the cylinder and has not yet degenerated into false penumbra, two streaks of light are to be seen around the true penumbra, on both sides and outside, brighter even than that directly from the sun; and these two streaks get weaker with distance.

It is a beautiful flame-like scheme. Taking it in three-tone terms, a triangle dark at its base and for rather more than a third of its extension then begins to shade off into and through a half-tone

that expires at the apex. But this fading triangle is defined along its edges by dark lines. Outside these dark lines is a zone of penumbra, a half-tone again expiring away outwards. Cradling the base of the triangle, answering to the diminishing dark centre, are two diminishing light streaks enclosing the penumbra.

Maraldi also observed the shadows of spheres, which showed an analogous sequence of features in a modified form:

> If you use spheres instead of cylinders, the shadow disappears much earlier, specifically at a distance of 15 or 16 diameters; it then changes into a false penumbra surrounded first by a circular black ring, next by a ring of true penumbra, then by another ring of very bright light. The false penumbra disappears at 110 diameters and the ring surrounding it changes into a dark black blotch; beyond this distance one does not see anything more than penumbra. M. Maraldi thinks the reason for the shadow disappearing earlier with spheres than with cylinders is that the form of a sphere is more fitted to make rays of light change direction than is the form of a cylinder.

This last remark is fair warning that we are with a fluid man, not a particle man, and Maraldi's explanation of the forms he has observed is a rather primitive example of the type:

> He compares the rays of light to a fluid meeting an obstacle in its course, like the water of a river striking the pier of a bridge and turning, partly, round the pier in such a way that it enters a space it would not if it were following the direction of the two tangents of the pier . . . from which it results, (1) that the real shadow, or space entirely deprived of light, extends much less than 110 diameters; (2) that the two edges or arcs of a cylinder round which the rays are turning, not being illuminated by the rays at all, should always cast a true shadow: thus the two black streaks that enclose the false penumbra and whose breadth nothing can make change. Since these edges are physical surfaces with unevennesses that cause reflections among the rays, it is these reflected rays that fall outside the true penumbra and, combining with the direct light that also falls there, forms there a light more brilliant than that of the direct light alone. This light weakens with distance, because the same number of rays occupy an increasingly large area; for

the rays that have fallen parallel with [the edges of] the cylinder diverge after reflection.

Diffraction proper is evaded.

Maraldi's dark and light streaks are intriguing. Almost certainly they were Mach band-like contrast or edge enhancement effects (fig. 23), which one can experience in cast shadows in strong sun. That is, they would be a subjective function of such antagonistic elements in vision as the concentric ganglion cells of the retina. Sciography, in any case, was incompetent.

27 Still, Maraldi had been examining cast shadows in direct sunlight, and in isolation from, or at least without reference to, the accidents of global illumination. This is rather sterilized shadow. There are other kinds of daylight, and there are massive intrusions into real-world shadow from the environment, and both – diffusion of light and reflection of light – had a background of commonplace doctrine in art criticism. In a preliminary way this background can be economically represented here by Gérard de Lairesse, a Walloon who had made a career in the Netherlands as an exponent of French academic values and eventually wrote well-illustrated and much-translated handbooks at the beginning of the eighteenth century. The rudiments will be found in figures 27(a)–(d).

Lairesse covers much of the normal eighteenth-century art-critical doctrine of diffused and reflected light in shadow, which for some time was uninventive. For instance, among those who discussed the phenomenal differences between direct 'solar' and diffused 'universal' light was Jacques Gautier D'Agoty (1753). Gautier D'Agoty was an independent, an engraver and pioneer in colour printing, an amateur physicist and journalist who for a time put out periodical volumes of his studies in art and science; his science is sometimes bizarre but included some interesting anti-Newtonian posturing about the nature of light, for which he had his own theory of fiery particles sliding through the interstices of an atmosphere made up of spherical particles that behave collectively like a transparent fluid. It seems a good platform for fresh observation of diffusion, at least, but on the whole Gautier D'Agoty is quite orthodox. The difference

C. Van Jagen fec.

(a)

(b) top (c) bottom

(d)

27 (above and previous pages) The rudiments of the action of diffused and reflected light on shadow. (a) *Diffusion*. Above, direct solar light; below, diffused universal light. The shadows are not absolutely darker in solar than in universal light, only darker relative to lit surfaces. This does not take account of local action by particular reflection. On the other hand, shadows are absolutely larger and sharper-defined in solar light. (b) *Reflection*. The white house D is more reflective than the rough tree trunk C, so that the gowned and bearded figure B has lower shadow intensities – self-shadow value 1, projected shadow 2 – than the approaching figure A – respectively 2 and 3. (c) Similar effects, but the man B on the left has diminished shadow values – 1 and 2 – because he is open to light from all around; and the kneeling woman has extreme values – 1 and 3 – because her self-shadow is diminished by reflection from the wall, and her projected shadow is not. (d) Reflection from below, dramatised with water. Man A: the arm across the chest has double-reflection of light from below, from water and body; and the shadow and shading of the body is generally weak from single reflection. Man B: face, in the shade of the tree, is lit by reflection from below – as is Head C, more at an angle to the face. Man D: the proximity to the water excludes reflection since he himself casts shadow on the potential reflector. In all cases the hue of the reflecting surface modifies the hue of the shadowed surface it reflects its light to. (From Gérard de Lairesse, *Groot Schilderboek*, (Amsterdam: Hendrick Desbordes, 1712), pls [xxx], [xxiva and b], [xxvib].)

between solar light and universal light as it affected painting is above all a difference in the strength of reflected light within shadow:

> Solar light is directed upon objects from one point only, like the light of a lamp or of a small window in a room; that is why reflections are less extensive and almost uniform, and why a solid body bears more shadow on the side away from the light. But universal light is light that comes from the same side and a number of points, as in open country before sunrise or after sunset: in these cases the east or, for the latter, west side of a body is the more illuminated, and the opposite side is the more shadowed, but in such a way that the great number of different reflections of light rays, reflected in all directions according to their [angles of] incidence, are all round the object and softly illuminate shadowed parts that would otherwise be darker.

This leads to two points about painting. Like some others, Gautier D'Agoty is anxious that a picture should be consistent to either solar or universal light, throughout: because of the practice of studying landscape and such of its units as trees out of doors, and the figure or other object in the studio, in different lights therefore, many pictures were false.

The second point is about the right match of light with genre.

> Light too harshly contrasted with shadows makes an extremely bad effect in landscapes. To avoid this fault assume in such pictures universal light, the half-light of dusk or a sun hidden by cloud, which is what nearly all the Flemish landscape painters carefully kept to in their pictures.
>
> The subjects lit by light direct from the sun are either architectural-pieces or a particular kind of narrative history picture in which the number of figures is not very great: in such cases the subject becomes the more vivid and prominent for it – as is so in the pictures of Rembrandt, like the one of Tobias in the Marquis de Voyer's rare collection, in which the heads have an admirable light and the shadows, with the darkest of colours put in opposition to this strong light, serve precisely to set up a contrast that is in the highest degree skilful, vigorous, natural.

But Caravaggio's lamp-lit shadows are too dark, too little

relieved by reflection and aerial perspective, and destroy space and distance.

The problem seems to be a sort of softness about the idea of reflection. The painter Jean-Baptiste Oudry [1749], who is explicit about his thought owing much to the Netherlandish-trained painter Nicolas Largillierre, made delicate discriminations about light in shadow. Solar-lit cast shadows keep their tone to their limits more than universally lit ones:

> . . . as for the too equal tone many painters give cast shadows from one end to the other, you will see in nature that these are very strong only opposite that part of a body that is set on the ground; and that immediately after this they begin to shade off, and continue to do so imperceptibly to their ends, on account of the glimmer that exists everywhere it is light.
>
> The principle applies to all bodies casting shadows with the exception that the shading-off is much less marked in the shadows of objects directly lit by the sun.

More interesting, shading and self-shadow and attached projected shadow all shade off in universal light too, but from bottom to top: it is a matter of relative proximity to the surface reflecting light upwards.

> In objects that are illuminated by natural daylight only – that is to say, without effect of direct sunlight – for instance, a standing figure, the upper part always has stronger shadows than the lower part, because the lower part is within range for receiving reflected light from the floor or ground, the effect of which diminishes in proportion to the distance from its cause and gives way to masses that get increasingly dark.

What is elegant about this is that a figure, considered as from its base or feet, has cast and body shadows modulating in contrary senses, cast shadow diminishing, body shadow increasing. But it is as lacking as any other art theory of the time in any focused concrete sense of just what is involved in light reflecting from one or another surface.

Yet this was soon to be close. In his *Essais sur la peinture* of 1766, towards the end of the mix of commonplace and rhetoric that is the chapter 'Tout ce que j'ai compris de ma vie du clair-obscur', Denis Diderot says one striking thing:

Imagine, as if in Cavalieri's geometry of indivisibles, the whole depth of the picture cut up, no matter in what direction, into an infinite number of infinitely small planes. The difficulty lies in the exact distribution of light and shadows, both on each of these planes and on each infinitely small facet of the objects occupying them; it lies in the echoes, the reflections of all these lights on one another.

It is an excellent evocation of the challenge of painting surfaces, which unfortunately he does not develop. But, in spite of the red herring of Cavalieri, it must surely have been suggested by the recent work of Pierre Bouguer, particularly by the model of the reflectivity of rough or matte surfaces Bouguer had presented in the *Traité d'optique sur la gradation de la lumière* of 1760.

Bouguer analysed the reflectivity of matte and rough surfaces, such as frosted and acid-whitened silver plates, fine white plaster, and 'Dutch' paper, in the second half of the second book of the *Traité d'optique* (II. iii–iv). In previous sections he had treated lustrous surfaces as if composed of perfectly polished minute hemispheres. He now treated matte surfaces as composed of an infinite number of minute reflecting planes set at different angles and causing different degrees of interference with light rays and different kinds of bias in direction of reflection – much like the simplified models of reflection and microshadow used now for computer graphics (fig. 3).

In photometry proper this is not considered to have been a productive move in the long term, but as a conceptualisation it surely had the advantage of establishing a firm framework for the relation between the physical facts of reflecting material surfaces and the phenomena experienced by a localised viewer. He studied and characterised reflective surfaces first in statistical terms of inferred distribution of plane reflectors, angle of elevation and, in the case of anisotropic surfaces like the minutely grooved 'Dutch' paper, orientation. On the basis of a 'numerator of asperities' (fig. 28(a)) he could then develop a geometrical description of the carefully observed reflective tendencies of different surfaces that allowed precise thought about quantity and direction, loss and bias, and the product for a beholder or for the interior of a shadow (fig. 28(b)). This was a mathematical description of meticulous observation, not mathematically generated theory. It was a visual, because geometrical, grammar of visual facts which

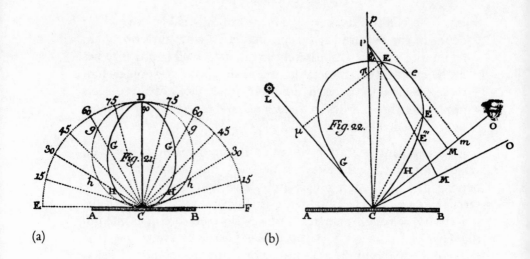

(a) (b)

Diderot was right to sense as a cognate of much good painting of the time.

28 However, it did not enter art theory. The ripple from Bouguer's *Traité* in Diderot's *Essais* raises the question, again, of theory and observation, of the relation of high science to the more general culture of shadow perception we are concerned with here. The two significant masters of photometry in the mid-eighteenth century were Bouguer (1698–1758), who had written an earlier *Essai d'optique* of 1729 as well as the larger *Traité* of 1760, and Johann Heinrich Lambert (1728–77). It is striking that Bouguer, who was the more genuinely empirical experimenter of the two, seems the less accessible to thinkers about painting. In fact, there is also relatively little in Bouguer that treats directly of shadow as perceived, though there will be reason to return to him apropos of shadow colour.

Lambert is different, partly because he was actively concerned to be of use to painters, but perhaps partly also because his willingness to mathematicize from a more slender base of experiment than Bouguer enabled him to cover a wider ground. His *Photometria* (1760), the book in which he describes the Lambertian diffusing surface, ends with a section on shadow. (This, much of which is a little remote from the present purpose, is summarised in the Notes.) Here it will be best to confine oneself to the Lambert of *La Perspective affranchie de l'embaras du plan géometral* (Perspective liberated from the encumbrance of the ground plane) of 1759, because in this, by explicitly limiting himself to what a painter needs for representation, he effectively also addresses himself to what is likely to be substantially active in perception.

Much of what Lambert deals with in his ten pages on shadow here is, of course, directed to the special problem of representing in true perspective on a picture plane the notional shadow of a notional object, sciography proper. He first (fig. 30, xv) gives a simplified method for drawing a candle-flame shadow – that is, a point-light source, with given bearing *and* distance – and then (fig. 30, xvi–xvii) for three bearings (from behind the picture plane, from before it, parallel with it) of sunlight shadow – at infinite distance but regressively treated as a point-source. He then (fig. 29) jumps to very extended light sources, which are

droites g h, e f, se croisent, & on fera v z perpendiculaire sur le plan du toit. En tirant une droite par les points S, v prolongée en f, on joindra les points f, t, & t f sera la direction & la longueur de l'ombre de v t.

§. 153. Dans les cas précedens toute l'ombre a un même dégré de force, à l'exception de ses extrémités, où elle se perd insensiblement, de même que l'ombre des objets plus éloignés, qu'on exprime plus foiblement, puisque l'éloignement en ternit la force. (§. 1.) Mais si la lumière, qui produit l'ombre, est fort grande, comme par exemple celle du jour, qui tombe par une fenêtre ou par une porte, on aura encore une penombre assez grande. C'est une ombre melée, d'un reste de la lumière, que l'objet ne couvre pas entièrement, & elle est d'autant plus foible, plus il y tombe encore de lumière. L'ombre totale provient de son entière privation. L'une & l'autre est limitrophe, de sorte que l'ombre totale se perd dans la penombre, & celleci dans la lumière, par des dégrés insensibles. Le dessin devant ressembler en tout au naturel, il est évident, qu'il y faut marquer aussi cette diminution successive de l'ombre, & que ses extrémités doivent se perdre & se confondre dans le jour.

§. 154. Que la lumiere du jour tombe F. 18. par la porte a b c d, & qu'il faille marquer l'ombre & la penombre du corp e f g. Par les points a, b, e, f, tirez les droites a e h, b f i, de même que a f k, b e l, les deux pre-

premières marqueront les extrémités de l'ombre totale, & les deux autres celles de la penombre. La longueur de la totale e h se trouve en tirant une droite c g h par les points c, h. Or a b & e f aboutissant dans le point de l'œuil P, tirez h i dans le même point, & e h i f sera le circuit de l'ombre totale. Si la lumière tombe par la porte de tout côté également, la penombre s'étend à l'infini, & on ne pourra marquer son extrémité, à moins qu'il ne se trouve quelque parois ou quelqu'autre corps, sur lequel elle puisse tomber. Dans ce cas on tirera une droite par b & g jusqu'à la surface de ce corps. Mais si on ne peut pas supposer, que la lumière, qui tombe de bas en haut soit assez forte, pour jetter quelque ombre sensible, on pourra se contenter de tirer par g une droite horisontale suivant la direction de b g, pour déterminer cette extrémité. Du reste la penombre se perdant dans le jour, son extrémité est trop foible pour être exprimée dans le tableau, desorte qu'il seroit superflu de se donner beaucoup de peine, pour la déterminer. On se contente communement de dessiner l'ombre totale, & de l'extenuer par dégrés vers les bords.

§. 155. En dessinant une chambre ou quelque autre partie interieure d'un édifice, on donne de l'ombre à toutes ces parties, où la lumière du jour ne tombe point directement, & qui ne sont éclairées que par la lumière reflechie. C'est ainsi que dans la 13e. fig. on tire une droite par les points m, p vers AG,

AG, & tout ce qui se trouve entre cette droite & le côté A g, est ombré plus fortement, puisqu'il ny tombe plus de lumière directe par la porte g n, & que celle, qui y tombe des fenêtres, est trop affoiblie par l'éloignement, pour y causer quelque clarté comparable à celle en g h.

§. 156. En dessinant un paissage, tel qu'il se présente dans le crepuscule, ou comme on dit, entre chien & loup, ou le ciel étant couvert de nuée, il y a une autre espece d'ombre, qu'on peut considerer plûtot comme une lumière affoiblie. Toute la clarté des objets ne provient en ce cas, que de celle du ciel, & il est évident, qu'une campagne, ouverte à tout l'horison doit être plus éclairé qu'une autre, où quelque objet voisin couvre une partie du ciel. Une ruelle étroite est toûjours plus obscure, qu'un objet, qui se trouve en pleine campagne. Cette sorte d'ombre est plus difficile à ecre bien exprimée sur le tableau, que les précedentes, si le tableau doit ressembler à la nature, puisqu'on a de la peine à déterminer la quantité & la grandeur de la lumière, qui éclaire chaque objet. Je traiterai quelques uns de ces cas dans la Photometrie. Mais ici on n'a pas besoin de tant d'exactitude, & on peut se contenter de ce que dicte le bon sens, sur la distribution de l'ombre. C'est ainsi que le pied d'un mur en rase campagne, n'etant éclairé que de la moitié du ciel, il est évident, que dans le tableau il ne faudra lui donner

donner que la moitié de la clarté, qu'on donne aux objets exposés à tout l'horison. Par la même raison il faudra doubler la force de l'ombre là où deux murs se joignent perpendiculairement, puisque l'angle, qu'ils renferment n'est éclairé que du quart du ciel. C'est ainsi qu'avec un peu de jugement, on déterminera le dégré de clarté, qu'il faudra donner aux objets, suivant qu'ils sont plus ou moins exposés à l'air.

30 (above) Johann Heinrich Lambert, *La Perspective affranchie* . . .
(1759), pl. II, figs XV–XVIII. Diagrams expounding shadow: see text,
p. 99 and fig. 29.

29 (facing page) Johann Heinrich Lambert, *La Perspective affranchie* . . .
(1759), pp. 82–5. On shadow, see text, p. 102.

where universal or diffused daylight comes in, though initially
only through a given aperture.

> In these preceding cases the whole shadow has had the
> same degree of force, except at the edges, where it falls off
> imperceptibly . . . But if the light that produces the shadow is
> very large, for example like that of daylight coming through a
> window or door, there will also be quite a large penumbra.
> This is shadow mixed with that remainder of light the object
> does not entirely screen, and the more light persists in falling
> into it, the weaker it is. Total shadow results from complete
> privation of light. Total shadow and penumbra conjoin in such
> a way that the one falls off into the other, and the other into
> light, by imperceptible degrees.

From shadow through penumbra to light is a continuum.

But it is a continuum within a structure. Lambert gives
a simple procedure for projecting the areas of shadow and
penumbra from daylight entering an aperture (fig. 30, and pl.
xviii). ABCD is the aperture of a door. EFG is the object. Draw
straight lines from A to E with extension for a future H, still
undefined, and from B to F with extension for a future I: the
extended lines are two edges of 'total' shadow, and the line HI
will presently mark the third, back edge. Draw similarly lines
AFK and BEL: these mark the outer edges of the penumbra. To
locate H simply draw a line from C through G to the intersection
with the extended AE: the intersection is H. But to locate I in a
plane representation like this, one must first establish a vanishing
point P by finding the intersection of extended AB and EF, the
bases of doorway and object. Draw a line from H to P, and the
intersection with extended BF is I. The area of total shadow is
now defined, and depicted: EHIF.

The penumbra's back edge is less easily defined and eventually
has to lead to unmathematical fudging:

> If the light falls through the doorway equally from each part,
> the penumbra extends to infinity and it will not be possible to
> fix its extremity unless there is a wall or some other body it
> can fall upon. In that case one draws a line from B through G
> to the surface of the body. But if it cannot be assumed that the
> light coming upwards from the lower part of the doorway is
> strong enough to throw a perceptible shadow, one could be

satisfied with just drawing through G a horizontal line following the direction of BG to set this edge. Besides, the penumbra fades away in the light and its extremity is too weak to be represented in a picture, so that it would be supererogatory to bother much about determining it. Usually it is enough to depict the total shadow, and gradually soften it off towards the edges.

This is subordinating any mathematical truth of the *Photometria* not to physical truth – there is no mention of such physical complications as diffraction – but to perceptual limits.

(When he added notes to a new issue of the German edition of *La Perspective affranchie* in 1774 he included one making a few complicating points about shadow. He was concerned to emphasize the rich relativity of shadows, through reflected light and differing strengths and angles of illuminations, and the example he finishes with is about penumbra. The penumbra round a shadow cast by an object can be as bright as a lit surface of that object, if that surface is being lit from a very oblique angle.)

In his last paragraph on shadow Lambert places the problem of diffused light in the open air:

> When depicting a landscape as it appears in half-light, or *'entre chien et loup'*, or when the sky is covered with cloud, there is another kind of shadow that can be considered as more like a weakened light. In this case all brightness of objects derives only from the brightness of the sky, and it is obvious that a countryside that is open to the horizon on all sides must be illuminated more than another one that has some neighbouring object screening it from part of the sky. A narrow lane or alley is always darker than an object standing in open country. This sort of shadow is more difficult . . .

He is thinking here not of cast shadows and their penumbra but of differential illumination, shading indeed. It is a matter of the degree of openness to the diffused, hemispherical light source, the sky. He is here close to Leonardo da Vinci.

> . . . the foot of a wall in open country is lit by only half the sky and obviously it will be necessary in a picture to give it only half the brightness given to objects open to the whole horizon. For the same reason one must double again the strength of

shadow where two walls meet at right angles, since the angle they enclose is lit by only a quarter of the sky.

He mentions that he will treat such cases in the *Photometria*, which was to come out a year later, but feels the painter will cope, with *le bon sens* and *un peu de jugement*.

29 In May of 1753 at the Académie Royale de Peinture et de Sculpture the engraver Charles-Nicolas Cochin gave a lecture on shadow, called 'On the effect of light in shadows, and the relation of this to painting'. The lecture was printed in 1757 among a collection of his papers, and it was also individually reprinted in the journal *Mercure de France* in 1758. Cochin has much to say about shadow elsewhere in his writings too, but this is his most systematic effort and deserves particular attention. Cochin attributes his central idea – which he considers one of those 'general principles' necessary for art – again to the painter Nicolas Largillierre. It is this:

> the darkest shadows should by no means be in the foreground of a picture; on the contrary, the shadows of objects in this first plane should be delicate and illuminated by reflected light, and the strongest and darkest shadows should belong to those objects that are in the second plane.

Cochin explains that he is using the usual scheme by which the picture space is conceived of as having three or four planes from foreground to horizon, foreground being first plane. And he admits that his idea runs counter to common opinion. In fact, like Dandré-Bardon and Oudry, he is partly polemicizing against the use of *repoussoir*, the dark foreground conventionally seen as setting off a brilliant second plane in pictures; and he is also in contention with the old formula of shadows simply becoming progressively fainter from foreground to distance, due to aerial perspective.

He first materializes his general principle in examples, the first of which recurs throughout much of the paper (fig. 31):

> . . . if you look at a wall that is receding, [self-] shadowed, and also casting a shadow on the ground along its whole length, I say that [both] these shadows, far from becoming weaker as they get further away, on the contrary increase in strength and

A B C, Rayon de lumiere qui frappe le terrein en B, est Reflechi sur la muraille en C, et renvoyé par elle a l'œil du Spectateur D.

E F G, Rayon de lumiere qui frappe le terrein en F, est Reflechi en G, et revient a l'œil D.

Le Rayon de lumiere E F G, a moins de chemin a parcourir pour frapper l'œil du Spectateur, que le Rayon A B C; donc le Rayon E F G donne une sensation de lumiere plus vive que le Rayon A B C. donc la muraille est plus obscure et plus forte d'ombre au point C. qu'au point G. &c.

31 Charles-Nicolas Cochin, *Dissertation sur l'effet de la Lumiere dans les Ombres . . .* (1757), frontispiece engraving expounding the effect of reflection of light within shadow at different distances of view.

darkness the further from our eyes they get; this increase continues for quite a distance.

The same is true of a receding avenue of trees or a receding colonnade on a building, each of which he describes. Since the lecture-room or printed page are ambiences in which he cannot demonstrate the fact empirically, by pointing to actual shadows in a prospect – cannot 'le faire voir, en raisonnant la nature devant les yeux' – Cochin will prove it by argument from some details of 'the mechanism of light', which will be 'a little abstract', but then chiaroscuro is anyway 'une science toute de réflexion'.

He begins from four axioms, incontestable verities: (1) we see objects by means of the light they reflect; (2) the less light, the less distinct and bright the image for the eye; (3) the greater the distance, the weaker the light; (4) and light also loses strength each time it is reflected. This last point is the first key.

One can compare the action of light to the movement of a billiard ball which, having been struck, runs and hits one side of the table which bounces it back against a second side, from which it is bounced back against a third. Each time it bounces off a side of the table it loses some force, so that it eventually stops running, even though it has not run nearly as long a road as it would have if it had met no obstacles.

Yet the reflection of light has this difference, that a single ray of light, however slender one may conceive it, has to be regarded as a sheaf or shower [*gerbe*] of rays which, when reflected, are bounced back all round: so that the light that falls on the point of a needle is reflected all around and the point is visible through the action of this reflected light to the eyes of all who look at it. Only burnished or glossy bodies reflect in a single direction.

Cochin does not enlarge here on lustre.

He now sets out on a classification of the different kinds of light involved in shadow intensity, the first distinction being between direct and reflected lighting:

Light leaves the sun and strikes the ground, directly. The ground reflects it in all directions; a proportion of the rays comes to our eyes and paints on them the image of the ground. The image is vivid and bright because this light has only undergone one first reflection.

Another proportion of the rays bounced back from the ground goes and strikes the [self-shadowed] wall and illuminates it: that is what we call reflected light [*reflet*]. If these rays which illuminate the wall were not bounced back a second time to our eyes, we would not see the wall at all, or at any rate we would see it as completely dark and would not make out anything on it; but these rays which have first been reflected by the ground are reflected a second time by the wall, and come to our eyes and paint on them the wall, the stones of which it is made up, and the other details to be met with on it. However, these rays have been reflected twice: they are weakened rays. That is why the wall appears darker than the [directly] lit ground, which transmits us its light through one single reflection only.

However, there is a further important distinction to be made within the category of reflected lighting, again following from the point about the weakening effect of reflection:

Of those rays that are reflected a second time by the wall, a proportion is thrown back on the [cast-] shadowed ground and from there reflected again to our eyes with a third reflection, and this paints on them the part of the ground that is in cast shadow and the objects that are on it. But these rays are only transmitted to the eyes through a third reflection and are very weak, and the image they paint is very dark. This is the reason for the following rule of chiaroscuro: *cast shadow is always stronger than the shadow on the body that casts it.*

A version of this rule is to be found in Leonardo da Vinci. Next, the third kind of lighting with effect on relative shadow intensity is diffused light:

The two shadows, [the self-shadow] of the wall and that which it casts on the ground, would appear even darker than they do if they received no other light than that just described, especially since, being reflected two or three times, it becomes very weak. But it is joined in them by another sort of light coming from the whole sky. This light is less bright than that of the sun, but it is quite strong since it is sufficient to let us see everything distinctly even when the sun itself is concealed by cloud. This light falls just about equally on the shadow on the wall and the cast shadow; whence it comes back to our

eyes on a first reflection, lights up both the shadows, and reduces the difference in darkness there would otherwise be between them.

Cochin has now distinguished between three kinds of light.

The first kind is primary, solar light reflected directly by the object to the eye, and because this can be blocked in its straight passage from the sun by solid and opaque objects, such as walls, it is the primary light agent in shadows. Moreover, if this were the only light, shadows would be absolute and visually impenetrable.

The second kind of light is secondary or tertiary (and notionally quaternary and so on too), being light reflected once or twice from blocking object to blocking object before final re-reflection to the eye. And because each reflection weakens its force further, tertiary light is weaker than secondary. Therefore, though this reflected light penetrates the shadows that are voids in the primary light and modifies their absolute darkness into a relative darkness, yet it differentiates sharply between self-shadow and cast shadow by penetrating the former with rather strong secondary light and the latter with nothing above rather weak tertiary light.

The third kind of light is multi-directional or diffused, 'from the whole sky'. It both helps the second light modify the absolute darkness of the shadows caused by the first light and softens the sharp differentiation made by the second light between self-shadows and cast shadows by entering them more indiscriminately. (Cochin does not elaborate on the mechanics of the diffusion of this third kind of light by the atmosphere, but Pierre Bouguer had developed a refined mathematical account of this whereby the particles of the atmosphere acted as reflecting objects, a sort of aerial micro-reflection of light.)

30 So far Cochin's description of shadow and its differential intensity has been objective and independent of any beholder's location. The beholder is now introduced by invoking the third of the initial axioms:

Now, I have said that rays of light weaken according to the distance they have to travel before arriving at the eye. It follows that the rays coming from the closest parts of the wall have more force than those coming from the furthest parts.

The more force, the brighter: we see the near parts with more clarity and detail than the distant.

The re-reflected light from shadowed objects at some distance has not sufficient force to affect our eyes; that is why we see these shadowed objects as very dark, in large *masses*, and without reflected light, consequently blacker and stronger in shadow than they would be if they were brought up to the foreground, where they would be lit by reflected light we could perceive.

Thus the effect Cochin illustrates in his frontispiece to the paper (fig. 31): light travelling EFGD – sun, reflecting ground, re-reflecting wall, eye – has a shorter last stage, GD, than the CD of ABCD. The vine can be made out within the self-shadow on the wall. Both kinds of shadow intensify in the middle-ground. Cochin has arrived back at the general principle he began from: shadows in the first plane are transparent and lit by visible reflected light, and it is those in the second plane that are the darkest and most impenetrable.

But it will be noticed that the third-plane or distant trees on the right have shadow less black than the second-plane or middle-ground tree behind the wall. Though Cochin does not mention it, they illustrate his next move, which is to accommodate a variable cutting across and countering the general principle.

It would seem to follow from the principle that, if shadows increase in force in proportion to their distance, those nearest the horizon ought to be the strongest in the whole picture and come near to complete darkness – which is not so in nature. On the contrary, very distant objects have very weak shadows . . .

The reason, of course, is old-fashioned aerial perspective, the interposition of atmosphere, which at a certain point begins to degrade the distinctness, the colour and also the tonal contrast of visible objects. At what point does it begin effectively to degrade them to the extent of perceptibly negating the principle?

. . . it is impossible to fix the distance, because it varies according to the amount of vapour the air is burdened with; to such an extent that on summer days I have seen strong shadows [of the second-plane type] at a distance of more than

eighty yards, whereas on fine autumn days they may scarcely appear even eight yards away.

It is an externally determined variable. Cochin has more to say – disposing of some apparent exceptions, such as unequally lit interiors; citing Veronese and Guido Reni as painters who handle these matters well; listing ways painters can exploit such effects; emphasising that what he has been saying does not regard local object colours – but his scheme for shadow intensity is complete.

For all the simplicity of his conception of physical light, Cochin's model of shadow intensity is elegant, with its two counter-scales of force and the moving point of dominance between them. It has the virtue of avoiding any crude linear sense of simple degradation by distance. It builds in a number of physically describable peculiarities of the behaviour of light. It sustains a clear sense of the distinction between objective and observed shadow. But the particular virtue is its neat variable, 'a certain line set at some distance into the picture where the shadows are strongest and darkest', on either side of which 'they diminish in force, whether coming forward to the foreground or moving back behind'.

31 The rococo-empiricists made a fetish of *reflection* of hues within shadows – a topic not new to art criticism and theory; Leonardo da Vinci had intended that the sixth section of his projected treatise on shadow should deal with it. The topic did not greatly lend itself to theoretical construction, in fact; and one impediment to analysis of colour-mixing in reflected light was likely to be the period's lack of a distinction between additive and subtractive colour. It was more a matter of sharp observation of detail, but what one has been primed to attend to, one is likely to see and also paint, perhaps disproportionately.

The Jombert-Cochin text sums up, in ¶10, such principles of hue within shadow as were current. (1) object hues in shadow diminish with distance. (2) object hues survive effectively unbroken in half-tones. (3) an object hue in shadow, if illuminated by a reflected light, becomes a blend of itself and the object hue of the reflecting surface – and, of course, of any hue in the general light source. By 1766 Diderot, who had been persuaded by the experience of reviewing Cochin's *Voyage d'Italie* in 1758

that he really must learn something about painting and its conceptualisation if he was going to go on writing about it, had appropriated a version of the idea. His exhortation to everybody is spirited and, again, seems to show some knowledge of the work of Pierre Bouguer:

> My friend, shadows have their colours too. Look attentively at the edges and even the whole mass of the shadow of a white object, and you will make out an infinite number of black and white points in it, interposed. The shadow of a red body is tinged with red; it seems the light, in striking the scarlet, detaches and carries away some of its molecules. The shadow of a body with the flesh and blood of human skin has a faint yellowish tinge. The shadow of a blue object takes from it a suggestion of blue; and the shadows and the bodies reflect on to each other. It is these numberless reflections of shadows and bodies that give rise to the harmony to be seen at this moment on your writing-table, where toil and talent together have thrown a pamphlet next to a book, the book beside a screwed up piece of paper, the paper among fifty objects dissimilar in nature, form and colour. Who notices this? Who understands it? Who represents it? Who establishes all these effects as one effect? Who understands the necessary *résultat*?

Diderot blames the modern painters' failure to handle colour reflection on the ignorance of the public: 'C'est la lumière générale de la nation qui empêche le souverain, le ministre et l'artiste de faire des sottises'.

It must be said for Diderot that, in a different context, he would not have struggled very hard against a suggestion that the painter Chardin understood the necessary *résultat*. In his Salon review of 1763 he had practically said as much, apropos of *The Olive Jar* (pls IV–V):

> . . . a vase of ancient Chinese porcelain, two biscuits, a jar full of olives, a basket of fruit, two glasses half full of wine, a mottled thing [*bigarade*] and a pie . . . This is the man who hears the harmony of colours and reflections. O Chardin! it is not white or red or black pigment you grind on your palette: it is the very substance of the objects, it is the air and the light you take on the point of your brush and attach to the canvas.

32 In 1743 Georges-Louis Leclerc, comte de Buffon, Intendant of the King's Garden, six years before publication of the first volumes of his monumental *Histoire naturelle* (1749–89), read a paper at the Academy of Sciences on the subject of 'accidental' colours. The main topic was after-images and contrast, but at the end of the paper he turned to coloured shadows, which he was under the impression had not been previously described:

> ... I think I should announce a fact that will perhaps appear extraordinary, but is none the less certain, and which I am astonished has not been observed: it is that the shadows of bodies, which should of their essence be black, since they are nothing but privation of light, that shadows, I say, are always coloured at the rising and setting of the sun. During the summer of the year 1743 I observed in the case of more than thirty dawns and as many sunsets that shadows falling on a white surface, such as a white wall, were sometimes green but most often blue, and a blue as vivid as the finest azure. I pointed this phenomenon out to several persons, who were as surprised as myself. It being summer-time was not a factor, for only eight days ago I saw blue shadows, in November; anybody willing to take the trouble of looking at the shadow thrown by one of his fingers on a piece of white paper at sunrise or sunset will see, like myself, this blue shadow. I do not know of any astronomer, any physicist, anyone (in a word) at all who has spoken of this phenomenon, and I trust that, in view of its novelty, I shall be allowed to give a summary of my observations.

This he did. On the whole, his observations were done in cloudless conditions, sometimes from an elevated vantage-point. The colour lasted from three to five minutes. The green shadows were from trees and, in one case, a trellis. In 1743 he did not propose an explanation.

It is strange that he thought his observation new, since the topic of coloured shadow had been around for a long time and is in any case surely a thing of common experience, but his paper, which was printed in the Academy's *Mémoires*, is important for putting the issue into scientific play, so to speak. The Abbé Millot's observations (p. 29) were in response to it; it later intrigued that enthusiast of coloured shadows, Goethe. However,

the most interesting direct response came from Pierre Bouguer. At the very end of his *Traité d'optique sur la gradation de la lumière* [1760] he is concerned with differential reflection of light by the particles that make up the atmosphere, specifically the greater reflection of blue light than of red light that leads, among other things, to the sky being blue. He adds:

> This furnishes us the explanation of a very singular phenomenon to which the painters have not failed to be very attentive, and which has procured us a memoir from M. de Buffon, but of which nobody, as far as I know, has given the physical reason. The shadows of morning and evening take on a very blue tint, and that of a candle produces almost the same effect when it takes the place of the sun which has not yet risen but is on the point of appearing. This phenomenon is caused by the aerial colour of the atmosphere which illuminates these shadows, and in which blue rays predominate. They are reflected obliquely in quantity, while the red rays, which lose themselves further on in following their original direction, cannot modify the shadow because they are not reflected, or are reflected much less.

It is understood that this happens when the sun is low because light then traverses more atmosphere. Bouguer's sense of the atmospheric particle was of a small reflecting solid body behaving towards light rather like a speck of dust – which does indeed scatter blue light more than red. It was not the modern conception of a minute particle reacting to collision with a photon by emitting high-energy, short-wavelength, blue light in any direction. But in effect he is describing something quite like this 'Rayleigh scattering', and offering a physical, objective cause for blue shadow. However, even in this brief note, in the conjunction of a reference to 'painters' and a reference to candle-light just before dawn, a conflict is latent.

When eighteenth-century scientists of light and vision invoke the opinions and practice of painters, as they very often do, it is tempting to imagine them visiting artists' studios to discuss matters of common concern: this is how cultural history should be. But more often than not, what 'painters' means is Fréart de Chambray's version of the *Traité de la peinture* of Leonardo da Vinci. This had been published as long ago as 1651, with engravings from the circle of Poussin, initially in fairly grand

TRAITÉ
DE
LA PEINTURE,
PAR
LEONARD DE VINCI,
REVU ET CORRIGÉ.
NOUVELLE EDITION.

Augmentée de la Vie de l'Autheur.

A PARIS,
Chez Pierre-François Giffart, Libraire
& Graveur, ruë saint Jacques, à l'image
sainte Therese.

MDCCXVI.

Avec Approbation & Privilege du Roy.

280 TRAITÉ

vent autant d'ombres differentes, que
les distances dans lesquelles on les voit
sont differentes : il n'y a que les om-
bres des orbites des yeux, & celles de
quelques autres parties semblables, qui
sont toûjours fortes; & dans une gran-
de distance le visage prend une demi-
teinte d'ombre, & paroît obscur; parce
que les lumieres & les ombres qu'il a,
quoy qu'elles ne soient pas les mêmes
dans ses differentes parties; elles s'af-
foiblissent toutes dans un grand éloi-
gnement, & se confondent pour ne
faire qu'une demi-teinte d'ombre; c'est
aussi l'éloignement qui fait que les ar-
bres & les autres corps paroissent plus
obscurs qu'ils ne sont en effet; & cette
obscurité les rend plus marquez &
plus sensibles à l'œil, en leur donnant
une couleur qui tire sur l'azur, sur
tout dans les parties ombrées; car dans
celles qui sont éclairées la varieté des
couleurs se conserve davantage dans
l'éloignement.

CHAPITRE CCCXXVIII.

*Pourquoy sur la fin du jour les ombres
des corps produites sur un mur blanc
sont de couleur bleuë.*

LES ombres des corps qui viennent
de

P. 281. Chap. 328

DE LA PEINTURE. 281

de la rougeur d'un soleil qui se couche
& qui est proche de l'horison, seront
toûjours azurées ; cela arrive ainsi,
parce que la superficie de tout corps
opaque tient de la couleur du corps
qui l'éclaire : donc la blancheur de la
muraille étant tout-à-fait privée de
couleur, elle prend la teinte de son
objet ; c'est-à-dire, du soleil & du ciel:
& parce que le soleil vers le soir est
d'un coloris rougeâtre, que le ciel pa-
roît d'azur, & que les lieux où se trou-
ve l'ombre ne sont point vûs du soleil,
puis qu'aucun corps lumineux n'a ja-
mais vû l'ombre du corps qu'il éclaire;
comme les endroits de cette muraille,
où le soleil ne donne point, sont vûs du
ciel ; l'ombre dérivée du ciel, qui fera
sa projection sur la muraille blanche,
sera de couleur d'azur, & le champ
de cette ombre étant éclairé du soleil,
dont la couleur est rougeâtre, ce champ
participera à cette couleur rouge.

CHAPITRE CCCXXIX.

*En quel endroit la fumée paroit plus
claire.*

LA fumée qui est entre le soleil &
l'œil qui la regarde, doit paroître plus
A a

32 Leonardo da Vinci, *Traité de la peinture* (1716), Title,
pl. 29 and p. 281. Blue shadows in the evening.

form; in the eighteenth century it was widely accessible as a duodecimo pocket-book, and its presence in thought about vision is pervasive, though often anonymous. What Bouguer certainly has in mind is the text and, one hopes, the illustration in figure 32:

Why, towards the end of the day, shadows projected on a white wall are of a blue colour.

The shadows of things coming from the red of a setting sun near the horizon will always be blued; this happens because the surface of any opaque body has the colour of the body that lights it. Now, the white of the wall being altogether without colour, it takes the colour of its [illuminating] object – that is to say, of the sun and of the sky. And because towards evening the sun is a reddish colour and the sky appears blue, and because the parts of the wall where the shadow is are not open to the sun, since no luminous body has ever penetrated to the shadow of the body that it illuminates, so the parts of the wall the sun does not shine on at all are open to the sky; the shadow projected on the white wall, being derived from the sky, will be of a blue colour, and the area surrounding the shadow being lit from the sun, whose colour is reddish, will share in this red colour.

Fréart de Chambray had had problems with Leonardo's difficult Italian, but the concept gets through: the shadow is blue because, shielded from the red sunlight, it is lit by blue skylight. Like Bouguer's it is a physicalist explanation.

33 But there was a quite different line of explanation, approximated by Jombert-Cochin (¶2):

In the morning, about sunrise, [the air] makes shadows seem bluish, often even violet; towards sunset the shadows again have a bluish quality. It is not that these shadows are really this colour, since all shadows are grey, in themselves – that is to say, their colour is extinguished by privation of light; what makes them seem bluish is contrast, with gold or red or other tints, making the grey seem blue.

In other words, the blue of shadows is a product of simultaneous colour contrast, a familiar phenomenon to painters. It is subjec-

tive. But there are two styles of framing such an explanation. The one is simply in terms of local colour contrast: near a red any element of blue is accented. Such an effect can be explained through the interaction of neighbouring retinal cells of contrasting colour sensitivity. The other is in terms of colour constancy and perceptual adjustment to the colour of light sources.

When Bouguer appropriates to those matters covered by his theory blue shadows from candle-light just before dawn he is moving too fast. What he seems to have in mind is the phenomenon reported by Otto von Guericke in 1672, well known in modern colour theory because of the interest taken in it by Edwin Land. Von Guericke observed that in the twilight of dawn the shadow thrown on a piece of white paper by his finger lit by a candle-flame appeared blue. He himself had an eccentric physical explanation (which is here sketched in the Notes), but the interest of the effect can be taken to be that it involves two light sources, the twilight general and white, the candle local and yellow-reddish. It is not covered by an explanation from atmosphere, nor indeed by simple simultaneous contrast.

Rather, it involves an inappropriate adjustment to the sense of local light colour, deriving from the sense of general light in the ambience. The mechanism is today still very discussable. For Edwin Land the Guericke effect was produced by the all-over white light intervening within the shadow, and unbalancing the lightness ratios registered by the three wavelength-specific receptor systems, from the relation of which three the mind constructs colour. A softer explanation would be that, in accepting the whiteness of the general lighting, the normal constancy adjustment for the redness of the candle-lighting immediately round the shadow was not made: its negative became not grey (that is, weak white) but weak white *minus* red, which is to say blue *plus* green. It is a cognate of the familiar demonstration in the generally red-lit room where the locally white-lit piece of white paper appears blue. The constancy mechanism is tricked. If one could justify the space, which one cannot, it would be proper to go back now to page 29 and the Abbé Millot, and make redress. By positing a red tile floor here, perhaps a yellow reflecting wall or even tree outside there, a reddening morning mist for the direct as opposed to indirect light to traverse, and the Abbé's own knowledge of his wall colour, it would be possible to work out circumstances in which he could indeed

have seen yellow-green and violet-blue shadows cast by the same chair.

Coloured shadows are not very important to our knowledge of the world, but they exemplify the explanatory tension that seems to emerge from the equivocal status of shadow. The tension is between explanation as physical object, as in Bouguer, and explanation as product of the perceiving subject, as in Jombert-Cochin. The tension still exists: if one looks up 'Shadows, coloured' in modern handbooks on vision, some may refer briefly to Rayleigh atmospheric scattering, others just as briefly to colour constancy, but I have never yet found both. It would be to mix genres.

LA GRENOUILLE QUI SE VEUT FAIRE AUSSI GROSSE QUE LE BŒUF. Fable III.

J.B. Oudry inv. *C. Cochin aqua forti. R. Gaillart cælo ecul.*

33 Jean-Baptiste Oudry (1686–1755). *The Frog who wanted to be as big as an Ox*. Jean de La Fontaine, *Fables choisies* (Paris: Desaint and Saillant, Durand, 1755–9), IV, p. 95. Redrawn and etched by C.-N. Cochin, engraved by R. Gaillart, 39.5 × 27.5 cm.

V

PAINTING AND ATTENTION
TO SHADOWS

34 The Rococo-Empiricist shadow-watchers were not quite a coterie but had some cultural coherence. Cochin, for example, had been a friend of Jombert since childhood; collaborated with Oudry in illustrating a famous edition of La Fontaine's *Fables* by translating Oudry's tonal wash drawings into linear terms for engraving (fig. 33); designed engravings for a book by Bouguer (a difficult and recessive man) and for several by Rousseau – including an allegorical portrait for the second edition of *La nouvelle Heloïse*, which Rousseau liked though suspected of irony; thought fairly well of Piazzetta, Tiepolo and Subleyras, on the whole; designed the allegorical frontispiece for the *Encyclopédie* and tried to teach his friend Diderot how to do art criticism, as did others. Diderot knew almost everyone, including Condillac. In one way and another Buffon (as an advisor), Montesquieu (as author of a famous article on Taste) and, of course, Formey (the article 'Ombre' and many others) were also involved in the *Encyclopédie*. Lambert, a Huguenot from Mulhouse who eventually became a member of Frederick the Great's Academy at Berlin, was an outsider, but it was Formey, himself a Berliner from an emigré Huguenot family and by now Secretary of that Academy, who delivered the eulogy there when Lambert died in 1777.

There is at least a convenient homogeneity of reference. The issues this shadow-watching community addressed were: What can be said about the outline form of shadows, and how rigorously can it be said? How do light's complex ways of moving, particularly by reflection and diffraction, affect the forms of shadow? What determines the different intensities of different shadows at different points in the same array? What

about shadows in diffused light? What happens to object colours within shadow, and why do shadows sometimes themselves appear coloured?

These issues of chapter IV are different issues, differently framed, from the modern issues of chapter III. Because they are much concerned with establishing principles for shadow appearance, the address to shadows sometimes has less in common with modern cognitive science than with the algorithm construction of modern representational computer graphics. But to consider what is necessary to represent perceived shadow well can be a special application of ideas about what part shadows have in perception: the issues are convertible into positions on this, and these positions are not identical with those of the empiricist psychologists sketched in chapter II.

For the empiricist psychologists of chapter II as for the modern cognitive scientists of chapter III, if shadow and shading have positive importance for perception of the world, it is for its modelling of forms into shapes – circles into spheres, or aerial photographs into landscapes. Even cast shadows are usually seen as forms which, if they have any perceptual use at all and are not just a stumbling-block, primarily offer information about the shape of objects. The message latent in chapter IV is different.

The message is that shadow's primary information is not immediately about shape. Because light diffracts and reflects in such complex ways (§§24–5), its negative local deposits, or shadows, are going to be too complexly encoded for normal perception to read off form from them, except in the gross but important matter of distinguishing between flat and convex and concave, at whatever level of detail. (For this a three-tone scale of values is likely to be quite adequate.) The simple distinction between flat and convex and concave helps us to use the seen edges of objects and our previous knowledge of objects to extrapolate to the three-dimensional object.

But shadow perception is much more about light, atmosphere and distance, and here *tout est relatif* – that is, a matter of differentials. First, we learn by perceiving the condition of shadows of objects of known shape, not by perceiving the objects' shape from their shadows. Second, what we learn about immediately is the condition of light and atmosphere, the ambience of objects, not in the first instance objects themselves. For instance, even a glance at a single shadow, the character of its edges and interior

degeneration (§27), gives us a basis for assessing the state of the sunlight, sharp-focused or diffused; this can help us read other characters of the visual array more finely, including the edges of objects. But, third, by doing something differential-equation-like with light and atmosphere values we fortify any distance percep-tions we have derived from perspective or interposition: Cochin's refined model of the modification of shadow for distance (§30) is reversible into perception of distance from the condition of shadow. In this, perception of 'groups' (§22) may well be as important as individual objects.

Some of the main types of perceived shadow we have met are listed and arbitrarily rough-ordered in figure 34, which is arranged for convenience, not as a taxonomy. If one thinks about them purely in terms of their phenomenal style, the sort of arrangement of appearances they would present to a processing mind, most of them involve one of three kinds of task.

The first kind of task – the task primarily of nos 1 and 2, Plinian and Waltzian shadow – is syllogistic, so to speak, in that something signifies once a couple of premises have been properly put together. Plinian cast shadow is the pure example: put together silhouette and light-source, and the product is object section; or, put together object and light-source, and there at the least is something to eliminate from among real object edges – or perhaps to use as the pro-syllogism from which to go on to the further syllogism of a Waltzian cast shadow.

The second kind – nos 3 and 4, Maraldian and Grimaldian degeneration of shadow intensity and edge with distance from the throwing object – lies in a regular, linear rate of increase or differentiation. Maraldi and Grimaldi (and Oudry) expounded them or their basis in relation to the increase within the unitary case, the single shadow. But they also appear in more complex forms. On any terrace floor dappled by sun shining through trees there is an extraordinary plane map of a three-dimensional reality: the relative intensity and sharpness of each leaf plots its relative distance from the floor. The complexity can come near to that of the third kind.

The third kind of task is that of most of the rest and is not intrinsically one type at all, but a mixed bag defined in the first place by being dispersed across the whole visual array, and in the second by having more than one primary dimension of differentiation. What they also have in common is a great

Projected shadow

1. Plinian (§18)	silhouette form	object section (reverse-sciographic)
2. Waltzian (§18)	deformation of silhouette	receiving surface form (post-no. 1)
3. Maraldian (§26)	attenuation of intensity	⎰ relative distance of object point
4. Grimaldian (§24)	edge-sharpness attenuation	⎱ from shadow point

Self-shadow

5. Self-shadow A	self-occlusion from light	shading anchor (→ no. 7 below)
6. Self-shadow B	self-occlusion from light	object section (cf. no. 1 above)

Shading

7. *Rilievo* (§14)	variables in modelling	surface form of the object
8. Utrecht *rilievo* (§17)	constants in modelling	surface form of the object

General shadow

9. Durerian ⎫ (*para-scio-graphic, §25*)	location of object shadow	light orientation ⎫ (*casting object given*)
10. Aguilonian ⎬	extension of object shadow	light distance ⎬
11. Desarguian ⎭	penumbra (sharpness)/form	light extension ⎭ and form
12. Lambertian (§§27–8)	intensity/sharpness	atmospheric medium of light/diffusion
13. Buffonian (§§32–3)	hue	light hue (→*colour constancy*)
14. Cochinian (§§29–30)	penetrability vs. dimming	object distances from viewer
15. Lairessian (§27)	local contrast intensity	local surface reflectivity/reflection
16. Gilchristian (§19)	global contrast range	ambience reflectivity (tone + texture)

34 Some possible shadow perceptions.

intricacy that makes one wonder whether the mind would find it economical to address them actively and comprehensively, and the fact of what has to be called systematicity. The systematicity embodies information by responding in a regular way to multiple determinants: the information is therefore about the determinants – light, surfaces, angles. An issue is whether the mind finds it best to read the causes by deductively aping the system backwards, or whether it has learned, individually or by evolution, to lie back and simply pick up the complex regularities it just knows are the product of a certain combination of the causes – again light, surfaces, angles.

It will have been noticed that the first two kinds of processing task covered all and only projected-shadow perception: Plinian, Waltzian, Grimaldian, Maraldian. (no. 5, Self-shadow A, an impoverished cognate, might have to be admitted too.) The shadow we sometimes notice, isolate and inspect *as* shadow is mainly cast shadow. The prominence to our minds of cast shadow is clearly due to a number of things. It often moves fast on its ground and is noticeable because of that. Because it is simple its constituent three terms – one light source, one object, one silhouette – are often simultaneously present to us in a satisfying way: so it expounds itself, the inviting territory of sciography. Its third term, the silhouette, has obvious resonances with the edge-seeking thrust of the whole visual system. And the nuisance effect of its intermittent interference with that thrust, our having to distinguish it from an object edge, also makes us aware of it. But perhaps a fifth reason is that its form, linear inference, is so much the form of our own conscious reflection: it flatters ratiocination by being amenable to it. We can easily and pleasurably attend to it, but that does not mean it embodies more useful information than other shadows.

Part of the interest of the Rococo Empiricists is that by trying to extend their rationality beyond the tractable cast shadow of the sciographers, they tried also to probe downwards a little towards the border country between the high-level and the low-level perception. Here the pure example is Cochinian shadow. It will be remembered that Cochin covers distance degeneration of shadow with a description using two counter-scales intersecting at a variable point: one scale is of decreasing tonal intensity (caused by intervention of atmosphere) and the other is of decreasing internal penetrability (caused by distance-attenuation

of light). At the variably distanced intersection point are the
'deepest' shadows. Each of the two scales is a scale of linearly
plottable decrease, and the intersection is a function of the
proportionate strengths of atmospheric density and light
intensity – variables; and though Cochin himself had no reason
to mathematicize it, his culture ensured he would know it to be
computable. Once Cochin has led one to attend, one notices
something like his scheme in operation in the visual world,
continually: pensively gauging the penetrability of middle-ground
shadows can become an enjoyable part of life.

On the other hand, that may be a morbid pleasure, a
deformation.

35 The Scottish philosopher Thomas Reid, in *An Inquiry into
the Human Mind* [1764], reflects on the faculty of sight, the
product of 'an organ, consisting of a ball and socket of an inch
diameter', with which we may within an instant perceive pro-
spects (the peak of Tenerife, or St Peter's church at Rome) it
would take the sightless a lifetime to perceive by touch:

> If we attend duly to the operation of our mind in the use of
> this faculty, we shall perceive, that the visible appearance of
> objects is hardly ever regarded by us. It is not at all made an
> object of thought or reflection, but serves only as a sign to
> introduce to the mind something else, which may be distinctly
> conceived by those who never saw.
>
> Thus, the visible appearance of things in my room varies
> almost every hour, according as the day is clear or cloudy, as
> the sun is in the east, or south, or west, and as my eye is in one
> part of the room or in another: but I never think of these
> variations, otherwise than as signs of morning, noon, or night,
> of a clear or cloudy sky.
>
> . . . A thousand such instances might be produced, in order
> to show that the visible appearances of objects are intended by
> nature only as signs or indications; and that the mind passes
> instantly to the things signified, without making the least
> reflection upon the sign, or even perceiving that there is any
> such thing. It is in a way somewhat similar, that the sounds of
> a language, after it is become familiar, are overlooked, and we
> attend only to the things signified by them.

Reid was in no normal sense empiricist in psychology. At least functionally, perception was immediate, in his opinion: we do not form Lockean ideas to mediate between sensation and knowledge. His challenge therefore sets the issue very sharply. Is shadow a sensation interpreted with actively attentive cognition, or is it – whether through familiarity or (as Reid tends to feel) by inborn disposition – just a sign transparent through to some physical reality?

I am writing this at a table with a wall each side of it, on a day of mixed sun and cloud. The wall on the right is modern, made of brick, and painted white with a matte but even emulsion paint. At the base of the wall the paint is blistering from damp. The wall on the left is much older, rough-cast rendering over un-dressed sandstone masonry, and there have been various attempts to patch gaps in the rendering with cement of various con-sistencies. It too is painted white, but with a rougher sand-textured stuff. This is flaking off in places due to an impermeable white flint element in the rough-cast; and in some but not all of these places desultory touching up has been done with a different, slick and clinging white paint, some of it applied by a roller and some boldly by a brush. The conspectus of the walls to left and right is almost as monochrome white, nevertheless, as one of Gilchrist's rooms.

As the sun comes and goes the various kinds of radiation change level by a large factor, certainly to the point of dis-comfort – there are windows on three sides – and yet the walls remain white: brightness constancy, of course. But, partly because of these shifts between direct strong light and diffused weak light on the monochrome walls, partly because of a special interest, I am very aware of being in an indescribably intricate ambience of microshadow. It may usually be called texture, a word that somehow invokes the sense of touch, but it consists visually of almost pure shadow – very small self-shadows, derived shadows, and slant/tilt shadings (fig. 3). It is almost purely from shadow that my visual access to the microstructure of the two plane surfaces of the walls derives. I do not think stereopsy is helping much.

What I do not do, or would not be doing but for a special interest, is attend to the individual microshadows as shadows or

as objects of perception in their own right. If I attend to part of a wall I get a sense of its surface quality and that seems enough. Even with a special interest, it takes an effort of will, a decree of the mind, to attend to the same area of wall, categorize its shadow types, and read the bearing of their lighting. It is not an optical problem of acuity, in this strong light; rather, it seems to go against the grain of the perceptual process.

Physically such microshadow is identical with any other shadow: perceptually it is likely to be a little different, and one respect in which microshadow differs perceptually from other shadow is the relative weakness of imagery. Experience of the match between certain sorts of microshadow and certain kinds of roughness no doubt plays a part. But there are no mental descriptions of forms (or functions) as specific as tables and trees. I must construe the detail of the walls more directly from the shadow, with only rather generic matching to knowledge of wall textures produced by the materials, tools and operations I find myself quick to infer as sufficient covering description of the formal complexity. Yet a compensating characteristic of much texture – continuity and regularity, as in fabrics or animals' coats or sandy beaches – is not so strong here.

If I now look out of the windows of the room, the array below sky-level is less monochrome than the walls, but still limited in colour range, being all vegetation and so reflecting light disproportionately in the range 500–575 nanometres. The left side of the array is taken up by a thick wood half a mile or more away across a valley, running along a ridge for a mile or two, oak with some ash. The right side has (progressively closer, from twenty yards away to five) a row of straggling sloes and a large yew. To the right of the yew a neglected hedge runs away again, hawthorn in principle but infiltrated by elder and hazel. Here and there among all this are areas of rough pasture grass. Though it can nearly all be described as 'green', the least precise of the simple colour terms, there is some range of object hue and even more of object tone.

This last, the range of object tone, is the first thing that makes shadow perception of the vegetation different from that of the walls, and more complex. One must allow for reflectance value as well as illumination value. A second difference is that there is some visible movement within the elements of the closer trees on the right, due to the wind, and this offers information about

interposition and depth. The third and higher-level difference is that I have a much richer and more specific repertory of mental images to match with the visible. My knowledge of types, possibilities and modes of organisation is more informed for trees than for the grainy and gravelly universe of the wall surfaces. This is presumably because, since I am not an insect, the former represents the scale I operate on in my normal negotiation of environment.

Otherwise, I think both the walls and the trees are likely to involve analogous density and variation of retinal array – compared with that produced when I look up at the cumulus clouds in the sky, for instance–though the walls are reflecting from close and the trees from further away. Because of its relative lack of reflectance variation and relative lack of imagery, the experience with the walls' microshadow is an unusually pure experience of shadow. As I have said, there was a curious sense of block when trying to attend to the shadows as parseable shadows; and the mind seemed quick to settle for a general description of surface character rather than a specific three-dimensional plotting. A question is, is the same true of such more usual perception as that of trees?

With a decree of the mind I can force myself to a methodical attentive survey of the abstracted visual properties of the yew tree, for a while. It is quite a barren exercise, much energy going into sustaining the procedure, which is what I mainly recall afterwards. On the other hand, I can sustain attention to the tree's form without strain if I am not straitened by such a drill, particularly if I am attending with some such purpose as assessing the health of the tree; but then I am attending to a tree, not to its visual properties. To draw it would sustain attention to these, though shared with interest in the drawing itself. As it happens, I can attend to the shadow on and in the deep recesses of the tree, and as shadow, but this may be untypical, since I am excited by its confirmation of Charles-Nicolas Cochin's account of the first two planes of shadow: the first plane shadows are indeed more penetrable than the second plane shadows.

36 It is both awkward and necessary that Thomas Reid should speak of address to shadow in terms of *attention*. Attention is a very unstable concept – either an act or a state, of focused

perception, and/or directed perception, selective perception, active perception, conscious perception, reflective perception. Reid himself uses the word in two different senses in the quoted passage. But it is appropriate, because it is still the unforced word for the case and his use of it prompts caution. Can we and do we 'attend' to shadow?

It is clear we can attend to Shadow, in the sense of reflecting on the workings of shadow as involved in perception in general, as the Rococo Empiricists did in chapter IV – a sort of meta-attention to shadow. This is not the problem. But can we attend to individual shadows? Clearly we *can*, again, but that is not the issue either. The issue is whether we can do so and at the same time preserve the pattern of our more usual utilisation of the same shadow in the course of normal variously directed percep-tion. And this simply leads to the issue of whether we *do* attend to individual shadows in normal variously directed perception of the world – as Reid thought we did not. It is here that the equivocal character of the term begins to seem obstructive, since in some uninteresting senses we clearly do not do so, almost in terms, and in other senses we possibly might, but cannot say, if the question is posed in terms of attention. These latter questions really depend from the general issue about how we process multiple dispersed stimulations in the course of negotiating the world of objects and space. No one will expect an answer to that here.

If Reid were given the opportunity to put his case within the modern universe of chapter III, he would first drop the term 'attention'. It is now used in too many discrete specialist senses in different sub-universes of the cognitive sciences: visual search, processing focus, integrative energy, frame, eye-movement/ neuron relation and others. But he would then find a schematised version of some of the content of his own distinction between attention and inattention in the modern distinction between serial and parallel perceptual processing. We saw in §14 that shape-from-shading has been done with both, and any reputable model of perception incorporates both; the more likeable models do not even posit any strict division into an early parallel process and later serial process, but complex interpenetration of the two principles. However, they *are* two principles. The parallel process is a relatively simultaneous, complex interaction of simple units reacting to inputs from a field with functional outputs informed

about that field: we behave like complicated sunflowers. The serial process is a regular sequential transformation of data so as to produce a specific sort of information: we are complicated sundials. Simply as a description of two gaits of shadow perception, the distinction conveys some of the feel of the switch from inattentive to attentive awareness – to return to the broad vernacular sense of the term.

This puts painters in a peculiar role. Thomas Reid again:

> . . . we must speak of things which are never made the object of reflection, though almost every moment presented to the mind. Nature intended them only for signs; and in the whole course of life they are put to no other use. The mind has acquired a confirmed and inveterate habit of inattention to them; for they no sooner appear than quick as lightning the thing signified succeeds, and engrosses all our regard . . .
>
> I cannot therefore entertain the hope of being intelligible to those readers who have not, by pains and practice, acquired the habit of distinguishing the appearance of objects to the eye, from the judgment which we form by sight, of their colour, distance, magnitude, and figure. The only profession in life wherein it is necessary to make this distinction, is that of painting. The painter hath occasion for an abstraction, with regard to visible objects, somewhat similar to that which we here require: and this indeed is the most difficult part of his art. For it is evident, that if he could fix in his imagination the visible appearance of objects, without confounding it with the things signified by that appearance, it would be as easy for him to paint from the life, and to give every figure its proper shading and relief, and its perspective proportions, as it is to paint from a copy. Perspective shading, giving relief, and colouring, are nothing else but copying the appearance which things make to the eye. We may therefore borrow some light on the subject of visible appearance from this art.

The painter (fig. 35), in other words, is a professional analyst of visual perception. He must address visual stimuli that are compounds of object colour, object figure, contingent lighting, observer distance, and all the other elements of vision we are used to addressing, blended into one complex sign; and he must do so with physical media that entail reflective analysis into elements. For instance, Reid points out elsewhere, simply to

35 Charles-Nicolas Cochin (1715–90). *Life Class*. Chalk drawing.
Owner unknown.

draw an object is to abstract figure from colour in a way we do
not normally do. The painter must backtrack down the channels
of perception, undoing the integration of features that is higher
perception's achievement, pushing right back down to the early
visual modules of brightness, colour and the rest – which have a
degree of homology both with his professional concepts and his
physical materials.

37 Oudry's *Hare, Sheldrake, Bottles, Bread and Cheese* (pl. vi)
was painted in the early 1740s for the dining-room of Cochin's
friend Charles-Antoine Jombert. For many years and certainly
through the 1740s Cochin spent practically every evening with
the Jomberts (often, as Jombert notes, drawing as he talked),
being devoted to Marie-Angélique Guéron, Charles-Antoine's
wife: when she died in 1778 he was desolate, he said, at the loss
'pas d'une amie mais d'un véritable ami'. Here, we may be sure,

is a painting Cochin, the Jomberts, at least some of their wide connection, and of course Oudry, had scrutinised.

This picture is assertive painting with none of the licked trickery of *trompe l'oeil*, and so one of its incidental subject-matters is pictorial knowledge. One topic is light. Oudry represents the extended form of the light source, a six-paned window, no less than five times: reflected twice on the bellies of the two round bottles; twice in a distorted and abbreviated but still recognisable form on the concave curve where the bellies join the necks; and once in a dim but striking version on the concave inner side of the far wall of the left-hand bottle, which is two-thirds empty. Oudry had not invented this conceit: he would have learned it from Netherlandish still-life. The matter but not the originating form of the light then runs into the centre of things through the series of reflections on the necks of the two round bottles, to reflections on the rectangular bottle (one of which has a faint after-echo of the form of the source if we know that form), to the drop of blood on the hare's nose. The three bottles and the blood-drop are *specular* reflecting surfaces, and the only ones, which is to say that the light they reflect is light at large, enfranchised or footloose light, lustre: the highlights would (on the real bottles and blood-drop) move as the beholder's position shifted, while the other lit surfaces would not move. They are in this sense out of system, with implications for the painter.

Then, thirdly, the stationary light and global illumination are registered with the old crumpled paper device, right of the cheese. Oudry prided himself on his painting of whites and urged it as an exercise, himself painting a demonstration still-life of all-white objects; this idea goes back to Largillierre, and probably beyond to the practice of such Dutch painters as Pieter Claesz. But here the motif is kept in low key, offering a rough plot of the luminance from different directions but not putting itself forward as a bravura feature.

For the central representation of the picture is the rococo cartouche form made up by duck, hare and shadow of hare: to an almost Cubist extent but not in a Cubist way the shadow is incorporated into the sense of this form. The simplicity of the shadow's actual facture is a foil to the elaborate *faire* of duck and hare, each of which is designed to display a contrasting virtuosity of brushwork in the service of differing anisotropic surface

textures, microshadow with a grain. The contrasting techniques of feather-painting and fur-painting were described by Oudry himself in one of his lectures at the Académie. With both the first stage is to block out the *masses* with pigment the colour of the intended shadow. This is one condition for the integration of the projected shadow into the shell-escutcheon form. With both it is then necessary to work, fast, with progressively lighter tones. But feathers are painted with a very fine brush, fully loaded, with well-thinned paint, not worked over; and fur is painted with thicker paint and worked over, with a sparsely loaded, coarser brush. What we see here is not *trompe l'oeil* but a performance inviting a flicker perception between the manipulation of pigments and the sensation of surfaces.

The larger cast shadows in the picture provide almost no direct information about the form of the objects casting them at all. In fact these are not Plinian but Waltzian shadows: they are interested less in the objects casting them than in the surfaces on which they are cast – the shelf edge (from the loaf), the shelf plane (from cheese plate and paper), but above all the principal background plane (from the hare). This last is important since the background is a nondescript, little defined at its edge, not clearly located by the nail alone, potentially rather a void. The hare's shadow places the background in relation to hare and duck, and hare and duck in relation to background, and is no more elaborated than will sufficiently enable this. This is not the sciographer's universe of consistent perspective projections.

Oudry is so indifferent to such things that some sort of perspective crux seems to have developed in the centre foreground. The rounded loaf and the straight-edged cheese play well against each other, similar in their large texture, dissimilar in their fine texture, though this last may be as much projected from the beholder's knowledge as conveyed in the paint: there is no Oudry lecture on the painting of bread and cheese, which Chardin painted better. But the loaf here is oddly unsatisfying, there in the middle, neither projecting enough to quite justify the size of its shadow within the dominant lighting, nor feeling quite right in its own diagonal perspective. It is not so much wrong as awkward or weak. Painters can falter, of course, but with good painters it is worth seeing if anomalies of such a banal kind can be resolved.

Two preliminary points are that the painting may have been

made with a view to a particular site, in Jombert's dining-room; and that it looks better when seen at an angle from the left, and from fairly low. (That is my opinion: some sense of whether it is felt to be true can be got from pl. VI, if appropriately angled.) Pictures tolerate viewing from many angles, and it has been fully demonstrated that our minds have the mechanism to allow for an angled picture plane and the distortions this causes; we do not need to view even a systematic perspectivist picture from the designed view-point to find it acceptable. One might conjecture that this tolerance has something to do with our ability to allow for the distortion of silhouette involved in projected shadows. But for centuries painters, while intuitively grasping this, had at the same time exploited any knowledge they might have about eventual dominant angled viewpoints; the one does not exclude the other, it confirms it.

A number of things change when one goes to the left view. Obviously we now have privileged access to the finest *faire* or facture: the duck and the left-hand bottle with the three reflections of the window come to the fore, as the hare's shadow, boring as paint, is distanced. The loaf, the only real diagonal into the picture plane, turns out to have been semi-anamorphic: it needed this foreshortening, not to take on recognisable form, like the skull in Holbein's *Ambassadors*, but to take on a positive role. It has now somehow swung round: the only real diagonal into the picture-plane becomes the only object, in the visual array *un*adjusted for angled picture-plane, that directly addresses us. Front centre-stage, this newly cogent form mediates between two universes like a Shakespearean chorus. The two universes here are the adjusted and unadjusted perceptions of the angled picture.

The relation of these two is complex. For instance, by going to the left side we have gone to the quarter of the represented light source, which is now more behind us, not so much to our left. This is because represented lustre has the viewer's position as one of its terms. There are, then, two lighting systems represented in the picture, the objective system of stable shadow and lit surface, and the viewer-dependent system of mobile specular reflection. The first dominates the right half, with its cast shadows and crumpled-paper lighting-indicator, and the second is concentrated in the lower left quarter, in the bottles, and as we shift position, they shift relation to each other. Of course, there are two possible

conceptions of the mentally adjusted image of the loaf: either it is turned to face us or we have moved to face it. All this ensures the persistence of productive tension between two moods, at least, to our sense of the representation: that it is an image of something *real*, and that it is an *image* of something real.

38 The phenomenal elements of shadow remain, of course. What the eye receives and the mind has to work on are continuities and discontinuities of reflected light, and the causes of these are finite. There are the character and location of light sources; there are the edges of matter; there are the molecular structures of the surfaces of matter, determining opaqueness, darkness, hue, and angles of light scatter; there are the objective causes of self-shadow, projected shadow and slant/tilt shading that we have discussed.

But a painting differs from a real visual array in many ways. Cheselden's boy, while some way into the process of learning to see the real world, had special difficulties with pictures (p. 24). One double difficulty was that they were flat, 'Party-colour'd Planes': before he perceived them as representations he was obstructed in perceiving them as such by the flatness; but after he had learned to perceive them as such, he was disconcerted by their being flat, not three-dimensional like the objects they represented. Another difficulty was with scale: 'Being shewn his Father's Picture in a Locket at his Mother's Watch, and told what it was, he acknowledged a Likeness, but was vastly surpriz'd: asking, how it could be, that a large Face could be express'd in so little Room . . .' There must also be some registration of the fact that no picture has anything like the luminance range of a real-world array.

A standard sometimes applied to stimuli or displays used in psychophysical experiment – the flashing lights in boxes and the computer graphics and so on – is 'ecological validity'. This refers partly to the problem of whether a stimulus, after the simplifications and isolations necessary for controlling interference from variables other than that under investigation, has retained a functional relevance to the complexity of real experience. But it is a relative term: a stimulus representative of and interactive with all of perception would hardly be studiable. And in any

particular case the question tends to be: in relation to which aspects of real perceptual experience can a given stimulus be reckoned valid?

The ecological validity claimed for looking at a painting by Oudry would be partly delimited by his paintings being: art depictions (flat, framed, out-of-scale, tonally restricted, in a representational tradition) of perception of shadow (a certain causal sector of brightness variation) in a representation of the visual environment including representation of most other visual elements save stereopsis and object movement; responded to by subjects, namely ourselves, whose sense of art representations, shadows and epistemological empiricism, among other things, is at a moderate cultural distance from the painter, and is active. The peculiarity of thinking about shadow with the help of paintings lies above all in a compound intensification and re-direction of ordinary attention. First, the paintings were made with a sustained – however selective – attention to such visual facts as brightness discontinuities, across a whole visual array defined by a frame. Second, they were made by these Reidian people whose training, metier and daily experience had long involved them in actual abstraction of and reflection on shadow and its circumstances. Third, they are being looked at by other people, us, directing more sustained and different attention to them than they usually direct to a visual array. Fourth, they have been made, by the painter, with such inspection, by us, in view. Fifth, we know this, and he knows that we know this: and so on.

A viable model for thinking about some aspects of art and culture is precisely as a market in attention itself, an exchange of attentions valuable to the other (fig. 36). We and the artist collude in a socially institutionalized assignation to barter our respective attentions. He values our attention for many reasons, and not only because it may be associated with whatever sort of material reward the culture offers: his social identity and his sense of his own humanity are complexly involved in the transaction. We, on the other hand, attend to the deposit or representation of his attention to life and the world because we find it enjoyable or profitable, sometimes even improving. The transaction is not symmetrical: he values the attention we direct at him and his; we value the attention he directs at life and the world. He values us as representatives of a general humanity: we value him for a specialised faculty, even if perhaps articulating a general human

36 Gabriel de Saint-Aubin (1724–80). *The Salon of 1753*. Etching, 14.7 × 17.7 cm.

quality. But the pattern is still that of a market, with choice on both sides and reciprocal agency.

39 What about Nicolas Largillierre? Both Oudry (1686–1755) and Cochin (1715–90) claimed in their Académie lectures that their thinking on shadow had been affected by Largillierre (1656–1746): Oudry had been Largillierre's apprentice for five years, about 1705–10. Largillierre himself had been apprenticed at Antwerp in 1668 to a painter of still-life and peasant genre, at a moment when Rembrandt was painting his last pictures in Amsterdam, and when Vermeer and (more to the point for the eighteenth century) Pieter de Hooch were still at work fifty miles over the border in Delft. In the later 1670s he was in London and an assistant to Peter Lely (formerly of Haarlem), for whose portraits he seems to have painted drapery and still-life accessories. The time-span here is intriguing: Cochin wrote his last

Salon review in 1787, a couple of years after the exhibition of Jacques-Louis David's *Oath of the Horatii*, a hundred years after Largillierre was *reçu* as full member of the French Académie in 1686.

Académie lectures, with their axioms and arguments, are not very representational of the fabric of a painter's operational reflection. That is always a problem with 'art theory', which at best is a translation into a differently structured language of conclusions arrived at through a revolving process with eye and pigment and judgement. Apart from proper piety, it may be that for Oudry and Cochin – both of them coming from artists' families of the *maîtrise* or painters' town guild, not from the Académie set up to counter it – to invoke Largillierre meant less a real sense of original profundity in the cited precepts than a coded statement of allegiance to at least two values. One would be to the minor genres as opposed to the exhausted but still oddly prestigious institution of history painting: Largillierre had been an important advocate in the Académie for such minor-genre painters as Chardin against the predominance of the history painter. The other value would be the Netherlandish tradition, of which Largillierre was such a prestigious relic. The two values intersect.

The optically self-conscious new painting in Paris at this time was not so much in history painting as in still-life, sometimes genre, occasionally landscape, but surprisingly often portrait painting. For fifty years, ever since the 1690s, Largillierre and his friend Hyacinthe Rigaud (1659–1743) had together dominated the portrait in France and by the 1730s they had developed it into an astonishing Rococo medley of mainly Netherlandish optical motifs from the most various sources. This is not the place for the stylistic history, but it is worth mentioning that Rigaud made a cult of Rembrandt and by the early eighteenth century is known to have owned seven pictures by or at least attributed to him, and recalling that Largillierre had begun as a still-life painter. Rigaud and Largillierre practised a sort of generic Rococo pseudo-opticism (pls VII–VIII).

In a way, the most obvious characteristic of such painting is an exhilarating performance of slick tricks with paint, but these turn on a sort of open pictorial double fiction, structurally much like the narrative fiction of Rigaud's portrait of Gaspard de Gueydan (pl. VII). There, a distinguished magistrate from Aix-en-Provence

appears in the role, but not fully in the guise, of a fictional character, a shepherd musician from an exceptionally artificial pastoral: he is portrayed with bagpipes as Céladon in Honoré d'Urfé's *L'Astrée*. He is certainly not in the role of a real shepherd, and he has not really dressed even for the role of the romance shepherd. It is not make-believe but an urbane charade in which three levels of reference – magistrate, romance character, actual everyday musical shepherds – are sustained and not permitted to conflate. No actual shepherd is any part of the representation: reality is at two removes. For that matter, the heavy young man of Largillierre's portrait (pls VIII–IX) is not really hunting, in that coat, but posing as a hunter.

Part of the decency of these portraits is that paint and sitter are treated in the same manner. Paint can pose as being representational, even pose as being illusive, while holding back from fully being either. Sometimes it can also appear in the role of some well-known paint that was once, in some other artist's idiosyncratic idiom, allusive to something actual. The distinct reality of the pigment as pigment is sustained in lively tension with what is only a performance of illusionism, fine fabrics and glossy leaves being conspicuously paint: perception flickers between paint and painted. And part of the recalcitrant paintiness of a fabric or leaf lies in its allusion to previous, usually Netherlandish painting of fabrics and leaves. In fact, the allusion may be generalized, or may be to an aspect of Rembrandt, say, that is not quite so important to us now – such as the fabrics of the early portraits; or it may be to a painter, such as Nicolaes Berchem of the lurid lighting, less central to us now than he was in the eighteenth-century canon. Such painting is pictorial rather in the sense that writing can be literary.

There is no call to be dismissive of Largillierre and Rigaud, since these pictures are entertainments and are still very enjoyable, but their representation of optical facts is a representation of the pictorial representation of optical facts. For instance, when they paint the degeneration of shadow with distance, which so interested Cochin, they paint it in inverted commas. This is not to be confused with some simple overstatement of the degeneration of shadow, due to incompetence or even a desire to impress with a little learning. It is part of the subject-matter of paintings made for a sophisticated public.

One interest of this situation in the present context is that such

pictures, being representations of painting, are committed to testing our perceptual tolerances. They are partly about what can be got away with, deploying paint that has a partly independent agenda to do with being paint. For instance, the painting of the microshadow of the surface of silk and velvet is a very old trick, here with a delicate balance – particularly in Largillierre's picture (pl. IX) – between our perceiving it as silk-reflected light or velvet-reflected light, on the one hand, and our perceiving it as differently thinned, differently edged application of white or white-lightened pigment in marks of different morphologies, scales and frequencies.

In itself this is commonplace enough, slick painters making a display. Also, with almost any picture at all we are quick to supply or project completion of what is lacking or elliptical; that is part of 'the beholder's share'. What makes these pictures a little different is a combination of several things that makes them coherent, coherent not perceptually but artistically, within themselves. They declare themselves as conventionalised not just through the standard set-up – standard poses, angled heads, cute dogs, still-life accents, rich fabrics and so on – but in the conventionality of the lighting topics handled: mixed lighting, heads and hands studio-lit against dramatically illuminated ambience, with arbitrarily highlighted leafy sprigs, and emphatic aerial perspective. Perceptual tolerance is tested by first alerting us to light with these cues, isolating them partly by differentiating their levels of pictorial specificity or styles of detail, and then denying any systematic consistency among them. Pressure is put on perceptual systematicity which is replaced by a marvellous balancing of diverse pictorial idioms. But for real pictorial thought about shadow perception one needs a different kind of painter from Largillierre, or even Oudry.

40 *The Young Draughtsman* (pl. x) by Cochin's friend Chardin is an image of shadow perception at several levels of pictorial representation. At the most literal level, the boy is studying shadow by copying with red chalk what seems itself a red-chalk drawing of an academic figure in academic lighting. He is learning to abstract illuminated form, or figure, from the more complex appearance of common experience.

The human figure in the drawing he is copying is broadly

modelled against a mid-toned ground in the three-tone scheme of academic chiaroscuro theory, corresponding to directly lit, indirectly lit and shadowed surfaces. (Chardin will comment on this in his modelling of the boy's coat.) The figure in the drawing also throws a heavy cast shadow. Apart from confirming the light-source, this shadow adds nothing much to our knowledge of the form of the figure, adequately constructed from edges, broad shape-from-shading, and of course imagery. But it adds a great deal to the solidity of our perception of what it is projected upon, the wall behind, which would otherwise be rather thinly located only by the base-line we can now be sure is a line of juncture between wall and floor. It is a Waltzian shadow (fig. 22): its action is mainly to give us information about the surface it is cast upon.

Chardin has framed the drawing – a representation of a representation – with shaped strips of, so to speak, first-representation shadow, right and bottom. This is emphatic cast shadow. On our assumption that the wall the drawing is pinned on will be flattish, it informs us of the irregularity of the buckled plane of paper. But it also informs us that the first-representation light-source, in the room, is fairly consistent in direction with the second-representation light-source, in the chalk drawing. By framing the drawing with shadow, Chardin has framed it with a confirming illumination.

The stage has been cleared for light and shadow by making the back plane of the picture orthogonal and parallel with the picture plane. Diagonality is given to just two elements, to the agonist draughtsman – whose drawing-board edge, left arm and back zigzag across the picture – and to light, which drives down from upper left more or less in parallel with the picture plane. It is unattended shadow that tells us this.

But, in such a way that we do not feel too flat about the back plane, there is a faint vertical line on the wall dropping to the boy's right shoulder that persistently invites a sense of *corner*. Again and again attentive inspection confirms, by looking at the top edge and the bottom edge of the parked canvas and stretcher on the right and at the lighting of the wall planes on each side of the line, that it is not likely to be a corner; but the power of a line to suggest planar edges is great and, not unrelated to the snap to and fro of reversible cubes, the corner effect still hangs about on the edge of attention, a marginal, parafoveal provocation giving

the back plane a kind of perceptual vibrancy. The line keeps twanging faintly, now and then, and reminding us that attentive vision and inattentive vision may give conflicting knowledge.

Apart from the head and the straightforward rectangular forms of the portfolio or drawing-board, the only foreshortened thing in the picture is the boy's lower left leg; most visible surfaces, even much of the coat, are aligned more or less across the picture plane. But the lower leg is not only foreshortened but in obscurity: this obscurity is gratuitous, not the shadow of anything in frame. That the portfolio would not cast it is pointedly stated by the knife further forward, an object contrasting with the lower leg in various ways – orientation, illumination, canonicity of viewpoint. A picture about light and shadow can accommodate a negative of light. The foot is a negative, of the light that elsewhere registers shadow: it is not in shadow – shadows have perceptually meaningful causes – it is just in obscurity, juxtaposed with the knife, breeches and portfolio edges that have the definition and colour light gives. The foot is simply not attended; it is merely a foot in about the right place.

The boy's coat is the picture's main modelling with light and shade, and Chardin here takes a revisionist attitude to the academic three-tone scale represented by the drawing on the wall. The coat is straightforwardly modelled with dark tones and middle tones, but the light tones are streaked on with a sparse touch that is different – not snow as in 'Constable's snow', but thin verglas. The point would have to be pursued with other pictures, but this one already suggests Chardin is a painter in two-and-a-half tones plus expansive lustre, expansive in that lustre encroaches on highlight; even here there is a hint of something strange in the affinity between the highlights along some folds and the lustre or specular reflection on the knife handle.

As for microshadow or texture, there is almost none in the direct representation; Chardin has effectively appropriated it for the actual facture, for his own performance. There are two points to make about this. Chardin was in some ways a slyly showy painter. He had fought his way into the Académie with an outrageously flash piece of paintwork, the superb and savage *The Ray*. But, once an Academician, he learned to speak also with the extreme, demanding quietness – small pictures one has to approach close to make out, banal subject-matters with little

independent interest – of someone out to exact intense attention to himself in a different way. This, not the directly manipulative de Pilesian centralized chiaroscuro, is how he catches and holds attention. Chardin's will to dominate, to insist on our attending to his performance, can be disquieting: there is a sinister aspect to exhibiting, at the Salon, an oil painting eight inches by seven. In any case, here he takes microshadow for himself and allows none to the appearances he is playing with, apart for some allowance for different reflectivities. And he has the nerve to represent, disguised as a canvas against the wall on the right, a picture of abstracted texture, pure Chardinian facture, as if in competition with the academic drill on the wall: he can, he convinces us, sustain our interest with a picture of a picture of nothing at all.

But the effect of this, in fact, is satisfying. By some odd conflation in the perceptual process, the rich and subtle real texture of the paint surface cues us to supply a sense of texture to the fictive surfaces. The release of perceptual energy involved in this flashover seems enjoyable in itself, but it also lends vitality to the fiction.

Academic art theory had opined that to capture and retain attention, the centre of a picture should be the centre of its lighting. Here it is not quite that. The centre of this picture is the boy's head, or rather the extraordinary conformation that we perceive as the boy's three-cornered hat, hair and coat collar. Here is the narrative centre, and the narrative is of attention. A little below the left shoulder the boy has a hole in his coat through which shows the red lining, also but more normally visible at two points elswhere. Red is emblematically the attention-attracting quality in eighteenth-century thinking about attention: it had played an important part in keeping the attention of Condillac's statue going, ultimately to achieve full visual perception. But this red here is a labelling epicentre in balance with another centre, the silhouette of the hat against the corner of the drawing – a narrative crux registered with the strongest tonal contrast in the picture.

This contrast-marked crux works in various ways. It would be trivialising to say that here the drawing comes out of the boy's head like a balloon in a cartoon, since this would be a reduction of a more open pictorial meaning, but it is an excited frontier. Its pictorial meaning is firstly as a boundary between two perceptual principles: the drawing on the wall – shape-through-shadow; and

the head – a form hardly readable except by supplying, from our mental imagery, an object which ought to be there and is not inconsistent with the form. Without context, if it were not on a human body seen from behind, it would be relatively hard to make out. The form is perceptually difficult, relatively but not too much so, and our own pleasurable exertion in reading it attaches itself to the form. The boy is thinking, and the thinking is pictorially injected into his head not by depicting a pensive face but by demanding play-exertion from us – a cognitive correlative for the boy's exertion.

He is thinking about shadow, of course, the shadow of the drawn figure he is re-drawing, but this is marked by associating the focus of his literally depicted regard with the sharp cast shadow thrown by his chalk-holder on his paper–a displacement. Cast shadows are what everyone sometimes attends to.

41 'Shadow' has never really been defined in this book and will not be now, but it must be clear that we have been moving rather freely up and down a scale of perceptual specificity. At some base pre-perceptual level there is a hole or irregularity in a flux of middle-range photons due to the interference of a solid. At a rather higher level, given a viewer, there is a brightness discontinuity registered in the eye. Then this can become a brightness discontinuity functionally somehow treated as an illumination discontinuity rather than a reflection discontinuity, perhaps treated as such simply by not treating any further. But it may become a brightness discontinuity treated as an illumination discontinuity related to the interference of a solid – treated, it could be said, as shadow. It is tempting to take some kind of stand on the brightness discontinuity only becoming shadow once it is treated as shadow, but it is usually more practical to take shadow simply as illumination discontinuity in perception.

We naturally think and talk in terms of both collective shadow and individual shadows. If one very consequentially treats individual shadows as independent things, one skirts an area of unrewarding logical awkwardness. (For example, the following problem has been raised and pursued: Suppose a projected beam of light and two fully opaque squares of material, A and B, of different sizes and to be set at different distances that will make either of them throw a shadow on the screen indistinguishable

from that of the other. If *both* squares are set in place, what then causes the shadow on the screen? A, the first, does not, since it now throws its shadow on B, not on the screen. B does not, since now no light falls on B for it to obstruct. Is the dark square on the screen still a shadow?) But in more casual use it is a productive resource of the culture to treat a local instance of illumination discontinuity as *a* shadow.

If one thinks of a shadow as an entity out there, it is strange. It is a real material fact, a physical hole in light, but it has neither stable form nor continuity of existence; on the other hand the metamorphoses it goes through are determinate, and though it is discontinuous it can recur. Like colour, shadow is only realised as a secondary to light; but unlike colour, shadow has no permanent molecularly denominated territory of its own. While its actual manifestation is on surfaces, its domain is three-dimensional and within this domain anything is subject to it. And so on. All this may have had something to do with Leonardo da Vinci and others sometimes being led to wonder whether shadow might be not just a local negative of light but an active opponent of light, radiating from denseness as light radiates from a light source.

The shaped and often grotesquely imitative mobility of a shadow, like some parasitical animal, can also be experienced as uncanny. Even in the cool sort of lexicon the eighteenth-century Enlightenment used, established extended senses of *Ombre* include ghost, of course, and chimera; unreal appearance, diminished trace; secret, pretext, concealment; the domination of a destructive presence; threat. Many of these are coloured by the thought of denial of light, darkness, which is a strong idea in itself. From Plato on, projected shadow has intermittently also had to appear in the role of bearer of imperfect knowledge of the object that projects it. So it is, on its own, but it is not normally on its own, and we have seen that the knowledge it offers is not always about the object that projects it. Even in Plato's cave it must have offered some sort of information about a light source and a wall, if that was desired, but probably it was not. The Platonic role of shadow is not really as bearer of imperfect knowledge but as bearer of the wrong knowledge.

Shadow is a secondary, the outcome of a relation between light and a dense solid. Light is energy on the move, but so are heat and sound. Heat and sound also can be obstructed by dense

matter causing areas of privation behind it; and these areas can be mobile, localised and bounded, sensible episodes of relative cool and quiet, and to that extent representational of the intervening matter they derive from. But there is not even a word for shadows of cool and quiet in fluxes of heat and sound – 'shade', after all, which is typically cool, being usually *shadow* signifying coolness, coolness made visible. The point is that even sensible holes in heat and sound can play little part in our perception of the world because they do not offer themselves in a composed array sensible from outside, from a distance, and so cannot much enlighten us about our larger ambience. Holes in light do so offer themselves and can so enlighten us, or (rather) they could.

To think about how shadow *could* bear us knowledge is some way short of determining how and how far it does so; we cannot, need not and do not work through all the sensory information about physical ambience we have access to. The comedy is that as soon as we are addressing shadow we are liable to denature it, a little as Largillierre does. It becomes something other than the shadow of usual experience simply by being addressed as itself. What we would need for the purpose of situating the Rococo-Empiricist shadow universe, and what we seem not to have, is a clear idea of specifically in-attentive perception as a productive complement to attentive perception – attention, this time, in the sense of a directed and focussed and constructive scrutiny in some reciprocal relation to consciousness. For many purposes 'attention' effectively disables itself as a concept by reducing the 'in-attentive' to a negative or absence of something, rather than the active, determined and structured field in which consciousness plays. (Chardin, like many painters, can be seen as having tried to paint this field.) In this respect, at least, shadow is a quite provoking image of the makings of any actual experience at all.

APPENDIX

THREE NOTES ON LEONARDO AND EARLY RENAISSANCE SHADOW

Leonardo da Vinci was an important source for eighteenth-century thinking about shadow, and he is also the first modern writer to offer a systematic view of shadow, as such: he addresses every objective kind of shadow and is still cited in the current literature (for instance, Koenderink and van Doorn, 1980). While his thought about vision in general clearly has a background in medieval and Renaissance optics, which has been well studied by Lindberg (1976) and others, his thought about shadow in particular seems much influenced by experience of art, and it is this context that it seems useful to pursue here.

I THE RENAISSANCE OF RILIEVO

For representing 'relief', two main rationales of tonal modelling have commonly been used in European art since the Renaissance, often in combination. One rationale is the tonal representation of the fall of localised light, as in Piazzetta's instructional engraving (fig. 6), with its imitation of self-shadow, projected shadow and slant/tilt shading. The other is given such names as 'modelling tone' (for example, Rawson, 1984, pp. 105–19) and is basically a matter of a tonal range from light to dark that darkens in proportion to the increase of slant/tilt away from the beholder. A facing surface, perpendicular to the optic axis, is light, and a retreating or receding surface, near-parallel with the optic axis, is dark, reaching maximum darkness at the object's visible edge or point of self-occlusion from the beholder. A sphere drawn by this method does not have the shadows, shading and highlight of Piazzetta. It is a circle darkening from centre to circumference.

Though drawing or painting with this modelling tone of the second rationale is sometimes referred to as conventional or symbolic, rather than naturalistic in the sense of imitative of phenomena, this is not necessarily true. Of course, it may be taught or may be used by rote or formula. But, to use the terms of §3, even in its purest form modelling tone can be representational of a type of *non-Lambertian* and *non-specular* surface in preponderantly *ambient* illumination: that is, it can represent reflecting surfaces that do not act as perfect diffusers or perfect reflectors, in conditions where light has been so dispersed by multiple reflection or atmospheric diffusion as to be falling equally from all directions. The surfaces are not like the moon or like a billiard ball, and the light-source is not like direct sun. They are more like someone's face indoors or on a cloudy

day. There is an element of this in most scenes other than a plaster cast or bronze statue lit by a spotlight, and an element of it creeps into all but the most programmatic shadow drawing. It is also extremely important that second-rationale modelling tone can be assimilated to first-rationale phenomenal lighting, if the lighting is posited as from the front.

To the extent that it used tonal differentiation to represent form – and there are other means of graphically or pictorially establishing three-dimensional shape than tonal differentiation – European art was content to use mainly this second rationale for something like a thousand years, from the decline of classical Roman painting to the thirteenth century. The retrieval or re-invention of a first rationale, with shadow and shading from a localised light-source, begins most clearly with the very early Italian Renaissance and this and its circumstances have been fully analysed by Hills (1987), whom I follow for the next paragraphs.

The first crystallization was a synthesis developed by Giotto (pl. XII) around 1300 out of a number of potentialities in the art of the previous century, and adapted to the large fresco narrative cycles he was painting in Florence, Assisi and Padua. Giotto's synthesis is in some ways an adaptation and enrichment of second-rationale modelling tone. Though there are some exciting experiments with angled and special close sources inside the picture space, a more usual format is to have a light source somewhere between side and front, to offer a clear key to this with boldly lit architecture or little crags, to model the drapery very strongly in general but not dogmatic conformity with it, but almost to play down the side-lighting of faces. For faces Giotto often just turns second-rationale modelling round a few degrees to acknowledge the lighting side, and sometimes up a few degrees to acknowledge the sky. There are certainly exceptions, but a radically shadowed head or anything like a sharp projected shadow is usually a special narrative accent.

It is important that the light sources are so often and so clearly on our side of the picture plane. This accommodates any second-rationale elements into any first-rationale frame of reference, whether in the painting or in the perceiving; it licenses them (at whatever level of awareness) as more or less consonant with front lighting. Tolerance of the second rationale was one reason why Giotto's empirical example was so accessible. For a hundred years Italian painters were able to work from it into an astonishing number of local and personal lighting dialects. It ruled nothing out, contained in its details or occasional experiments innumerable suggestions a lesser artist could isolate and specialise into a personal mark, offered resources the most timid artist could adapt to develop this or that old regional idiom. The 'Giottesque' school of Florentine fresco painters was only a small part of all this.

The second crystallization, Masaccio (pl. XIII) in the 1420s and more particularly the manner in which he was read by the next generation, was quite different, systematic and exclusive. Masaccio had taken elements from the local Florentine 'Giottesque' and reduced them to meet the special standards of the new Florentine system of linear, single vanishing-point perspective. Pictorial space was now constructed a priori to a powerful simplified formula, and the lighting was systematized and specialized to interlock with this. The lighting principles learned from his frescoes in the Brancacci chapel (pl. XIII) were simple and rigorous: (1) exclude second-rationale tonality; (2) limit variety of *object* tone, except for special accents; (3) limit the range of object-surface reflectivity, except for special accents; (4) pull the light source right round to the side, only a little in front of and sometimes even behind the picture plane; (5) mark its direction *and elevation* with selected cast ground-shadows from figures; (6) do

shape-from-shading in the *middle* scale – surface features in the picture plane range 1″–7″ – with a tonal contrast outweighing either projected or self-shadow; (7) in the case of drapery folds, at least, treat self-shadow as transparent through to shape-from-shading.

This is not Masaccio, but Masaccio the functional teacher of coarse *rilievo* to the Florentine fifteenth century. Masaccio himself had other subtler resources. One of these, the cross-terminator, might be noted representatively. A terminator is the border-line between the illuminated side and the self-shadowed side of an object. Its sharpness depends on the extension of the light source, the reflective quality of surface, and the amount of secondary or global illumination from around: the sun makes a sharp terminator on the Lambertian and isolated quarter-moon. Masaccio often accents his terminators. In plate XIII the mantle of St Peter and the shivering neophyte on the right both exemplify this; the foreground neophyte kneeling in the water does not, being devoted to another resource of Masaccio's, stretching the three-tone scale. Since the lighting is so much from the side, the terminators register a section of the object running straight into the picture, perpendicular to the picture section. The sections are visible foreshortened (thus stimulating us to conceive depth) on this side of the object and are projected by our stimulated minds for the other invisible side, giving us an armature on which we can conceive it as a rounded volume. Often a sort of quadrature within space is completed by a cast shadow, naturally at right angles to the terminator.

What grew out of the coarse reading of Masaccio over the next fifty years often brutalised Masaccio himself but it became an authoritative idiom which people came to Florence to learn. It effectively killed finer old traditions, like the fluid bracelet modelling of Pisanello; and even when a painter's view of Masaccio was not coarse, still vulgar Masaccism needed energy to resist. Piero della Francesca, for example, had to resort to an epic journey back to the best of Sienese art of the previous century to arm himself against it. But people learned it because it was teachable, and as a general method, particularly in conjunction with a three-tone scale of values.

The tendency in European art to conceptualize representational tonality in the form of a scale of three tones has been very strong. Usually this takes the same form as the classical scale described by Pliny the Elder (*Natural History*, xxxv. 29): there is a middle value derived from the object colour, sometimes described as indirectly lit; a dark value derived from the parts in shadow; and a light or high value derived from the illuminated part, which however also has a special super-high occasional accent of lustre included within it. Usually some emphasis is laid on subtlety of transition, *harmoge* (or joining) to Pliny, but three-tone thinking persists.

It is difficult to know how far this trinity is a product of shaping constraints in the mind and how far of the practical exigencies of mixing pigments in pots, but certainly it was installed in fifteenth-century colour practice and theory (well summarised in, for instance, Gavel, 1979). Writing his discursive recipe-book about 1400 in the Florentine Giottesque tradition Cennino Cennini specified three methods. (1) The basic or general method is a rising scale: hue, hue + white, hue + white + white. This means shadow has the intensest colour. (2) A special, second method, for light-toned pigments only, is: hue + black, hue, hue + white. (Many painters, like Masaccio in much of plate XIII, tended to use mainly the first method for drapery, the second for flesh.) (3) A special, occasional, third method for subtractive secondaries like green is the scale: *darker* primary (blue), two primaries (blue + yellow = green), *lighter* primary (yellow). This beautiful method was backed by the broadly classical

tradition of hues being a scale of values produced by different proportions of black and white or darkness and light, Aristotle's version of the scale being: black, blue, green, violet, red, yellow, white.

The three methods Cennini describes survived through the fifteenth century. This gives painting of the period part of its look: a cheerful but irrational chatter between at least three distinct and discrete three-tone colour systems (two of them with preternaturally saturated or colourful shading and self-shadow), in pictures earnestly rational about the consistency of both space and solids, is quattrocento.

2 THE ANALYTIC OF DRAWING: SECOND DERIVATIVES ON A ZERO–GROUND

For complex reasons, from the fifteenth century much more of the painters' preparatory thought about shadow has been in the form of drawing. But graphic media are no more neutral than conceptual media, and drawing in general is a tendentious vehicle for thought about appearance. Because it dramatises the case, the episode to scrutinise here is a proliferation in the years 1465–85 of a type of drawing of single figures in two tones on paper of intermediate tone, but much of what will be said of this type is generalisable to other types.

Several hundred of these two-tone drawings (pl. XIV) seem to be from the relatively large and intercommunicating Florentine workshops of Verrocchio, Pollaiuolo, Botticelli, Filippino Lippi and Ghirlandaio (a convenient collection in Ragghianti and Dalli Regoli, 1975). They range from much obvious apprentice work to some drawing of high skill, and there has been a long history of attempts to attribute them to hands and names, but this will be ignored here and the type treated as generic.

What they have in common is medium, period, place, general artistic ambience and also function: these are *rilievo* studies from the life done for self-improvement. Usually the motif is not destined for use in a particular picture. The drawings are mostly metalpoint with *biacca*: that is, dark marks were made by drawing with a perhaps silver or lead stylus on paper treated with a tinted bone-ash wash, often buff or reddish or pale blue, abrasive enough to cause the point to leave oxidizing traces; and, afterwards rather than before, white lead (*biacca*) was added with a fine brush. Since the tinted paper offers an intermediate tone, the technique might seem to have a potentiality for analysis of appearance within the three-tone structure in which artists were used to thinking and working. Three aspects of the tendency within it are here located, with recourse to terms and concepts used in current vision research.

Zero-grounds: A zero-line is a section across the visual array recording the constantly varying local average brightness values. It is registered in machine vision (figs 18–19) as a straight line, but it does not represent some one value. It might be visualised as a piece of string charged with values by having been laid along the undulating line that would chart the local brightness averages across the array, and retaining those values when pulled straight. The array is covered in two dimensions by such lines or strings, making a net. Again, the net represents not one value but a continuum of local brightness averages. One can think of a drawing ground as like this net, a zero-ground whose tone represents not some one absolute brightness value but the local average value, or tone. It is flat and even-coloured but it is charged with hills and valleys of changing average value.

The mid-toned ground of metalpoint and *biacca* drawings (like, in various but not always such forthright ways, the ground of almost any drawing) is really a zero-ground of this kind. It does not register an objective middle tone of stable value but rather the variable local average value from which locally lighter and darker features are registered as rising and falling. It is mainly this that enables the draughtsman to negotiate, though not in any precise sense register, a wide range of values with pigmentations – *biacca* and oxidized metal – that are basically each one unmixed tone with only the most limited possibility of intensity variation by such means as area hatching. So white and dark-grey in the drawing represent not white and dark grey but some optical event above or below the local average: local average plus or minus something. But the something is not simply a brightness value.

Brightness values and brightness changes: The basic units of vision are not globally calibrated brightness values, but values of brightness change from what is next, 'spatial derivatives'. The first derivative is the gradient or rate of change between adjacent values, and then the second derivative is the rate of change in this rate of change. It is the second derivative that is used in computer vision, because it distinguishes sharp discontinuities from gentle gradients more clearly, and so (it is claimed) object edges from shadow.

Few draughtsmen have tried to draw with pure brightness values: Seurat is a rare example to come to mind. Most have introduced elements of brightness change. If the computer's language were metalpoint and *biacca* rather than digits, it would represent with a white *biacca* mark an increase in the rate at which brightness is increasing. In a quite different medium, Cézanne was one draughtsman whose drawing of lighting also focused on the second derivative.

But the drawings are not made by computers. Most mature graphic media combine or overlay or alternate representational languages. We are very quick to pick up internal systematicity in compound graphic modes sufficiently well to read them. The Florentine drawings are drawings in which a white mark could indicate a bright value in relation to the varying average of the zero-ground behind, or an increase in brightness in relation to a value next to it, or an increase in the gradient of that increase in brightness – for instance, a place where an evenly brightening curved surface sharply increases its rate of brightening because of some kink – and often indicates more than one of these together.

Spatial frequency: The eye offers the mind both fine and coarse optical takes of things (§16 above). Machine vision tries to imitate this by combining takes of the visual array that have been passed through two or more filters, with a view to selecting those features that survive in more than one of the takes. The filters do two main things: they average out values over a chosen span or spatial frequency; and they exaggerate local variation at the chosen frequency by giving more weight to the values within the span and less weight to the values immediately next to or outside the span. Most drawings also work with preferential frequencies – that is, scales of registration and emphasis.

Physical and procedural facts of a medium play a part here. These drawings are two-tone drawing first down and then up from the notional median of the ground. The tools of the down (to darker) drawing and the up (to lighter) drawing, respectively metalpoint and brush with *biacca*, are radically different in their self-jigging characters – that is, the movements their physical forms easily accommodate in conjunction with natural movement of hand, arm and fingers; and so the marks they consequently like to make. Metalpoint naturally makes fine linear marks and urges linear continuity; object and plane edges can be abstracted with fine lines, and internal detail and differentiation of surface

can be worked on with the help of hatching. Brush and *biacca* naturally accommodate the making of blobs and bars rather than fine lines, and lend themselves less readily to differentiation within their domain.

There is an imbalance between the characters of notation on the minus and the plus sides of the median, therefore. Quite often one can see a draughtsman resisting it by coarsening his point work and taking pains to refine his brush. But the metalpoint drawing is still usually done first; the drawings work from the shadowed up into the lit. Shadow is the original site of general design and is the more precisely established in form. Some drawings resist this bias by radically minimising the quantity of dark marks and maximising the light. This can be made to pay the extra and disreputable dividend of a facile effect of nocturne-like *rilievo*: many of the worst apprentice drawings fall for this.

However, there is also interference in these drawings from a sort of superfrequency. The drawings are of single figures, even when there are several on one piece of paper, whereas most of the paintings the artists made had several figures and objects. We are therefore coming in one tier down in the structural hierarchy of a Renaissance picture.

We do not value painting for proximity to a real visual array, but fifteenth-century painting did have imitation of the real as an important part of its ambition. Whether as a cause or a symptom, Florentine drawings in the period 1460–80 lay out a set of distortions in tonal analysis embodied also in Florentine painting, and the urgency of Leonardo's shadow analysis is partly a reaction to this predicament, part of what is referred to by the mid-sixteenth-century critic Giorgio Vasari as 'dryness'.

3 LEONARDO ON SHADOW IN 1490–93

Leonardo came out of the design ambience represented by the metalpoint and *biacca* drawings. He had probably gone into Verrocchio's workshop in 1469 at the age of seventeen, was admitted to the Florentine painters' confraternity in 1472 and was still living in Verrocchio's house in 1476. There are works by him attributed to the 1470s – in particular, a group of studies of drapery, monochrome brush drawings in black or dark grey on mid-grey-toned linen with white heightening (pl. xv) – which seem both an implicit critique of metalpoint and *biacca* practice and an early stage in his own analysis of shadow.

In trying to understand Leonardo's thought on a matter it is often an anxiety that, because of the massive quantity of notes written over decades, the whole process of thought is being telescoped and scrambled. The trouble is not so much apparent internal contradictions due to his thought evolving over time, as the loss of momentary internal coherences across his thinking about the matter and the loss of relation to his other activities of the moment. It is sometimes best to establish a base on a favourable moment – in the sense of a moment when his thought on the topic is cross-coherent, urgent, copious, securely dated and central to the total – and to set any different thoughts at other times in their relation to this moment. In the particular case of shadow this is an unforced and fairly easy course to take, and the benign moment happens to be early, 1490–93.

The years 1490–93 are fairly clearly the culmination of a period in which Leonardo was much interested in working out his views on vision, and on light and shadow. Among other things it seems the moment when he finally relinquished any doubts about intromission: that is, he puts aside residual hankerings after a visual ray emitted by the beholder's eye as opposed to vision by light

admitted to the eye (Lindberg, 1976, pp. 159–61). He had been in Milan since 1483, long enough to gain some distance from Florence. It does not seem an important moment in his active production of painting, lying between the first *Virgin of the Rocks* of the mid-1480s and the *Last Supper* of the mid-1490s: the great project of the time was sculpture, the aborted bronze equestrian monument of Francesco Sforza. Perhaps the work on vision was partly a surrogate for painting. In his technical drawings for anatomical and other such study there is a climax of fine diagonal rectilinear hatching representational of light on modelled surface. (In later years, it is generally held, this was to give way to more objective bracelet hatching following the contours of surfaces, a little like that of Dürer's engravings, and at the same time his subjective or phenomenal drawing had a divergent development in such media as chalk.)

By 1490–93 Leonardo had already developed his concept of the 'radiant pyramid'. That is, he believed that any object radiates material likenesses of itself in all directions and in straight lines, and that these likenesses diminish in size proportionately with their distance from the object. Formally the 'radiant pyramid' is the visual pyramid of vanishing-point perspective construction backwards. The medium of radiation is the atmosphere, filled with an infinite number of these progressively shrinking likenesses which, though they are material, are subtle enough to pass through each other on encounter. The atmosphere has to be activated for our visual perception of the likenesses, by light. Light also travels rectilinearly in rays.

Shadow is the absence of light and, in a very strong sense indeed, its opponent. Light is always accompanied by shadow. As there are luminous bodies emitting luminous rays there are also 'umbrous' (*ombroso*) or shadowing bodies emitting shadowing rays, by opposing light with denseness. Being dense is the opponent of being luminous. Leonardo, at this time, is even prepared to say shadow is stronger than light because it can entirely extinguish it, whereas light cannot entirely extinguish the shadow caused by dense shadowing bodies; but this is not an idea he develops.

Leonardo's many particular propositions and demonstrations are carried out mainly with two straightforward operations: by tracing rectilinear rays from light sources to objects, and by establishing simple proportional relations between terms. For instance, extension of derived shadow is the product of the relation between the extension of light source and the occluding section of a dense shadowing object. Extension of light-source is a frequent element in the propositions partly because Leonardo is not yet fully tackling ambient, or 'universal', light; but he is moving towards this by studying lighting from very extended sources like windows with posited universal light outside (pl. xvi).

There are three kinds of shadow: (1) *'original'* or 'primitive' shadow, which is formally but not functionally what we have been calling self-shadow, (2) *'derived'* shadow and (3) *cast* shadow, which two are a redistribution of our projected shadow. There is also the greater or lesser illumination involved in our shading, sometimes called *mezzano* or (4) intermediate shadow.

(1) The main point about the original self-shadow is that it is not just the self-occluded surface of an object but is original or originating in the sense of being the source of derived shadow rather as an 'original light' is the source of rays of light: original shadow emits shadowing rays. Apart from its shadow-emitting property, there are two other peculiar characteristics about original shadow. Intrinsically it has the same value all over, unlike derived shadow and shading, which vary in intensity from here to there. And it clings to the object: move a sphere in light and the self-shadow may move on the surface of the object but will always be there.

(2) As for the derived shadow, Leonardo's reference with the term is labile, but at this time he seems to use it less of shadow on surface than of the volume of atmosphere occupied by those shadowing rays. Derived shadow attenuates in intensity as it distances itself from its origin: this is seen as the expression of a general natural principle whereby things weaken as they leave their sources, rather than a result of the progressive intervention of reflected light, not mentioned at this point.

(3) Cast shadow is then specifically that surface product of derived shadow that is 'surrounded by light'. Leonardo usually seems to visualise it as cast by something like a detached sphere (or rather, of course, by the self-shadow on the light-occluded side of that detached sphere). Cast shadow is interesting because it modifies the form (or rather, section) of derived shadow in response to the angle, as indeed to any form, of the surface on which it is cast – though Leonardo does not show the sciographer's passion for working out case after complicated case of this, which indeed would have involved rather more elaborate geometry than he was using. One uses the eye, as his less formal advice that the painter adjust cast shadows to the shape of the surface they fall on suggests.

(4) Slant/tilt shading is firmly conceived of as a function of the angle of incidence of light of a lit surface, indeed of the force of impact resulting from that angle: throwing a ball at a wall at different angles and so with different bounce is used as a formal analogy. (In relation to painting, Leonardo intermittently adopted the three-tone model without complaint.)

An important matter is the relative intensity of original self-shadow and the derived or cast shadow associated with it. On the one hand, the original self-shadow is intrinsically stronger because it is not subject to the attenuation with distance the derived shadow suffers. On the other hand, the original shadow is subject to interference by reflected light from illuminated surfaces around the cast shadow deposited by the derived shadow; whereas the cast shadow faces the darkness of the original self-shadow (fig. 37). Clearly it would depend on the angles of surfaces and the proportions of luminous and shadowing bodies, and also on the character and alignment of adjacent surfaces, but Leonardo seems intrigued by the case of the more intense cast shadow, and it was this aspect that Jombert-Cochin, Dandré-Bardon and so many others were later to pick up and simplify into a rule. Leonardo is generally alert to the role of reflected light in the intensities of shadow and within shadow.

Finally, there is the matter of shadow edges. Leonardo describes the effect of contrast, that the edge of a shadow on a light surface will (specifically) 'appear' darker and also that on a dark surface it will appear less so. For painting he urges contriving the former, mainly to establish relief and distance. But he is already alert to the soft edge. Derived shadow edges soften as they distance themselves from the original shadow until the shadows imperceptibly disappear: it follows that cast shadow edges must soften with distance from the shadowing object. And, for painting, the balance is already towards the *sfumato* transition, for aesthetic reasons of grace. One should not sharpen the edges of indistinct or minor shadow or the painting will look wooden; contrive to paint faces in diffused light – and the rest of his well-known tips for setting up the working space.

There is some temptation to take the more idiosyncratic emphases of Leonardo's account of objective and physical shadow – the shadowing rays emitted by shadowing surfaces, the derived shadow occupying volume with waning force, the dark cast shadow facing just the original shadow – as oblique or displaced propositions about the structure of shadow perception. One cannot

37 After Leonardo da Vinci. Light reflecting from around a cast shadow on to
a self-shadow. A is light source, BC primitive self-shadow on intervening solid,
NM cast shadow on surface DE. Light reflects back from DN and ME on to
BC. Redrawn as a conflation of Vatican Library, Rome, Codex Urbinas
Latinus, fol. 184 verso, and Bibliothèque de l'Institut de France, Paris, MS
2174, fol. 4 verso.

quite do that because they have too many affinities with his general convictions
about energy and proportion in physical nature.
 In later notes on shadow (which will not be sorted out chronologically here)
he does not so much revise as apply the theory of 1490–93 in expanded ways.
In effect, he takes it out of the studio into the open and puts it to use. It is the
frame for his meticulous observations of the complex light and shade of trees,
and it is accommodated though not prominent in his accounts of atmospheric
perspective. He works out cases of multiple light source. He extends his
analysis of reflection to include more about hue and hued shadow – such as the
blue shadows at sunset (fig. 32) – as well as intensity of shadow, but this does
not involve any methodical innovation. The main development of method is
the neat formula for working out the shading from universal light, diffused
light out-of-doors. It is treated as a super-extensive light source in the form of a
hemisphere enclosing the object, the hemisphere being reduced to a plane
semicircle for the purpose of the geometry (fig. 38). This is an expansion of the
arc used in his earlier window studies (pl. xvi). The formula is particularly
prominent in the seventeenth-century reduction of the sixteenth-century com-
pilation known as the Codex Urbinas and was clearly familiar to Lambert (§28).
 (*Texts*: Leonardo had planned a systematic treatise on shadow in seven parts,
which seems not to have been written; his observations are dispersed in notes of
various periods. Something like half of them survived into the posthumous
compilation from his papers by his heir, Francesco Melzi, of a 'Treatise on
Painting', the Codex Urbinas Latinus 1270 in the Vatican Library; figure 2 is
from this, and the French translation of 1651 (fig. 32) was done from a reduced
manuscript version of it. The other half are scattered among several different
autograph manuscripts.

38 After Leonardo da Vinci. Universal light and a house. The hemispherical source is CMR. The relative irradiation on any point is determined by the angle of the arc to which it is open within CMR. For instance, BC is the proportion of universal light falling on the area AO under the eaves. Redrawn after Vatican Library, Rome, Codex Urbinas Latinus, fol. 201 recto.

There is much matter on shadow, since it is important to painting, in the Codex Urbinas. Some of it can be matched with material in two surviving notebooks of this period, 'Libro G' or MS C (Paris, Institut de France, MS 2174), twenty-eight folios, which is dated both 1490 and 1493, and Ashburnham II (now Paris, Institut de France, MS 2185), which consists of thirty-five folios abstracted from the Institut's MS A and is attributable to 1492. These two contain much other work on shadow and relevant work on light not used in the Codex Urbinas and they constitute the basis for a view of Leonardo on shadow in 1490–93. Of the Codex Urbinas shadow matter not in them, much was taken from a lost notebook, 'Libro W', probably of considerably later date.

The Codex Urbinas is accessible in an edition with facsimile and English translation (Leonardo, 1956), with which light and shadow can be pursued in the excellent index. The most convenient selection of shadow observations in translation is now in Leonardo (1989), pp. 97–115 especially, which includes material not in the Codex Urbinas. The sharpest exposition of Leonardo on visual perception is still Lindberg (1976), pp. 154–68, with guidance through the earlier bibliography in nn. 34–98, and in general establishing the intellectual-historical frame. For shadow specifically, see also Keele (1983), pp. 49–60, Kemp (1990), pp. 267–9, and particularly Veltman (1986), pp. 326–37. Most studies of Leonardo have something on his shadow.)

NOTES AND TEXTS

NOTES TO CHAPTER I

1 'Holes in light': Lecat (1767), pp. 367–8, 'un espece de trou ou de vuide dans le corps de la lumiere'. The context is worth giving here particularly for its second paragraph:

L'ombre
Toutes brillantes que soient la lumiere et les couleurs, elles ne formeroient aucune image, mais un lac immense et uniforme, plus propre à nous éblouir qu'à nous éclairer, sans *l'ombre* qui les divise, les distribuë, les modifie, les fait enfin valoir, tout ce qu'on sçait qu'elles valent dans les images qu'elles composent. *L'ombre* est une dégradation ou diminution de la lumiere et des couleurs, dont le dernier degré est *le noir*, non pas que le noir d'un corps soit une privation totale de la lumiere, car le corps seroit invisible; mais le corps noir est de tous les corps celui qui réflechit le moins de lumiere, parce qu'il l'absorbe et l'éteint presque toute. Le noir parfait ou la privation totale de la lumiere, n'est pas proprement une chose visible, puisqu'elle n'envoye rien dans l'organe, elle ne se distingue que par les corps illuminez qui l'environnent, c'est un espece de trou ou de vuide dans le corps de la lumiere.

L'art de dessiner prouve bien que la seule gradation de l'ombre, ses distributions et ses nuances avec la simple lumiere, suffisent pour former les images de tous les objets, de même que le mêlange des soufres, de la terre et de l'eau avec ses sels, font les diverses saveurs. L'art de peindre porte dans chaque couleur ces mêmes nuances, dont l'ombre est toûjours le principe, et l'on sçait que ces arts ne sont que les singes des opérations de la lumiere et de l'ombre dans les phénoménes de la vision.

2 For Leonardo on shadow, see Appendix.

3 The account of shadow in computer graphics that I found the most relevant to the present purpose was Foley et al. (1990), chap. 16 ('Illumination and Shading'), especially pp. 722–54 and 760–93. It contains further bibliography.

For Bouguer and Lambert, see §§ 27 and 28 below.

5 For the Piazzetta prints and drawing discussed here, *Piazzetta* (1983a), pp. 210–15 (nos 96–9), and *Piazzetta* (1983b), pp. 46–7 and 79–82 (nos 91–3); for Piazzetta more generally, Knox (1992). Piazzetta had prepared designs for a set of instructional model engravings, probably around 1750. He died in 1754, and his friend the printer Giovanni Battista Albrizzi had them engraved and then published in 1760 as a volume called *Studi di pittura*. The schematic preliminary prints (fig. 5) were evidently Albrizzi's initiative, see *Prefazione*

dell'editore: 'per renderlo più facile ed utile al Giovane studioso, giudicai necessario far precedere ad ognuno de' suddetti Disegni anche i Contorni con diligenza ombreggiati, acciochè vegga in essi come si cominciano i primi Tratti . . .'

NOTES TO CHAPTER II

6 Studies of the episode sketched in this chapter are Mérian [1770–79], Markovits (1984) and particularly Morgan (1977). For its wider context, Pastore (1971), chaps. 1–6, and Yolton (1984).

The first edition of Locke's *Essay* was published in 1690 (London: Thomas Bassett). Molyneux began corresponding with him in the summer of 1692 and, at Locke's suggestion, sent a number of comments on the book during the following winter: the letter with the Query is of 2. iii. 1693. The revised second edition, quoting the letter, was published in the spring of 1694 (London: Samuel Manship). There are many modern editions. The text used here is the edition of P.H. Nidditch (Locke, 1975, pp. 145–57) which is based on the fourth edition of 1700. But it has seemed better to give references by section for Locke, as for the other canonical philosophers who now exist in many editions. The philosophical literature on Locke's psychology of perception is vast and intimidating: I found Mackie (1976) and Tipton (1977) accessible.

7 The standard edition of Leibniz's *Nouveaux Essais* is *Sämtliche Schriften und Briefe* (Deutsche Akademie der Wissenschaften zu Berlin), series VI (Philosophische Schriften), vol. 6, ed. A. Robinet and H. Scheppers (Berlin: Akademie-Verlag, 1962), but altogether more handy is the edition by Jacques Brunschwig (Paris: Flammarion, 1990). Leibniz's sections follow Locke's. For Leibniz, perception and apperception, McRae (1976), especially chap. 3.

A convenient edition of the relevant works by Berkeley is *Works on Vision*, ed. Colin M. Turbayne (New York: Bobbs-Merrill, 1963), used here. For Berkeley and his relation to Locke, Bennett (1977).

8 For Cheselden's artistic interests beyond anatomical illustration, Cope (1953), pp. 38–42, 86–8, 102. For the Case, particularly Morgan (1977), pp. 16–24.

9 Voltaire [1738], II. vi. (p. 469). Mérian [1770–79], 5, for the 'changements considérables dans la science de l'Esprit humain'; pp. 24, 40 and 106 for Jurin (who was Secretary of the Royal Society 1721–7). Buffon (1749), pp. 314–18. Diderot [1749], pp. 48–55. Condillac [1746], I. vi. 1–16 (pp. 182–90), and [1754], III. 4–5 (pp. 189–201); for the statue learning to see [1754], III.3 (pp. 167–88).

Condillac [1754], p. 174 (III. 3):

Elle apprend à voir un globe

La première fois qu'elle porte la vue sur un globe, l'impression qu'elle en reçoit, ne représente qu'un cercle plat, mêlé d'ombre et de lumière. Elle ne voit donc pas encore un globe: car son oeil n'a pas appris à juger du relief sur une surface où l'ombre et la lumière sont distribuées dans une certaine proportion. Mais elle touche, et parce qu'elle apprend à porter avec la vue les mêmes jugemens qu'elle porte avec le tact, ce corps prend sous ses yeux le relief qu'il a sous ses mains.

Elle réitère cette expérience, et elle répète le même jugement. Par-là elle lie

les idées de rondeur et convexité à l'impression que fait sur elle un certain mélange d'ombre et de lumière. Elle essaye ensuite de juger d'un globe, qu'elle n'a pas encore touché. Dans les commencemens elle s'y trouve sans doute quelquefois embarrassée: mais le tact lève l'incertitude; et par l'habitude qu'elle se fait de juger qu'elle voit un globe, elle forme ce jugement avec tant de promptitude et d'assurance, et lie si fort l'idée de cette figure à une surface, où l'ombre et la lumière sont dans une certaine proportion, qu'enfin elle ne voit plus à chaque fois que ce qu'elle s'est dit si souvent qu'elle doit voir.

10 Montesquieu [1729], pp. 265–6:

– Raphaël est admirable; il imite la nature. Il ne met pas ses figures dans une attitude contrainte pour faire porter des ombres sur la figure, et faire par art le clair-obscur. Il met la figure dans la position où elle doit être, où elles sont naturellement, et ne se sert point de ces sortes d'avantages. Il lui suffit que la lumière tombe sur ses figures, sans avoir besoin que le positions mettent des variétés et cachent à la lumière des membres pour en faire paraître d'autres.

Ce sont les reflets qui font saillir les corps, et la science du peintre consiste à disposer les choses de façon que les lumières, les ombres, les reflets, fassent l'effet désiré. Une partie est dans la lumière; l'ombre est tout près; ensuite vient une lumière jetée par une partie voisine; et il est aisé d'observer: que les lieux éclairés par une lumière directe et une lumière réfléchie sont plus éclairés que ceux qui ne le sont que par la lumière directe; que les corps dans l'ombre, qui vient de l'obstacle arrivé à la lumière directe, sont éclairés par une lumière réfléchie du côté opposé, et le sont à proportion de l'éloignement du commencement de l'ombre, qui devient par là toujours de moins en moins obscure: la plus grande obscurité étant le plus près de la lumière.

Lo sbattimento, ou l'ombre causée par les pieds et les jambes des figures, et qui parait sur le fond, est d'autant plus large que le corps est plus près, parce qu'on le voit sur un plus grand angle. Lorsque la figure ne pose pas à terre, mais est en l'air, lo sbattimento est éloigné de la figure, comme il arrive dans le naturel.

Lorsque la lumière vient du dedans d'une chambre, par le moyen de quelque corps lumineux qui y est, les objets les plus éclairés seront les plus éloignés de l'oeil, et, à mesure qu'ils seront plus obscurs, ils paraîtront plus près: car l'oeil juge de la manière dont il a coutume de juger; et c'est précisément le contraire de ce qui arrive dans le cours ordinaire des choses, c'est-à-dire lorsque la lumière vient du soleil. On voit un bel exemple dans les salles du Vatican, où Raphaël a peint saint Pierre délivré de ses liens: car les barreaux de la prison plus noirs paraissent être les plus près, et fort éloignés des Anges qui éclairent le tout. C'est que la dégradation y est admirablement observée. On voit quatre lumières: celle de l'Ange; celle d'un autre Ange à côté; celle de la lune; celle d'un flambeau. Cependant il n'y a aucune erreur.

For Montesquieu and Hildebrand Jacob, Ehrard (1965), pp. 14–17.
A letter from the Abbé Millot cited by Buffon in his 'Observations sur les couleurs accidentelles et sur les ombres colorées', in Buffon [1743/4], pp. 148–9:

...je suis obligé de tracer la topographie de ma chambre: elle est à un troisième étage; la fenêtre près d'un angle au couchant, la porte presque vis-à-vis. Cette porte donne dans une galerie, au bout de laquelle, à deux pas de distance, est une fenêtre située au midi. Les jours des deux fenêtres se réunissent, la porte étant ouverte[,] contre une des murailles; et c'est là que

j'ai vu des ombres colorées presque à toute heure, mais principalement sur les dix heures du matin. Les rayons du Soleil que la fenêtre de la galerie reçoit encore obliquement, ne tombent point par celle de la chambre, sur la muraille dont je viens de parler. Je place à quelques pouces de cette muraille des chaises de bois à dossier percé. Les ombres en sont alors de couleurs quelquefois très vives. J'en ai vu qui, quoique projetées du même côté, étaient l'une d'un vert foncé, l'autre d'un bel azur. Quand la lumière est tellement ménagée, que les ombres soient également sensibles de part et d'autre, celle qui est opposée à la fenêtre de la chambre est ou bleue ou violette; l'autre tantôt verte, tantôt jaunâtre. Celle-ci est accompagnée d'une espèce de pénombre bien colorée, qui forme comme une double bordure bleue d'un côté, et de l'autre verte ou rouge ou jaune, selon l'intensité de la lumière. Que je ferme les volets de ma fenêtre, les couleurs de cette pénombre n'en ont souvent que plus d'éclat; elles disparaissent si je ferme la porte à moitié. Je dois ajouter que le phénomène n'est pas à beaucoup près si sensible en hiver. Ma fenêtre est au couchant d'été, je fis mes premières expériences dans cette saison, dans un temps où les rayons du Soleil tombaient obliquement sur la muraille qui fait angle avec celle où les ombres se coloraient.

Rousseau, [1762], III, p. 114 (end of book 2):

J'ai ouï raconter à feu milord Hyde qu'un de ses amis, revenu d'Italie après trois ans d'absence, voulut examiner les progrès de son fils âgé de neuf à dix ans. Ils vont un soir se promener avec son gouverneur et lui dans une plaine où des écoliers s'amusaient à guider des cerfs-volants. Le père en passant dit à son fils: *Où est le cerf-volant dont voilà l'ombre?* Sans hésiter, sans lever la tête, l'enfant dit: *Sur le grand chemin.* Et en effet, ajoutait milord Hyde, le grand chemin était entre le soleil et nous. Le père, à ce mot, embrasse son fils, et, finissant là son examen, s'en va sans rien dire. Le lendemain il envoya au gouverneur l'acte d'une pension viagère outre ses appointements.

Quel homme que ce père-là! et quel fils lui était promis!

NOTES TO CHAPTER III

11 For Subleyras's *Charon*, Subleyras (1987), pp. 162–3. Half of the left-hand shrouded figure – the rest of the picture being masked by another canvas – is shown in *L'atelier* (Vienna, Akademie), the picture of his studio Subleyras painted some short time before his death in 1749. *Charon* is not dated but on arguable stylistic grounds is reckoned to be fairly early, about 1735 being spoken of.

12 The literature on the issue of how far the models of artificial intelligence can be related to the operations of human intelligence is large, factious and repetitive. For the art historian or similar reader one entry into the more interestingly specific questions might be through three of the good papers in Posner (1989) and their unusually selective bibliographies: the papers are Zenon W. Pylyshyn, 'Computing in Cognitive Science', pp. 49–92; Philip N. Johnson-Laird, 'Mental Models', pp. 469–500; and Gilbert Harman, 'Some Philosophical Issues in Cognitive Science: Qualia, Intentionality, and the Mind-Body Problem', pp. 831–48.

13 Animal countershading and reverse countershading: the standard books seem, still, G.H. Thayer, *Concealing Coloration in the Animal Kingdom* (New

York: Macmillan, 1918), and J.P. Hailman, *Optical Signals: Animal Communication and Light* (Bloomington: Indiana University Press, 1977), but I have not pursued the topic.

This and other topics in the traditional argument for the importance of shadow in perception are well illustrated in Metzger (1975), chap. 16, which comes out of a broadly Gestalt-psychology background of reference. For shadow in the framework of direct perception, Gibson (1966), pp. 208-16.

For a number of demonstrations of the force of shading in convex/concave discriminations and the presence of light-from-above hard wiring in these, Ramachandran (1988a) and (1988b). It should be kept in mind that they are two-dimensional displays, computer graphic isolations of shading, specialised pictures. For a good summary of the research on the role of shadow in picture perception in early childhood, see Yonas (1979) and Olson et al. (1980), which are perhaps more interesting for conclusions about the relative importance of the components of shadow perception – for instance, location of light-source or the role of cast shadow – than for shadow's primitive importance in perception.

A locus for the downplaying of the role of shadow in perception, which is often a matter of emphasis more than argument, is Marr (1982), specifically pp. 239 (even shading is 'only a weak determiner of shape') and 294 (which introduces fig. 10 in the context of a suggestion that illusions like the reversible Necker cube are related to perception bringing an assumption of three-dimensionality and surface continuity to contradictory cues from the line/edge structure). Mingolla and Todd (1986) produce some evidence for both cast shadow and knowledge of light source direction playing little role in accurate perception of computer images of shaded ellipsoid solids.

14 For the modular model, classically Marr (1982), Chap. 3. For ecological perception particularly Gibson (1966), in my view the most balanced of his accounts: for shadow specifically, pp. 208-16, 'The causes of structure in reflected ambient light'. This is also a moment to mention the excellent general survey by Gordon (1989), with chaps. 7 and 8 respectively on Gibson and Marr.

Shape-from-shading in serial machine vision is a specialised and intricate field, and short accounts in general handbooks are not in practice helpful. In the end the most accessible book I found is Horn and Brooks (1989), a collection of seventeen reprinted papers on various problems, mostly quite detailed and technical but with an explanatory introduction. But it does not include parallel processing techniques.

Lehky and Sejnowski (1988) describe a network of a common three-tier pattern, a middle layer of 'hidden' units mediating between a number of input and output units. In such a system each connection carries a positive or inhibiting stimulus of adjustable weight to or from a mediating unit of adjustable sensitivity. While learning to perform a task, weights and sensitivities adjust in response to feedback. Then eventually – according to the sum of positive and negative stimuli, their input units of origin, and its own sensitivity at the moment, the mediating unit will or will not fire a stimulus as one contribution to this or that output unit's own decision about how to declare.

The shape-from-shading network learned to give good outputs by modifying its own sensitivities and responses on the basis of trial-and-error feedback, specifically backward error propagation. While the learning procedure, as opposed to the finished competence, was not intended to simulate human procedures, it was a plastic, reactive, association machine that would have pleased Condillac more than Locke.

The stimuli were two-dimensional images of single elliptical paraboloid Lambertian surfaces, either convex or concave, each curved with different orientations and magnitudes, each differently centred in the field and lit from a different direction, lighting being sufficiently diffused to exclude any sharp projected shadow edges.

One hundred and twenty-two circular receptor or input units were arranged to overlap with each of six neighbours in a hexagonal array that would cover a patch of the visual field analogous with that covered by a column of processing cells in the visual cortex. Half had an excitatory centre and inhibitory surround, half the contrary. Each communicated with all of twenty-seven hidden units. Each of the hidden units reacted on to all of twenty-four output units with a graded value on ten steps, 0.0 to 1.0. The output units reacted with values for the orientations and magnitudes of curvatures and with decisions between convexity and concavity. Most of the 12 per cent error, which was in curvature magnitude, would be removed by using a larger network accommodating units responsive to differing spatial scales of brightness stimulus.

The demonstration is invoked here for its direct bearing on shadow, but it should be mentioned that the technical interest it has aroused lay particularly in a different matter. The network once trained in shape-from-shading, the mediating units were examined and some turned out to be most responsive not to immediate facts of the shading of curved surfaces but to end-stopped bars of light or dark in particular orientations. Neurophysiologists had long before located cells in the mammalian visual cortex which responded to analogous bars, and these cells had been taken to have the straight purpose of responding to such bars as part of the structuring of the optic array. The demonstration suggests a greater complexity of systematic function in the brain.

In general, beyond the retinal stage, the middle-order physiological particulars of the visual system seem hard to make secure inferences from at present, since individual details of behaviour are still easily mistaken for function in the system. I have fought shy of post-retinal physiology here, but, among the introductory books already cited, Bruce and Green (1990), chap. 3, is one of many that offer a summary and bibliography.

15 For the hollow face illusion, Gregory (1970), pp. 126–31, for instance.

For the Tiepolo drawing, *Tiepolo* (1970), unpag., no. 8. It is uncertain what picture the drawing was preparation for, if any, but style and facture lie firmly in the 1720s.

16 *The visual process*: The scheme of visual process referred to is fairly standard, but classically described by Marr (1982). Underlying most thinking is the model of process from $2\frac{1}{2}$-D *sketch* (the viewer-centred perception of the orientation and distance of visible surfaces previous to construction of these into stable organisations) to *3-D representation* (which has attained objects in objective space transcending the particular retinal moment). All handbooks explain this, but it is still best read in Marr, chaps. 4–5.

Artificial intelligence workers have been more conjectural about the upper middle (cube and sphere level) than the lower middle (luminance discontinuities and features); and it has evidently been hard to develop psychophysical experiments that have much relevance or rigour. But it is obviously critical for any account of visual process, deeply involved in the transition from $2\frac{1}{2}$-D sketch to 3-D representation, and therefore schemes have been proposed for a toy-town universe of general component forms from which such complex

objects as human bodies would be composed (fig. 16); or rather, from which the structures of such objects would be described. For instance, *generalized cones* (fig. 15) are really liberal or elastic cylinders that may swell or narrow, or flex; *geometric ions* or *geons* are a set of basic forms like wedge and cylinder; *superquadrics* are another such set, the items in which (such as the sphere) may be deformed within given limits. But it is part of the paradigm that the move from $2\frac{1}{2}$-D to 3-D is a move beyond the specific viewpoint and so the thrust of all these is naturally to find forms whose properties survive rotation or changes in viewpoint in one way or another. It is about the invariant; shadow is a variant. There is a convenient short survey of ideas about this stage of perception in Bruce and Green (1990), chap. 8, 'Object Recognition', outlining not only the schemes in the style of *generalised cones* but also the important issue of canonical views, which I do not discuss here. A good short discussion of the problems set by the relative lack of development in ideas about upper-middle perception is in the last section of the paper by Ellen C. Hildreth and Shimon Ullman, 'The Computational Study of Vision', in Posner (1989), particularly pp. 610–20 ('High-Level Vision').

The retina: The structure (fig. 17) and pre-processing operations of the retina are described in all general surveys of vision – in our bibliography, for instance, Bruce and Green (1990), Chaps. 1–2 – but I have worked particularly from De Valois and De Valois (1988), whose perspective accommodates a number of the issues of shadow perception.

Fine and coarse takes: The first problem of machine vision is how to proceed from a grid of light measurements produced by a grid of electronic cells towards the eventual perception of real objects. The individual measurement is not in itself helpful: relativities are. Since real objects tend to be associated with luminance discontinuities at their edges, luminance discontinuities are the relativities first sought. (There are two big assumptions made here: that objects tend to be homogeneous in the reflective character of their surfaces; and that the luminance changes of object edges tend to be sharper than those of shadow edges.) So serial machines read the luminance field linearly in two dimensions, left to right, say, and top to bottom, and these two linear plots are presently integrated into a field plot.

Since discontinuities are the first target, the zero-line commonly used in the linear plot across any part of the field is not some median light-measurement – the absolute brightness of the surfaces is again not helpful in itself – but simply a gauge of change: the zero-line itself just represents no change. And what has been found more advantageous to plot on this line than the rate of change in brightness is, in fact, the rate of change in the rate of change in brightness, the second derivative. So, a luminance gradient whose rate of increase is evenly increasing – as one can conceive in the shading of some curved surfaces directionally lit – comes out at zero.

The second derivative can discriminate neatly between different kinds of discontinuity. A change in the rate of change, such as is often caused by the meeting of two differently angled and so differently shaded planes on the surface of an illuminated object, shows up as a single blip above the zero-line in the case of increase, below in the case of decrease. But an actual sudden change of brightness, a brightness boundary between different brightness areas, such as is often caused by the edge of one object occluding whatever is behind it (though also by some other things, such as cast shadows), shows up as an unbroken doubleblip, first one above the line and then immediately one below, or vice versa. Some programmes have concentrated on the points where the doubleblip crosses the line – called zero-crossings (fig. 18) – but others have

productively processed the blips above and below the line – called peaks and troughs (fig. 19).

At this stage an issue of scale of plot arises. If the scale is fine the important discontinuities like those caused by object edges and forms get drowned out by chatter from very local detail like the microshadow of surface texture, which can involve brightness contrasts as great as object edges. But if the scale is coarse distortions are liable to appear and important detail is lost; for instance, the sharpness of discontinuities is not differentiated clearly enough for them to be ascribed to objects (as sharper) or to shadows (as more blurred, perhaps). There are disabling problems in finding a good compromise scale, partly but not just because scenes differ in character.

The best solution has proved to be to add together, in one way or another (figs 18–19), plots put through two or more filters that remove different proportions of the higher spatial frequencies: that is to say, removing different amounts of the smaller-scale detail of brightness contrast, and so having different blurring power. (These filters usually also exaggerate local variation at the chosen span or spatial frequency by giving more weight to the light values within the span and less than just weight to the values immediately next to the span: the 'Gaussian' function.) What persists through several of these filters is privileged.

17 Koenderink and van Doorn (1980) is reprinted in Horn and Brooks (1989). Though it is frequently cited, its radical implications do not appear to have been much taken up.

18 Waltz (1975) and his productive shadow are well summarised in Johnson-Laird (1988), pp. 107–14, generally a most helpful book, chaps. 4–6 being devoted to vision. For the accepted placing of block worlds, Marr (1982), pp. 344–5.

19 The Mach bands and contrast illusions are discussed in most general handbooks on vision: for example Frisby (1979), pp. 136–9.

Gilchrist (1979) also describes an experiment about the role of knowledge of differential lighting. A flat three-value display was half brightly, half dimly lit, at a ratio of 30:1 which corresponded with the 30:1 range of differential reflectance of the surfaces. To some observers the lighting was revealed, from others it was concealed. The former saw the tonal relations fairly true; the latter assumed coherent lighting, mistook the illumination value for reflectance value, and misassessed the values in each half to an extent not inconsistent with 15:1. This involved misreading a sequence across the display of grey-black-grey/grey-white-grey as white-grey-white/black-grey-black.

Another experiment was about the role of knowledge of spatial layout, and produced analogous results for this. Observers apprised by stereopsis of the layout of a differentially lit three-dimensional structure saw the tonal values of surfaces correctly: but those confined to monocular vision by having to look through a single eye-hole mistook the form of the deliberately misleading structure and so misread surface values accordingly.

20 For neurons responsive to differentiated patterns of gradated shading, Fujita et al. (1992), pp. 343–6, especially figure 3.

For mental imagery there is an excellent short sketch of the current issues in Johnson-Laird (1988), pp. 121–6, and an excellent longer analysis in Pinker (1985), pp. 36–58. A balanced handbook is Finke (1989).

21 A note on the word 'information': In the cognitive sciences use of the word seems both equivocating and attenuated. For the first, it moves between information-theory references of high-technical colour – relating, that is, to an item viable in a channel of transmission – and quite vernacular senses not far from gained or given 'knowledge', of the world or whatever it may be. The attenuation seems partly a product of a lack of wholeheartedness in the equivocation: the sense of information-as-knowledge is pared down to get by as information-as-consignment. If the channels of early perception are treated as modular, and if shadow (as opposed to shading) is not allotted an isolable module distinct from brightness edges, on the trivial level of definition it cannot be seen as either being or bearing information at this stage. The problem here is not real, but awkwardness is caused for thinking about intermodularly and relationally perceived things such as perceived shadows. I use the word in the vernacular sense, which does not exclude or assume individual consignability.

NOTES TO CHAPTER IV

22 De Piles [1708] on chiaroscuro, the sections 'Du Tout ensemble', pp. 69–78, and 'Du Clair-obscur', pp. 165–75 (in the original edition (Paris: Estienne, 1708; repr. Geneva: Minkoff, 1971), pp. 94–112 and 361–86). On de Piles's aesthetic on these matters, particularly Puttfarken (1985), pp. 72–105.

The ten points on chiaroscuro are a summary of Dandré-Bardon (1765), pp. 106–29. On Dandré-Bardon as painter, teacher and writer, Chol (1987), especially pp. 61–72 and 138

23 Jombert (1755), pp. 103–6:

Il faut observer que les objets voisins de l'oeil sont plus reflettés que ceux qui en sont éloignés, & que les couleurs en sont plus vives, non seulement dans les lumieres, mais même dans les ombres, parce qu'étant plus reflettées, elles perdent moins de leur couleuque que dans les object éloignés: que leur couleur se perd tout-à-fait dans les ombres, & qu'elle s'affoiblit & se grise beaucoup dans les lumieres. Que lorsque l'air n'est point chargé de vapeurs, ces ombres sont fort obscures, sans qu'on puisse décider de quelle couleur elles sont; mais quand au contraire l'air s'en trouve chargé, les ombres sont moins noires, & participent de la couleur que les vapeurs prennent par la lumiere du soleil qui éclaire leurs particules. Cette couleur des vapeurs, ou autrement dit de l'air, varient selon les momens du jour. Le matin, vers le lever du soleil, elle fait paroître les ombres bleuâtres, & souvent mêmes violettes: vers le coucher du soleil, les ombres ont encore quelque chose de bleuâtre. Ce n'est pas que ces ombres soient effectivement de cette couleur; car toutes les ombres sont en elles mêmes grises, c'est-â-dire, que leur couleur est éteinte par la privation de la lumiere; ce qui les fait paroître bleuâtres, c'est l'opposition des tons dorés ou rouges, ou autres qui fait paroître le gris bleuâtre; ces remarques concernent plus particuliérement les Peintres de paysages. Il y a quelques regles générales qu'il est nécessaire de savoir; que les ombres portées par les corps, sont toujours plus fortes que la partie ombrée de ces mêmes corps; les touches & les ombres les plus fortes sont toujours auprès des lumieres les plus vives, ce qui est cependant subordonné à la lumiere des reflets, qui, lorsqu'elle est vive & prochaine, peut détruire une partie de cette force, & ne la laisse que dans les endroits où les reflets ne peuvent pas entrer: que les touches & les détails qui sont dans les ombres, ne

sont jamais aussi forts & aussi sensibles que ceux qui sont dans la lumiere, & que par consequent, les parties ombrés sont toujours vagues & de repos, en comparaison des parties éclairées.

On donne encore un autre principe de clair obscur, qui est d'autant meilleur qu'il conduit à faire de grande maniere, & qu'il aide à produire des effets piquans & sensibles; c'est que les reflets, dans leur parties les plus claires, sont toujours plus bruns que les demi-teintes dans leurs bruns les plus bruns. Il faut convenir que cette regle est sujette à beaucoup d'exceptions. Car premierement la différence des couleurs y produit quelquefois des reflets si sensibles, qu'il semble qu'ils soient plus clairs que certains demi-teintes colorées: par exemple, l'ombre reflettée d'un linge blanc, peut être plus claire que la demi-teinte, & même que la lumiere d'une étoffe noire. Cependant cette regle est bonne, & conduit à produire beaucoup d'effet, en ce que par là les masses sont bien décidées dans un tableau, & se distinguent mieux de loin, ainsi je crois que cette loi doit être suivie dans les grands tableaux d'Histoire, qui sont supposés devoir être vûs d'une distance un peu éloignée, parce que en effet, c'est ce qui se voit dans la nature vûe d'un peu loin: les masses d'ombres sont plus obscures qu'elles ne le seroient si elles étoient vûes de près, & sur tout lorsque c'est la lumiere du soleil qui éclaire le tableau, car cette lumiere produit des ombres fieres & bien décidées. Il n'en est pas de même lorsqu'il est question d'un portrait, qu'on suppose vû de près, puisqu'on y représente les moindres détails qui peuvent contribuer à la ressemblance: il peut y avoir des reflets vifs & clairs; & les couleurs particulieres de chaque objet, y ont leurs différences plus sensibles.

Il faut encore observer que les bords des objets sont doux & un peu indécis, non-seulement quand ces objets sont ronds & tournants, mais encore quand ils sont plats, & même lorsqu'ils se tirent en brun sur des fonds clair; il semble que les rayons qui viennent peindre les fonds clair contre ces bords, aient une sorte d'aberration, & se brisent un peu en passant à côté de ces objets en se rapprochant, & que par une sorte de vibration, ils peignent ces bords d'une maniere indécise; si cela est ainsi, ce doit être une des causes qui font qu'un objet placé au grand air paroît de moindre volume qu'il ne l'est; une colonne, par exemple, paroît de moindre diametre qu'elle n'est en effet. Cette remarque conduit à peindre moëlleux, en ne cernant point les bords des objets. Comme il y a de necessité de l'air entre les objets du tableau & le Spectateur, il s'ensuit que ces objects doivent être peints avec un commencement d'indécision qui en ôte la sécheresse & le tracé: c'est ce que l'on appelle peindre large & mölleux; mais il faut que cela soit traité avec beaucoup de modération; car quelques-uns tombent dans le défaut de peindre les objets comme s'ils étoient vus au travers d'un nuage. Cela doit être d'autant moins sensible, que lorsque nous regardons un tableau, nous laissons un véritable espace d'air entre nous & le tableau, qui nous l'adoucit déja.

Une des principales regles de l'accord général d'un tableau, c'est que toutes les ombres doivent avoir quelque chose de commun entr'elles; car l'harmonie des tableaux consiste en ce que les ombres soient toutes d'un ton qui les fasse tenir l'une de l'autre; la monotonie qu'il semble que cela doit produire est détruite par la différence des couleurs des demi-teintes, où chaque objet conserve sa couleur locale, sans autre changement que celui qu'y produira la distance de l'objet, & l'interposition de l'air. Je m'explique: les couleurs des objets nous paroissent détruites dans les ombres un peu éloignées par la privation de la lumiere, qui leur donne leur existence. C'est proprement un anéantissement total de toute couleur, qu'une ombre qui seroit supposée parfaitement obscure. Celle qui est moins obscure, est une diminution de

l'existence des couleurs, plus ou moins grande, selon l'obscurité plus ou moins grande de l'ombre. Si donc on peut supposer qu'on ait trouvé une matiere propre à la Peinture qui n'ait aucune couleur, & qui n'ait d'autre propriété que celle d'obscurcir toutes les couleurs, jusqu'à pouvoir arriver à l'obscurité parfaite: elle représentera parfaitement les ombres; mais la chose est impossible, on ne peut pas représenter exactement un néant d'être par un être. On the peut trouver pour imiter cela que des couleurs obscures, tellement mêlées ou rompues qu'elles n'aient aucune couleur qu'on puisse désigner; cela ne se peut pas non plus trouver exactement, le plus habile est celui qui en approche le plus. C'est pourquoi tous les Maîtres ont une couleur pour les ombres; les uns les font roussâtres d'autres tirant sur le violet, d'autre jaunâtres, d'autres olivâtres, &c. La meilleure est celle qui est brune, sans qu'on puisse précisément lui donner un nom. Je dis donc, par supposition, que si l'on a trouvé cette teinte, elle doit entrer dans toutes les ombres, plus ou moins, selon ce qu'on les veut faire plus ou moins brunes. Une seconde cause de l'accord général d'un tableau, c'est que les lumieres doivent toutes avoir quelque chose de commun entr'elles. La lumiere qui éclaire les objets, prend la couleur en quelque chose du milieu par lequel elle passe, ou pour mieux dire, les rayons de cette lumiere sont modifiés par ce milieu. Ce milieu c'est l'air qui prend différents nuances, selon la quantité qu'il y en a, & selon les vapeurs, dont il est chargé, par lequel ils passent de maniere à produire une couleur légere & peu sensible, mais qui rompt un peu toutes les couleurs locales des objets dans leurs parties éclairées. Ainsi quelquefois la lumiere semble un peu dorée; quelquefois elle est d'une couleur argentée, d'autres fois d'une couleur un peu violette, & ce ton léger doit entrer dans toutes les lumieres, & y rompre un peu les couleurs locales; par ce moyen les lumieres participent les unes des autres, & le tableau paroît éclairé de la même lumiere. Mais dans les passages de cette lumiere à l'ombre, que l'on appelle demi-teintes, les couleurs locales restent entieres, ou du moins si elles sont rompues, c'est d'une maniere qui n'est pas sensible, & elles paroissent n'éprouver d'autre rupture, que celle que produisent les degrés d'éloignement. Ainsi on peut poser pour principe, que les lumieres ont un ton général dont elles participent, qui ne détruit pas leur couleur véritable, mais seulement se mêle avec elle; que les demi-teintes ont la couleur propre des objets, & que les couleurs se grisent & perdent de leur force à proportion qu'elles s'obscurcissent, & que quand elles recoivent quelque lumiere de reflet, elles sont mêlées de leur propre couleur que cette lumiere fait reparoître, & de la couleur de l'objet qui leur envoie le reflet. On peut remarquer dans la nature, qu'une ombre paroît plus obscure, lorsqu'elle est auprès d'une lumiere vive; mais cet effet se fait aussi naturellement dans le tableau, sans qu'on soit obligé d'y fortifier l'ombre; car dans la Peinture, de même, une ombre paroît plus forte qu'elle ne l'est, lorsqu'elle est opposée á un grand clair.

([1] It is to be noted that objects close to the eye are reflected to it more strongly than those distant from the eye, and that their colours are more lively, not just in the lights [or illuminated surfaces] but in the shadows also, because, being reflected more, they lose less of their colour than do distant objects: these latter lose their colour altogether in the shadows, and it weakens and greys a great deal in the lights. Also, when the air has no vapour in it, these shadows are very dark, it being impossible to tell what colour they are; but when, by contrast, the air is charged with vapour, the shadows are less dark and take on some of the colour that vapour takes on from the sunlight illuminating its particles.

[2] This colour of the vapour – which is to say, of the air – varies according to the time of day. In the morning, about sunrise, it makes shadows seem bluish, often even violet; towards sunset the shadows again have a bluish quality. It is not that these shadows are really this colour, since all shadows are grey, in themselves – that is to say, their colour is extinguished by privation of light; what makes them seem bluish is contrast, with gold or red or other tints, making the grey seem blue. These remarks more particularly concern landscape painters.

[3] There are some general rules that need knowing: shadows cast by bodies are always stronger than the shadows on the shadowed parts of those bodies; the strongest shadows and strongest handling are always near the brightest lights – this nevertheless depending on the light from reflections which, if it is both bright and close, can destroy part of that strength and let it persist only in those places reflected light cannot penetrate; the handling and detail in shadows are never as strong and visible as those in light, and consequently shadowed sections are always soft and quiet compared with lit sections.

[4] Another principle of chiaroscuro has been laid down as a rule, one that has the advantage of conducing to painting in a grand manner and of helping to produce piquant and noticeable effects; it is this: reflected lights, even in their brightest parts, are always darker than the half-tones are, even in their darkest darks. It must be admitted that this rule is subject to many exceptions. In the first place, a difference of object colours sometimes gives rise to such conspicuous reflections that they seem brighter than some coloured half-tones: for instance, a shadow lit up by reflection from a white sheet can be brighter than the half-tone, and even the fully lit surface, of a black fabric. Still, the rule is a good one and leads to the production of great effect in that thereby the masses are well resolved in a picture, and are more distinct from a distance; so I think this law should be followed in big history paintings, which are supposed to be viewed from some distance, because that in fact is what is seen in nature, when viewed from some way off. The shadow masses are darker than they would be if seen from nearby, and above all when it is sunlight that lights the picture, since this produces bold and well-defined shadows. It is not the same when it is a matter of a portrait, which one supposes seen from close, since there the smallest details able to contribute to likeness are represented: there one can have lively, bright reflections, and the specific colours of each object show their differences more noticeably.

[5] It is to be noted too that the edges of objects are soft and a little blurred, not just when the objects are rounded and curving, but when they are straight-sided too, and even when they stand out dark on a light ground; it seems that the rays of light that carry the image of the light background past and near these edges have a kind of aberration and are broken a little while passing close by the objects, and that through a sort of vibration they carry these edges in a blurred form. If this is so, it must also be the reason why an object set up in the open air may seem of a lesser volume than it is; a column, for instance, of smaller diameter than it really is.

[6] This observation points to painting with a soft touch, not outlining the edges of objects at all. Since there must be atmosphere between the objects in the picture and the beholder, it follows that these objects should be painted with a slight hesitation, a hint of indecisiveness that will remove any dryness and hardness of outlining: that is what is called painting with a broad, soft touch; but this must be practised with much moderation, since there are people who fall into the vice of painting things as if seen through a mist. It

should be all the less marked in that, when we look at a picture, we leave an expanse of actual atmosphere between it and ourselves, which softens it for us already.

[7] One of the principal rules of general concord in a picture is that all the shadows should have something in common; for the harmony of pictures consists in the shadows being all of one colour, making each share something of the character of another; the monotony it might seem this would produce is countered by the difference among the colours of the half-tones, where every object keeps its local object colour without alteration, except that produced by distance and the interposition of atmosphere. Let me explain: in shadows that are a little distance from the beholder, the colours of objects appear extinguished by privation of that light to which colours owe their existence. This is properly a total annihilation of all colour, in shadow supposed as being completely obscure. The shadow that is less than completely obscure constitutes a diminution of the existence of colours, the greater or lesser according to the more or less great obscurity of the shadow.

[8] If, then, one supposes that a material proper to painting, a pigment, had been discovered that had no colour, and had no other property than to obscure all colours, to the point of being able to attain complete obscurity, this would represent shadows completely. But the thing is impossible: a *néant d'être* cannot be accurately represented by an *être*. All one can find to imitate it with is dark colours, so mixed and broken as to have no designateable colour. Even this cannot be contrived exactly: the most skillful is he who comes closest. That is why all painters have a colour for shadows: some make them reddish, others tend to violet, others yellowish, others olive-ish, and so on. The best colour is that which is *brun* [dark, perhaps and/or brown-ish], without being precisely nameable. So I say, supposing one has found this mixed colour, it should enter into all the shadows, either more so or less so, according to how dark one wants them.

[9] A second source of general concord in a picture is that the lights should all have something in common. The light that illuminates the objects takes something of the colour of the medium through which it passes; or, rather, the rays of this light are modified by this medium. The medium is the air, which takes on different shades according to how much of it there is and also according to the vapours with which it is charged; through this air the rays pass in such a way as to produce a colour that is gentle and not very noticeable but breaks all the local object colours slightly, on their illuminated surfaces. So, sometimes the light seems a little golden; sometimes it is a silvery colour, other times a slightly violet colour – and this gentle shade should enter into all the lights and slightly break the local colours. By this means the lights partake of each others' character and the picture appears lit by the same light.

[10] But in the transitions of this light towards shadow, which are called half-tones, local object colours remain intact, or at any rate, if they are broken, it is in a way that is not noticeable; and they seem to suffer no more breaking of their colour than is caused by their distance from the beholder. So one can lay down as principle: that the lights have a general shade they share which does not destroy their real colour but just blends with it; that the half-tones have the proper colour of their objects; and that colours grey and lose their force in proportion to their darkening [through privation of light]; and that when they receive some reflected light they become a blend of their own proper colour, which this light makes reappear, and of the colour of the object that sent them the reflected light.

[11] One can observe in nature that a shadow, when it is close to a strong light, seems darker; but this effect happens naturally in a picture, without one needing to strengthen the shadow – since in painting too a shadow appears stronger than it is, when set in contrast with a big light.)

For Jombert and his relation to Cochin, Michel (1987), pp. 38–40 and (1993) *passim*. For Cochin's explicit views on chiaroscuro, Tavernier (1983), pp. 72–8. An interesting account of his complex sense of the relation of painting to reality in Hobson (1982), pp. 62–7, Part I of which book also provides an intellectual-historical context for the issue. The older literature on Cochin is listed by Tavernier and Michel.

24 The literature on notions of light in this period is vast. In the present context, good approaches are through Sabra (1967), for Newton in relation to the seventeenth century; Cantor (1983), for the diversity of post-Newtonian ideas; Guerlac (1981), chap. 5, for the French reaction to Newton; and Blay (1983) and (1989). More generally, Priestley (1772) is still a valuable resource.
Formey (1765), 463a–b:

> ... des lois invariables aussi anciennes que le monde, font rejaillir la lumiere d'un corps sur un autre, et de celui-ci successivement sur un troisieme, puis en continuant sur d'autres, comme par autant de cascades; mais toujours avec de nouvelles dégradations d'une chûte à l'autre. Sans le secours de ces sages lois, tout ce qui n'est pas immédiatement et sans obstacle sous le soleil, seroit dans une nuit totale. Le passage du côté des objets qui est éclairé à celui que le soleil ne voit pas, seroit dans toute la nature comme le passage des dehors de la terre à l'intérieur des cave et des antres. Mais par un effet des ressorts puissans que Dieu fait jouer dans chaque parcelle de cette substance légere, elle pousse tous les corps sur lesquels elle arrive, et en est repoussée, tant par son ressort que par la résistance qu'elle y éprouve. Elle bondit de dessus les corps qu'elle a frappés et rendus brillans par son impression directe: elle est portée de ceux-là sur ceux des environs; et quoiqu'elle passe ainsi des uns aux autres avec une perte toujours nouvelle, elle nous montre ceux mêmes qui n'étoient point tournés vers le soleil.

For Formey's contributions to the *Encyclopédie*, see particularly Marcu (1953). While the article on shadow was not published until 1765, Formey (1711–97) had been writing towards his own project of an encyclopaedia since 1742 and sold his materials to D'Alembert and Diderot's publishers, about the time he left Paris to return to Berlin. There is nothing in the article that demands a dating later than the 1740s.
Grimaldi (1665), pp. 1–11 on diffraction. One good summary in Blay (1983), pp. 40–45.
Edme Mariotte is more impressive than his reaction to Grimaldi and Newton represents, and is conveniently read in the compilation *Essais de physique, IV, De la Nature des couleurs* (1681), pp. 200–11 for Newton and Grimaldi, but elsewhere much other fine observation.

25 For the earlier history of study of cast-shadow projection in Europe, Kaufmann (1975). The eleventh-century treatise of Al-Bīrūnī, *The Exhaustive Treatise on Shadows* (1976), anticipates much of this, but was not known and had no equivalent in the west. A general impression of the character of later seventeenth- and eighteenth-century sciography can be got from illustrations in Descargues (1977), and see too Kemp (1990), s.v. 'Shadow' in index. For the

technical culture in which sciography was installed, Taton (1964) and Vérin (1993).

Desargues's geometry of conic sections was applicable to the sun being treated not as a point light-source but a circular source of specific extension. He himself used shadow projection as an illustration of his principles: for his *Leçons de ténèbres* see Taton (1951a), especially pp. 44–8. The extension to academic art training was attempted by Abraham Bosse, for whom see Bosse (1648) and Kemp (1990), pp. 120–28, with earlier bibliography. For Monge, especially the early *Petit Traité des ombres à l'usage des Écoles du Génie*, Taton (1951b), pp. 77–79. An example of the modern survival of sciographic drawing method is Gill (1975), chap. 8 and also pp. 159–67.

Formey (1765), 462a:

> Au reste, il n'est pas inutile de remarquer que tout ce qu'on démontre, soit dans l'optique, soit dans la perspective sur les *ombres* des corps, est exact à la vérité du côté mathématique; mais que si on traite cette matiere physiquement, elle devient alors fort différente. L'explication des effets de la nature dépend presque toujours d'une géométrie si compliquée, qu'il est rare que ces effets s'accordent avec ce que nous en aurions attendu par nos calculs. Il est donc nécessaire dans les matieres physiques, et par conséquent dans le sujet que nous traitons, de joindre l'expérience à la spéculation, soit pour confirmer quelque fois celle-ci, soit pour voir jusqu'où elle s'en écarte, afin de déterminer, s'il est possible, la cause de cette différence.

'sGravesande (1774), I, p. 59 ('Essai de Perspective', chap. VII, 'Des Ombres'):

> ... un Peintre aura plutôt fait de prendre garde aux ombres qu'il voit à tous momens, pour se mouler là-dessus dans le besoin, que de recourir à des régles qui ne peuvent pas comprendre tous les cas. Je passerai aussi sous silence la matiére du *clair-obscur* un peu d'attention à ce qu'on peut voir journellement éclaircira mieux cette matiére que ne pourroit faire un long discours, d'autant plus qu'il est impossible, sur ce sujet, de fournir des régles générales, et que la multitude infinie des figures ne souffre pas qu'on les examine chacune en particulier: outre que pour attraper le *clair-obscur* un Peintre doit faire attention non-seulement aux figures des objets, mais encore à leur couleur et à leur matiére.

For 'sGravesande's sense of diffraction, Cantor (1983), pp. 35–8.

26 Formey (1765), 462a–b.

> Feu M. Maraldi voulant éclaircir ce phénomene, a fait des expériences en plein soleil avec des cylindres et des globes, pour voir jusq'où s'étend leur *ombre* véritable. *Voyez mémoires de l'académie 1721.* Il a trouvé que cette *ombre*, qui devroit s'étendre à environ 110 diametres du cylindre ou du globe, ne s'étend, en demeurant toujours également noire, qu'à une distance d'environ 41 diametres. Cette distance devient plus grande quand le soleil est moin lumineux. Passé la distance de 41 diametres, le milieu dégénere en pénombre, et il ne reste de l'*ombre* totale que deux traits fort noirs et étroits qui terminent de part et d'autre la pénombre, suivant la longueur. Ces deux traits sont de la noirceur qui appartient à l'*ombre* véritable; l'espace qu'occupe la fausse pénombre et ces deux traits, appartiendroit à l'*ombre* véritable, parce qu'il est de la largeur qui convient à celle-ci. La largeur de la fausse pénombre diminue et s'éclaircit à mesure qu'on s'éloigne, et les deux traits noirs gardent toujours la même largeur. Enfin, à la distance d'environ 110 diametres, la

fausse pénombre disparoît, les deux traits noirs se confondent en un, après quoi l'*ombre* véritable disparoît entierement, et on ne voit plus que la pénombre. Il faut remarquer que la vraie pénombre qui doit dans la théorie entourer et renfermer l'*ombre* véritable, accompagne des deux côtés les deux traits noirs d'*ombre*.

Quand l'*ombre* est reçue assez proche du cylindre, et qu'elle n'a pas encore dégénéré en fausse pénombre, on voit autour de la vraie pénombre, des deux côtés et en dehors, deux traits d'une lumiere plus éclatante que celle même qui vient directement du soleil, et ces deux traits s'affoiblissent en s'éloignant.

M. Maraldi, pour expliquer ce phénomene, prétend que les rayons de lumiere qui rasent ou touchent le corps opaque, et qui devroient renfermer l'*ombre*, ne continuent pas leur chemin en ligne droite après avoir rasé le corps, mais se rompent et se replient vers le corps, de maniere qu'ils entrent dans l'espace où il ne devroit point du tout y avoir de lumiere, si les rayons continuoient leur chemin en ligne droite. Il compare les rayons de lumiere à un fluide qui rencontre un obstacle dans son cours, comme l'eau d'une riviere qui vient frapper la pile d'un pont, et qui tourne en partie autour de la pile, de maniere qu'elle entre dans l'espace où elle ne devroit point entrer si elle suivoit la direction des deux tangentes de la pile. Selon M. Maraldi, les rayons de lumiere tournent de la même façon autour des cylindres & des globes; d'où il résulte, 1°. que l'*ombre* réelle ou l'espace entierement privé de lumiere, s'étend beaucoup moins qu'à la distance de 110 diametres; 2°. que les deux bords ou arcs du cylindre autour desquels les rayons tournent, n'en étant nullement éclairés, doivent toujours jetter une *ombre* véritable; et voilà les deux traits noirs qui enferment la fausse pénombre, et dont rien ne peut faire varier la largeur. Comme ces bords sont des surfaces physiques qui par leur inégalités causent des réflexions dans les rayons, ce sont ces rayons réfléchis qui tombant au-dehors de la vraie pénombre, et se joignant à la lumiere directe qui y tombe aussi, forment par-là une lumiere plus éclatante que la lumiere directe. Cette lumiere s'affoiblit en s'éloignant, parce que la même quantité de rayons occupe toujours une plus grande étendue; car les rayons qui sont tombés paralleles sur le cylindre, vont en s'écartant après la réflexion.

Si on se sert de globes au lieu de cylindres, l'*ombre* disparoît beaucoup plutôt, savoir à 15 ou 16 diametres; elle se change alors en une fausse pénombre entourée d'un anneau noir circulaire, puis d'un anneau de vraie pénombre, et ensuite d'un autre anneau de lumiere fort éclatante. La fausse pénombre disparoît à 110 diametres, et l'anneau qui l'environne se change en une tache noire obscure; passé cette distance, on ne voit plus que la pénombre. M. Maraldi croit que la raison pour laquelle l'*ombre* disparoît beaucoup plutôt avec des globes qu'avec des cylindres, c'est que la figure des globes est plus propre à faire tourner les rayons de lumiere que la figure du cylindre.

Formey's reference is erroneous. Maraldi's article is in fact 'Diverses expériences d'optiques sur l'ombre des corps', *Mémoires de l'Academie Royale de Paris, 1723* (Paris, 1725), pp. 111–18.

For Maraldi, *Dictionary of Scientific Biography* (1981), IX, pp. 89–91 (article by René Taton).

27　　　For Lairesse, here invoked simply as a convenient summary of generally current commonplace, Roy (1992). An earlier book by Lairesse, *Grondlegginge der Teekenkonst* (1702), was translated into French in 1719. *Het Groot Schilderboek*

was translated into German in 1728 and English in 1738, but much of its thrust is in its illustrations, some of which had been republished in Japan by 1787.

Gautier D'Agoty (1753), pp. 57 and 53–4

La Lumière du Soleil n'est dirigée que d'un point sur les objets, ainsi que celle d'une lampe & celle d'une petite fenêtre dans une chambre; c'est pourquoi les réflexions sont moins étendues et presque uniformes, et le corps dans l'endroit opposé à la Lumière, par conséquent, plus chargé d'ombre. Mais la Lumière universelle est celle qui vient du même côté, et de plusieurs points, comme dans une campagne avant le lever du Soleil, ou après son coucher: la partie d'Orient ou d'Occident est la plus éclairée, et celle du côté opposé la plus ombrée; mais de façon que la grande quantité de réflexions différentes des rayons du jour, qui se réfléchissent en tous sens, selon leur incidence, entoure l'objet et l'éclaire avec douceur sur les parties ombrées, qui autrement seroient plus obscurcies.

La Lumière tranchée par les Ombres avec trop de dureté, fait un très-mauvais effet dans les Paysages. Pour éviter ce défaut il faut supposer dans ces compositions une Lumière universelle, un jour de crépuscule, ou cacher le Soleil avec ces nuages; ainsi que les Peintres Flamans Paysagistes ont presque tous exactement observé dans leurs compositions.

Les Sujets que l'on éclaire par la Lumière qui vient en droiture du Soleil, sont, ou des morceaux d'Architecture, ou des compositions particulières d'Histoire, ausquelles le nombre des Figures n'est pas considérable: alors le Sujet est plus vif & plus saillant, ainsi que les Tableaux du *Rembrand*, tel que celui de Tobie, dans le précieux Cabinet de M. le Marquis de Voyer, où les Têtes ont une Lumière admirable, et où les Ombres dans leurs Teintes les plus noires opposées à cette vive Lumière, ne servent qu'à former le contraste le plus sçavant, le plus vigoureux et le plus naturel.

I have found no general study of Gautier D'Agoty, who is, however, regularly invoked in accounts of the history of colour and colour printing for his antagonism with Jakob Christoph Le Blon.

Oudry [1749], pp. 393 and 392:

. . . quant au ton trop égal, que plusieurs leur [i.e. ombres portées] donnent d'un bout à l'autre, vous verrez dans la nature qu'elles ne sont très-fortes que contre ce qui est posé à terre: qu'immédiatement après, elles commencent à se dégrader, ce qu'elles continuent de faire insensiblement et jusqu'au bout, à cause de la lueur qui règne par-tout où il fait jour.

Principe qui a lieu à l'égard de tous les corps qui portent des ombres, avec une distinction cependant, que cette dégradation est beaucoup moins marquée dans les ombres des objets qui sont éclairés par le soleil.

Dans les objets qui ne sont éclairés que du jour naturel, c'est-à-dire, sans effet du soleil, comme par exemple, dans une figure étant debout, le haut est toujours plus fort dans ses ombres, que ne l'est la partie d'en bas, parce que celle-ci est à portée de recevoir les reflets du pavé et du terrein, dont l'effet diminue à mesure qu'il s'éloigne de sa cause, et fait place à des masses qui montent en brunissant toujours.

For Oudry, Opperman (1977) and Oudry (1983).

Diderot (1968), p. 686:

Imaginez, comme dans la géométrie des indivisibles de Cavalleri, toute la profondeur de la toile coupée, n'importe en quel sens, par un infinité de plans infiniment petits. Le difficile, c'est la dispensation juste de la lumière et des

ombres, et sur chacun de ces plans, et sur chaque tranche infiniment petite des objets qui les occupent; ce sont les échos, les reflets de toutes ces lumières les unes sur les autres.

The Bolognese Bonaventura Cavalieri had produced the standard systematisation of the geometry of indivisibles in his *Geometria* of 1635.

Bouguer on reflection, *Traité d'optique* [1760], pp. 161–228, and (1961), pp. 112–52, English translation with introduction and notes.

28 In Lambert's *Photometria* (1760) shadow is discussed in VII. ii. 1218–43 (pp. 537–47). The main content of this section is: 1218–21. Introduction and distinctions between full shadow and penumbra (partial shadow), and between darkness (absolute) and shadow (partial darkness). 1222. Intensities of shadow a function of the behaviour of direct and indirect light, already dealt with in pts I, III and V. 1223–5. Worked example of this, the case of a shadow projected on the ground by a wall, producing the formula: *umbra* = $\frac{1}{2}$ *c A* cos² $\frac{1}{2}$ *CED* (*c* = brightness value of sky, *A* = brightness value of un-shadowed surface of ground, *CED* = the angle formed by lines from top and bottom of wall at any perpendicular ground point beyond the shadow). 1226–30. The same but with two walls. 1231–2. Estimate of relative luminances from sun and from the hemisphere of the sky – about 6 : 1, but very variable. 1233–43. Penumbra and eclipses of the moon. Though not complete, the selective German translation and the notes by Ernst Anding in Lambert (1892) are helpful, partly for acerbic commentary on the mathematics and terminology.

Lambert's *La Perspective affranchie* . . . , used here (Lambert, 1759), was also published in the same year by the same Zurich publisher in a German edition, *Die freye Perspective* . . . For the note to the 1774 edition of *Die freye Perspective* on penumbra brighter than directly lit surface when the angle of incidence to the latter is very acute, Laurent (1987), p. 260.

'Lambert's law' is, in modern terminology: the quantity of light reflected from any unit area of the surface towards a viewer is directly proportional to the cosine of the angle between the direction of that viewer and the normal or perpendicular. (The already current 'cosine law' of illumination did not involve a viewer: simply, illumination of an area of surface was proportional to the cosine of the angle of incidence.) The main application of Lambert's law is to describe the 'Lambertian perfect-diffusing surface' – in which, since the area of surface seen is inversely proportional to the cosine of the same angle between viewer direction and normal, differences of viewer angle cancel out (*Photometria*, III. ii. 696–702). In other words, whatever the increase in the angle of the surface towards us, there are two mutually compensating factors – decrease in the amount of light reflected towards us by any area of actual surface, but increase of the area of actual surface included in the visual area, through foreshortening. Unfortunately, one sometimes meets the term 'perfect diffusion' used also of a surface that objectively reflects equally in all directions, a less interesting property.

For Lambert, the introduction and commentary by Max Steck in Lambert (1943), Charles Scriba in *Dictionary of Scientific Biography* (1981), VII, pp. 596–600, Arndt (1979), Laurent (1987), with newer bibliography. There has been much work on Lambert's colour and perspective theory, not bearing directly on shadow.

29–30 Cochin, 'Dissertation sur l'effet de la Lumiere dans les Ombres', in Cochin (1757), pp. 184–216:

Le principe dont il est question est celui-ci: *les ombres les plus fortes en obscurité ne doivent point être sur les devants du tableau, au contraire les ombres des objets qui sont sur ce premier plan, doivent être tendres et réfletées, et les ombres les plus fortes et les plus obscures doivent être aux objets qui sont sur le second plan.* (186)

... si l'on considère une muraille fuyante, ombrée, et portant aussi dans toute sa longueur une ombre sur le terrein; je dis que ces ombres, loin de s'affoiblir en s'éloignant, vont au contraire en augmentant de force et d'obscurité, plus elles s'éloignent de nos yeux: cette augmentation se continue même jusqu'à une distance assez grande. (187–8)

On peut comparer l'action de la lumiere au mouvement d'une balle de billard, qui, étant poussée, va frapper une bande qui la renvoie contre une autre, d'où elle est renvoyée contre une troisieme. Chaque fois qu'elle est renvoyée par quelque bande, elle perd de sa force, tant qu'enfin elle s'arrête d'ellemême, quoiqu'elle n'ait pas parcouru, à beaucoup près, un chemin aussi long qu'elle auroit fait si elle n'avoit rencontré aucun obstacle.

La réflexion de la lumiere a cependant cette différence, qu'un seul rayon de lumiere, quelque délié qu'on le conçoive, doit être regardé comme une gerbe de rayons qui, en se réfléchissant, sont renvoyés à la ronde, tellement que la lumiere qui tombe sur la pointe d'une aiguille, est réfléchie tout à l'entour, et cette pointe est visible par l'action de cette lumiere réfléchie aux yeux de tous ceux qui la regardent. Il n'y a que les corps polis qui réfléchissent dans une seule direction.

La lumiere part du soleil, et va frapper directement sur le terrein. Ce terrein la réfléchit en tous sens; une partie des rayons vient à nos yeux, et y peint l'image de ce terrein. Cette image est vive et lumineuse, parce que cette lumiere n'a encore souffert qu'une première réflexion.

Une autre partie des rayons qui sont renvoyés par ce terrein, va frapper contre la muraille, et l'éclaire: c'est ce que nous appellons *reflet*. Si ces rayons qui éclairent la muraille, n'étoient pas renvoyés une seconde fois jusqu'à nos yeux, nous ne verrions point la muraille, ou du moins nous la verrions parfaitement obscure, et nous n'y distinguerions rien: mais ces rayonss qui ont d'abord été réfléchis par le terrein, le sont une seconde fois par la muraille, et viennent jusqu'à nos yeux y peindre la muraille, les pierres qui la composent, et les autres détails qui peuvent s'y rencontrer. Cependant ces rayons ont été réfléchis deux fois; ils sont affoiblis: c'est pourquoi la muraille nous paroît plus obscure que le terrein éclairé, qui nous envoie sa lumiere par une réflexion simple.

De ces rayons qui sont réfléchis pour la seconde fois par la muraille, une partie est renvoyée sur le terrein ombré, et delà se réfléchit encore vers nos yeux par une troisieme réflexion, et y peint la partie du terrein qui est dans l'ombre portée, et les objets qui s'y trouvent. Mais ces rayons n'étant renvoyés à nos yeux que par une troisieme réflexion, sont très-foibles, et l'image qu'ils peignent est fort obscure. C'est la cause de cette regle de clair obscur, *que l'ombre portée est toujours plus forte que l'ombre des corps qui la portent.*

Les deux ombres, de la muraille et du terrein sur lequel elle porte ombre, nous paroîtroient encore plus obscures qu'elles ne nous le paroissent, si elles ne recevoient point d'autre lumiere que celle dont nous venons de parler, d'autant plus qu'étant réfléchie deux ou trois fois, elle devient très-foible. Mais il s'y joint une autre lumiere qui vient de tout le ciel; elle est moins vive que celle du soleil: cependant elle est assez forte, puisqu'elle suffit pour nous faire voir distinctement tous les objets, lorsque le soleil est caché par le nuages. Cette lumiere frappe à peu-près également sur l'ombre de la

muraille, et sur l'ombre portée; de-là elle revient à nos yeux par une première réflexion, nous éclaire toutes ces ombres, et diminue la différence d'obscurité qu'il y auroit entr'elles.

C'est par les diverses réflexions de ces différentes lumieres que nous voyons ces ombres. Or nous avons dit que les rayons s'affoiblissent par la distance qu'ils ont à parcourir avant que d'arriver à l'oeil. Donc les rayons qui viennent des parties de la muraille, les plus proches, ont plus de force que ceux qui viennent des parties les plus éloignées. S'ils ont plus de force, ils sont plus lumineux, et nous font voir ces parties prochaines de la muraille plus claires et plus détaillées que les parties qui sont plus éloignées.

La lumiere de *reflet*, qui vient des objets ombrés dans l'éloignement, n'a pas assez de force pour affecter nos yeux; c'est pourquoi nous voyons ces objets ombrés très-obscurs, par masses et sans aucun reflet, par conséquent plus noirs et plus forts d'ombres qu'ils ne seroient, s'ils étoient rapprochés sur le devant, où ils seroient éclairés par des lumieres de reflet, que nous pourrions appercevoir. (193–98)

Il paroît s'ensuivre de ce principe que, les ombres augmentant de force à proportion de leur éloignement, celles qui sont les plus proches de l'horizon, devroient être les plus fortes de tout le tableau, et approcher de l'obscurité parfaite; ce qui n'est pas dans la nature. Au contraire les objets très-éloignées ont des ombres très-foibles: c'est l'air interposé entre ces objets et nous qui en affoiblit ainsi les ombres. (199)

... il est impossible de fixer cette distance, parce qu'elle varie suivant la quantité de vapeurs dont l'air est chargé, tellement que j'ai vu dans des jours d'été, ces fortes ombres à plus de quarante toises de moi, au lieu que dans de fort beaux jours d'automne, elles paroissent à peine à quatre toises. (201)

For Largillierre, see *Largillierre* (1982), MacGregor (1993), and §.39 below.

31　　Diderot (1968), pp. 688–9 on shadow colour:

Mon ami, les ombres ont aussi leurs couleurs. Regardez attentivement les limites et même la masse de l'ombre d'un corps blanc; et vous y discernerez une infinité de points noirs et blancs interposés. L'ombre d'un corps rouge se teint de rouge; il semble que la lumière, en frappant l'écarlate, en détache et emporte avec elle des molécules. L'ombre d'un corps avec le chair et le sang de la peau, forme une faible teinte jaunâtre. L'ombre d'un corps bleu prend une nuance de bleu; et les ombres et les corps réfletent les uns sur les autres. Ce sont ces reflets infinis des ombres et des corps qui engendrent l'harmonie sur votre bureau, où le travail et le génie ont jeté la brochure à côté du livre, le livre à côté du cornet, le cornet au milieu de cinquante objets disparates de nature, de forme et de couleur. Qui est-ce qui observe? qui est-ce qui connaît? qui est-ce qui exécute? qui est-ce qui fond tous ces effets ensemble? qui est-ce qui en connaît le résultat nécessaire?

On Diderot and the results of his reviewing Cochin, Chouillet (1973), pp. 560–67, this book being in general the best account of Diderot's eclectic formation as an art critic. Diderot (1968), pp. 483–4 on Chardin's *The Olive Jar* (*Chardin*, 1979, no. 114, pp. 322–4):

... un vase de vieille porcelaine de la Chine, deux biscuits, un bocal rempli d'olives, une corbeille de fruits, deux verres à moitié pleins de vin, une bigarade avec un pâté. ... C'est celui-ci qui entend l'harmonie des couleurs et des reflets. O Chardin! ce n'est pas du blanc, du rouge, du noir que tu

broies sur ta palette: c'est la substance même des objets, c'est l'air et la lumière que tu prends à la point de ton pinceau et que tu attaches sur la toile.

32 Buffon [1743/1774], p. 146:

...je crois devoir encore annoncer un fait qui paraîtra peutêtre extraordinaire, mais qui n'en est pas moins certain, et que je suis fort étonné qu'on n'ait pas observé; c'est que les ombres des corps qui par leur essence doivent être noires, puisqu'elles ne sont que la privation de la lumière, que les ombres, dis-je, sont toujours colorées au lever et au coucher du Soleil; j'ai observé pendant l'été de l'année 1743, plus de trente aurores et autant de soleils couchants, toutes les ombres qui tombaient sur du blanc, comme sur une muraille blanche, étaient quelquefois vertes, mais le plus souvent bleues, et d'un bleu aussi vif que le plus bel azur. J'ai fait voir ce phénomène à plusieurs personnes qui ont été aussi surprises que moi; la saison n'y fait rien, car il n'y a pas huit jours que j'ai vu des ombres bleues, et quiconque voudra se donner la peine de regarder l'ombre de l'un de ses doigts au lever ou au coucher du Soleil sur un morceau de papier blanc, verra comme moi cette ombre bleue. Je ne sache pas qu'aucun Astronome, qu'aucun Physicien, que personne, en un mot, ait parlé de ce phénomène, et j'ai cru qu'en faveur de la nouveauté on me permettrait de donner le précis de cette observation.

Bouguer (1760), pp. 367–8 and (1961), pp. 240–41:

Ceci nous fournit l'explication d'un phénomene très-singulier, auquel le Peintres n'ont pas manqué d'être très-attentifs, et qui nous a procuré un Mémoire de M. de Buffon, mais dont personne que je sache, n'a donné la raison physique; les ombres le matin et le soir prennent une teinte très-bleue, et celle d'une bougie produit à peu-près le même effet, lorsqu'elle tient lieu du soleil, qui n'est point encore levé, et qui est sur le point de paroître. Ce phénomene est causé par la couleur aérienne de l'atmosphere qui éclaire ces ombres, et dans laquelle les rayons bleus dominent: ils rejaillissent obliquement en quantité, pendant que les rayons rouges, qui vont se perdre plus loin en suivant la ligne droite, ne peuvent pas modifier l'ombre, parce qu'ils ne se réfléchissent pas, ou qu'ils se réfléchissent beaucoup moins.

Other responses to Buffon are well summarised in the *Supplément* (1776) to the *Encyclopédie*, II, 636a–638b (apropos of *couleurs accidentelles*), and IV, 143a–147a (s.v. 'Ombre').

Leonardo on the blue shadow on the white wall at sunset: Leonardo (1956), I, 148v–149r, II, no. 478.

33 Guericke (1672), IV. xii. Edwin Land on von Guericke in Land (1977), in Rock (1990), pp. 39–62, especially p. 59.

Von Guericke's own physical explanation for the blue shadow rests on odd semi-Aristotelean premises. Blue is a middle-point between white and black: a demonstration of this is that if a drop of milk conjoins a drop of ink, their meeting-point will look blue. Thus presumably the blue shadow, half-lit by the dawn half-light.

The context, and the interest for von Guericke, is the bearing on the old issue of why the sky is blue. Because light (both *lux* and *lumen*) is inoperative except in circumstances where it has contact (*attritus*) with matter, and because interplanetary space is empty space – which is the subject of his book – it is black-dark: only as the light from the sun reaches the beginning of our atmosphere, with its friction of material watery vapours, does it begin to

whiten. The blue of the sky is the moment of light's transition from the black of void space to the white of light in atmosphere.

NOTES TO CHAPTER V

34 For Cochin's connections, Michel (1987) and (1993), especially Part 1 (for Cochin's copies of Locke's *Essay*, in French (1735 ed.) and English (1743), p. 36).

35 Reid [1764], VI, 2, pp. 93. For Reid's psychology of perception, Morgan (1977), chap. 5, and Yolton (1984), particularly chap. 11.

36 Reid [1764], VI, 3, pp. 95–6; on drawing as abstraction, VI, 7, p. 114. Reid's views on art are discussed by Funnell (1982) and Macmillan (1986), p. 74. In point of fact, the painters' observations he invokes – relating mainly to the degradation of colour and distinctness with distance (VI. 3, p. 96 and VI. 22, p. 225) and to visual expression of the passions (VI. 8, pp. 120–1) – suggest his reading optics and Leonardo's *Traité de la peinture* rather than frequenting Aberdeen lofts.

37 For Oudry, Opperman (1977) and *Oudry* (1983).
 For pictures seen from an angle, Pirenne (1970), particularly chap. 8, and Kubovy (1986), chap. 6.

38 There is a considerable literature on the relation between painting and general perception. Hochberg (1978) is an excellent introduction to the issues, with bibliography. Two books with chapters specifically relevant to shadow are Arnheim (1974), chap. 6, on 'Light', and Kennedy (1974), chap. 7, on linear registration of cast shadow. Gombrich (1960) remains a basic study.
 The market in attention was particularly explicit throughout the eighteenth-century Enlightenment, paintings and their perception being seen as exemplary of attention itself. This had an intricate background of reciprocal dependence: for Roger de Piles [1708] the control of the beholder's attention to a painting was to be determining for the picture's chiaroscuro, and thus the centralised structure of the composition of light and shadow (fig. 7). Painting had therefore prepared itself to be a demonstration ground for attentional effects.
 But sometimes painting's control of attention was seen as benign absolutely. The best statement of this was that of the Abbé Dubos [1719], a friend of John Locke, who saw the function of art as that of healing the terrible affliction of *ennui*, which was not just boredom but a serious malaise of attention: if the mind was not disposed to attend to interior matters, by reflecting or meditating, as is often the case, then it needed exterior objects for attention; otherwise it suffered from a condition of disorder, 'an infinity of ideas without connection or relation, tumultuously succeeding each other' (I. i). *Ennui* was a painful and destructive complaint. The arts, poetry and painting, could counter it by offering artificial objects of attention, as it were; but painting was unlike poetry in that it was proper for its interest to lie primarily in its manner of representation rather than its matter (I. x–xiii).
 When Condillac [1754] constructed his thought experiment of the statue that learned to perceive, attention became central to his model – a 'sensationalist' model that excluded the Lockean cognition of mediating complex ideas – because, being the presence of a sensation in consciousness, and being powered

by a restless nexus of need and desire and curiosity, it was the active preliminary
to all the other faculties; attention was the preliminary condition for recollection
(attention to past attention), comparison (attention to two things), judgement,
imagination, recognition. And at crucial moments of his argument it is to our
experience of paintings he appeals. The statue's effort to put a construction
on the field of sensations offered by his eyes is like ours when attending to
a painting: it takes time, persistence and experience. As the statue must pains-
takingly scan a square to perceive it (I. xi, p. 84) or separate out the different
colours in an array (I. xi, p. 77) or learn to narrow attention when confronted
by some larger scene he cannot make out as a whole (III. iii, p. 175), we exert
ourselves when addressing the forms, colour and organisation of a complex
painting.

For variously nuanced accounts of the painters' response to this situation,
Hogarth [1753], Fried (1980) and Crow (1985).

39 For Largillierre in general, *Largillierre* (1982) and MacGregor (1993).
General surveys of French eighteenth-century painting are Conisbee (1981) and
Levey (1993). For Largilliere and Cochin, Michel (1993), pp. 218–22.

For collections of Netherlandish art in Paris, Dézallier d'Argenville (1749),
with subsequent editions.

Paris, in fact, had access to particularly impressive Netherlandish collections.
The great general picture collection of the Duke of Orléans in the Palais-Royal
(not sold off till 1792) put Rubens with the Italians but Rembrandt with other
Dutchmen, in the Library. More striking still, there were two visitable and
remarkable specialist collections of Netherlandish painting a few minutes walk
from the Palais-Royal, that of Gaignat in the Rue de Richelieu (sold in 1768)
and particularly that of Blondel de Gagny in the Place Vendôme. These had
large holdings of genre and still life painting. For the King's pictures one
could from 1750 go across to the Luxembourg Palace, where a selection from
Versailles had been lodged for the public good, including Rembrandt's *Tobias*,
open Wednesdays and Saturdays, mornings in winter, afternoons in summer.
Also at the Luxembourg was the Galérie with the cycle of twenty-one pictures
of the life of Marie de Médicis painted for it by Rubens in 1622–25, very much
a school for painters and amateurs, particularly of history painting.

Rubens's Marie de Médicis cycle: Dandré-Bardon, who was cited for his account
of artistic chiaroscuro in §. 22, made this the object of an exceptional piece of
sustained practical criticism; towards the end of his *Traité de peinture* (1765) he
put a seventy-page *Étude raisonnée* of the cycle, 'an enquiry after principles of
coloris' – that is, colour and chiaroscuro – in which each picture becomes a
model for one or two aspects of this.

No. 2, *Birth of the Queen*, is the basis for a discussion of reflected lights in
shadow: these express the spatial relation between reflecting surface and
receiving surface, particularly when they have picked up a hue from the first
that modifies the object hue of the second; and they introduce a secondary
register of shape-from-shading into zones which might otherwise be rather
flattened by uniform self-shadow or cast shadow (pp. 237–9).

No. 7, *The City of Lyon meets the Queen – mutual rapport of lights, half-tones and
shadows* is an exposition of the three-tone system. The figure of Lyon, in a car
drawn by lions mounted by amoretti, rejoices at being the scene of the union of
Marie with Henri IV.; Hymen, Jupiter and Juno, and various other suitable
figures assist. Dandré-Bardon is concerned with the artistic balancing of the
three tones. He proposes for pictures a basic formula for the general tonal
structure of light/half-tone/dark in the proportions 2:3:4, learned by painters

like Rubens empirically from nature and pragmatically from successful application. Yet Rubens's use of it here is not an *effet vrai*: that is to say, it serves an aesthetic purpose, not illusion. The scene takes place out in the open, where reflected light would in fact enter most of the shadow and raise its value from dark to that of the half-tone, true dark remaining only in relatively few places with that specifically *projected* shadow into which no perceptible reflected light could penetrate. Dandré-Bardon seems to propose that the proportions of light/half-tone/dark in a scene like this would really be something like 1:2:1 (pp. 251–6).

No. 17, *The Queen escapes from the Château de Blois*, is a night piece and exemplifies the simple shadow world of artificial lighting. In the first place, because the light source is relatively close and concentrated, shadow edges have a more uniform and simple gradation of sharpness. In the second, and for much the same reason, surface brightness is more reduced to a binary distinction between lit and not-lit; the critical third dimension of half-tone is largely wiped out (pp. 288–93).

For Largillierre's *Portrait of a Man*, Lauts (1971), pp. 40–46.

40 For Chardin's *Young Draughtsman*, *Chardin* (1979), pp. 227–8, and Rosenberg (1983), pp. 87–8.

41 For the problem of the two opaque squares in the beam of light, Todes and Daniels (1975), especially pp. 86–93.

The extended senses of *ombre* are taken from Furetière (1727), III, unpag., s.v. 'Ombre'.

BIBLIOGRAPHY

Al-Bīrūnī (1976), *Kitā fī ifrād al-maqāl fī amr al-zilāl (The Exhaustive Treatise on Shadows)*, 2 vols, trs. and comm. E.S. Kennedy (Aleppo: Institute for the History of Arabic Science, University of Aleppo)

Arndt, Hans Werner (1979), 'J.-H. Lambert et l'esthétique du XVIIIe siècle', in *Université de Haute-Alsace: Colloque internationale et interdisciplinaire Jean-Henri Lambert, Mulhouse, 26–30 Septembre 1977* (Paris: Ophrys, 1979), pp. 197–208

Arnheim, Rudolf (1974), *Art and Visual Perception* (2nd edn, Berkeley and Los Angeles: University of California Press), chap. VI, 'Light'

Bennett, Jonathan (1977), *Locke, Berkeley, Hume: Central Themes* (Oxford University Press)

Berkeley, George [1709], 'An Essay towards a New Theory of Vision', in *Works on Vision*, ed. Colin M. Turbayne (New York: Bobbs-Merrill, 1963), pp. 7–97, also in *Works*, ed. A.A. Luce and T.E. Jessop (London: Nelson, 1948–57), I, pp. 141–239

Blay, Michel (1983), *La Conceptualisation newtonienne des phénomènes de la couleur* (Paris: Vrin)

Blay, Michel (1989), 'Etudes sur l'optique newtonienne', in Isaac Newton, *Optique*, trs. Jean-Paul Marat [1787] (Paris: Christian Bourgois), pp. 371–504

Blinn, J.F. (1977), 'Models of Light Reflection for Computer Synthesized Pictures', *Computer Graphics*, XI, 2, Summer 1977, pp. 192–8

Bosse, Abraham (1648), *Maniere universelle de Mr Desargues pour pratiquer la perspective* (Paris: Pierre Des-Hayes; repr. Alburgh: Archival Facsimiles, 1987)

Bouguer, Pierre (1760), *Traité d'optique sur la gradation de la lumiere* (Paris: Guerin and Delatour)

Bouguer, Pierre (1961), *Optical Treatise on the Gradation of Light*, ed. and trs. W.E. Knowles Middleton (University of Toronto Press)

Bruce, Vicki, and Green, Patrick R. (1990), *Visual Perception: Physiology, Psychology and Ecology*, 2nd edn (Hove and Hillsdale, NJ: Lawrence Erlbaum)

Buffon, Georges-Louis Leclerc, comte de [1743/1774], 'Observations

sur les couleurs accidentelles et sur les ombres colorées', in *Un autre Buffon*, ed. Jacques-Louis Binet and Jacques Roger (Paris: Hermann, 1977), pp. 146-9

Buffon, Georges-Louis Leclerc, comte de [1749], 'Histoire naturelle de l'homme', in *Histoire naturelle, générale et particulière*, III (Paris: Imprimerie Royale)

Cantor, Geoffrey (1983), *Optics after Newton: Theories of Light in Britain and Ireland, 1704–1840* (Manchester University Press)

Chardin (1979), *Chardin 1699–1779*, exh. cat., ed. Pierre Rosenberg (Paris: Grand Palais/Cleveland: Museum of Art/Boston: Museum of Fine Arts)

Chol, Daniel (1987), *Michel François Dandré-Bardon* (Aix-en-Provence: Edisud)

Chouillet, Jacques (1973), *La Formation des idées esthétiques de Diderot* (Paris: Armand Colin)

Cochin, Charles-Nicolas (1757), *Recueil de quelques pièces concernant les arts* (Paris: Jombert; repr. Geneva: Minkoff, 1972)

Condillac, Etienne Bonnet de [1746], *Essai sur l'origine des connaissances humaines*, ed. Jacques Derrida (Paris: Editions Galilée, 1973)

Condillac, Etienne Bonnet de [1754], *Traité des sensations* (Paris: Fayard, 1984)

Conisbee, Philip (1981), *Painting in Eighteenth-century France* (Oxford: Phaidon)

Cope, Zachary (1953), *William Cheselden 1688–1752* (Edinburgh and London: Livingstone)

Crow, Thomas E. (1985), *Painters and Public Life in Eighteenth-century Paris* (New Haven and London: Yale University Press)

Dandré-Bardon, Michel-François (1765), *Traité de peinture* (Paris: Saillant; repr. Geneva: Minkoff, 1972)

Descargues, Pierre (1977), *Perspective: History, Evolution, Techniques*, trs. Mark Paris (New York: Abrams)

De Valois, Russell L., and De Valois, Karen K. (1988), *Spatial Vision* (Oxford University Press)

Dézallier d'Argenville, Antoine-Joseph (1749), *Voyage pittoresque de Paris* (Paris: De Bure, with numerous subsequent edns; 1757 repr. Geneva: Minkoff, 1972)

Dictionary of Scientific Biography (1981), ed. Charles Coulston Gillispie, 16 vols (New York: Charles Scribner's Sons)

Diderot, Denis [1749], *Lettre sur les aveugles*, ed. Robert Niklaus, 3rd ed. (Geneva: Droz, 1970)

Diderot, Denis (1968), *Oeuvres esthétiques*, ed. Paul Vernière (Paris: Garnier)

Dubos, Jean-Baptiste [1719], *Réflexions critiques sur la poésie et sur la peinture* (6th edn, Paris: Pissot, 1755)

Ehrard, Jean (1965), *Montesquieu critique d'art* (Paris: Presses Universitaires de France)

Encyclopédie, ou Dictionnaire raisonné des sciences, des arts et des métiers (1751–72), ed. Denis Diderot and Jean Le Rond d'Alembert, 28 vols (Paris: Briasson et al.)

Finke, Ronald A. (1989), *Principles of Mental Imagery* (Cambridge, MA: MIT)

Foley, James D., van Dam, Andries, Feiner, Steven K., and Hughes, John F. (1990), *Computer Graphics: Principles and Practice*, 2nd edn (Reading, MA: Addison-Wesley), chap. 16 ('Illumination and Shading')

Formey, Jean-Henri-Samuel (1765), 'Ombre', in *Encyclopédie* (1751–72), XI, pp. 461–4

Fried, Michael (1980), *Absorption and Theatricality: Painting and Beholder in the Age of Diderot* (Berkeley: University of California Press)

Frisby, John P. (1979), *Seeing: Illusion, Brain and Mind* (Oxford University Press)

Fujita, Ichiro et al. (1992), 'Columns for visual features of objects in monkey inferotemporal cortex', *Nature*, CCCLX, 26 Nov pp. 1992, 343–6

Funnell, Peter (1982), 'Visible Appearances' in *The Arrogant Connoisseur: Richard Payne Knight, 1751–1824*, ed. Michael Clarke and Nicholas Penny (Manchester University Press), pp. 82–92

Furetière, Antoine (1727), *Dictionnaire universel*, rev. Henri Basnage de Beauval and Jean Baptiste Brutel de la Rivière (The Hague: Pierre Husson et al.; repr. Hildesheim: Georg Olms, 1972)

Gautier [D'Agoty], Jacques (1753), *Observations sur la peinture et sur les tableaux anciens et modernes* (Paris: Jorry/Delaguette; repr. Geneva: Minkoff, 1972)

Gavel, Jonas (1979), *Colour: A Study of its Position in the Art Theory of the Quattro- and Cinquecento* (Stockholm: Almqvist and Wiksell)

Gibson, James J. (1966), *The Senses considered as Perceptual Systems* (Boston: Houghton Mifflin)

Gilchrist, Alan L. (1979), 'The Perception of Surface Blacks and Whites', *Scientific American*, CCXL, 3, March 1979, pp. 88–97, also in Rock (1990), pp. 63–78

Gill, Robert W. (1975), *Creative Perspective* (London: Thames and Hudson)

Gombrich, Ernst J. (1960), *Art and Illusion* (London: Phaidon)

Gordon, Ian E. (1989), *Theories of Visual Perception* (Chichester: Wiley)

'sGravesande, W.J. (1774), 'Essai de perspective', in *Oeuvres philosophiques et mathématiques*, ed. Jean Allemand, 2 vols (Amsterdam: Rey), I, p. 59

Gregory, R.L. (1970), *The Intelligent Eye* (London: Weidenfeld and Nicolson)

Grimaldi, Francesco Maria (1665), *Physico-Mathesis de Lumine, Coloribus et Iride*, ed. Girolamo Bernia (Bologna: Vittorio Benacci heirs; repr. Bologna: Arnaldo Forni, 1963)

Guericke, Otto von (1672), *Experimenta Nova (ut vocantur) Magdeburgica de Vacuo Spatio* (Amsterdam: Johannes Jansson; repr. Aalen: Milliaria, 1962; trs. and ed. Hans Schimank et al., Düsseldorf: Verlag des Vereins Deutscher Ingenieure, 1968)

Guerlac, Henry (1981), *Newton on the Continent* (Ithaca, NY: Cornell University Press)

Hagen, Margaret A., ed. (1980), *The Perception of Pictures* 2 vols (New York: Academic Press)

Hills, Paul (1987), *The Light of Early Italian Painting* (New Haven and London: Yale University Press)

Hobson, Marian (1982), *The Object of Art: The Theory of Illusion in Eighteenth-century France* (Cambridge University Press)

Hochberg, Julian (1978), 'Art and Perception', in *Handbook of Perception*, ed. Edward C. Carterette and Morton P. Friedman, X (New York: Academic Press, 1978), pp. 225–58

Hogarth, William [1753], *The Analysis of Beauty*, ed. Joseph Burke (Oxford: Clarendon Press, 1955)

Horn, Berthold K.P., and Brooks, Michael J. (1989), eds., *Shape from Shading* (Cambridge, MA: MIT Press)

Humphreys, Glyn W., and Bruce, Vicki (1989), *Visual Cognition: Computational, Experimental and Neuropsychological Perspectives* (Hove and Hillsdale, NJ: Lawrence Erlbaum)

Jeaurat, Edme-Sébastien (1750), *Traité de perspective à l'usage des artistes* (Paris: Jombert)

Johnson-Laird, Philip N. (1988), *The Computer and the Mind* (Cambridge, MA: Harvard University Press)

Jombert, Charles-Antoine (1755), *Méthode pour apprendre le dessin* (Paris: Jombert; repr. Geneva: Minkoff, 1973)

Kaufmann, Thomas Da Costa (1975), 'The Perspective of Shadows: The History of the Theory of Shadow Projection', *Journal of the Warburg and Courtauld Institutes*, xxxviii, pp. 258–87

Keele, Kenneth (1983), *Leonardo da Vinci's Elements of the Science of Man* (New York)

Kemp, Martin (1990), *The Science of Art* (New Haven and London: Yale University Press)

Kennedy, John M. (1974), *A Psychology of Picture Perception* (San Francisco: Jossey-Bass), chap. 7

Knox, George (1992), *Giambattista Piazzetta 1682–1754* (Oxford University Press)

Koenderink, Jan J., and van Doorn, Andrea J. (1980), 'Photometric Invariants Related to Solid Shape', *Optica Acta*, xxvii, 2, pp. 981–96, also in Horn and Brooks (1989), pp. 301–22

Kubovy, Michael (1986), *The Psychology of Perspective and Renaissance Art* (Cambridge University Press)

Lairesse, Gérard de [1707], *Het Groot Schilderboek* (Amsterdam: trs. J.F. Fritsch, London, 1738)

Lambert, Johann Heinrich (1759), *La Perspective affranchie de l'embaras du plan géometral* (Zurich: Heidegger; repr. Alburgh: Archival Facsimiles, 1987)

Lambert, Johann Heinrich (1760), *Photometria, sive de mensura et gradibus luminis, colorum et umbrae* (Augsburg: Klett)

Lambert, Johann Heinrich (1892), *[Lambert's] Photometrie (Photometria sive de mensura et gradibus luminis, colorum et umbrae)*, ed. and trans. Ernst Anding, 3 vols (Leipzig: Wilhelm Engelmann)

Lambert, Johann Heinrich (1943), *Schriften zur Perspektive*, ed. and intr. Max Steck (Berlin: Georg Lüttke)

Land, Edwin (1977), 'The Retinex Theory of Colour Vision', *Scientific American*, CCXXXVII, 6, Dec. 1977, pp. 108–28, and in Rock (1990), pp. 39–62

Largillierre (1982), *Largillierre and the Eighteenth-century Portrait*, exh. cat. (Montreal: Musée des Beaux-Arts, 1981–82)

Laurent, Roger (1987), *La Place de J.-H. Lambert (1728–1777) dans l'histoire de la perspective* (Paris: Cedic)

Lauts, Jan (1971), *Französische Bildnisse des 17. und 18. Jahrhunderts* (Karlsruhe: Staatliche Kunsthalle)

Lecat, Claude-Nicolas (1767), *Traité des sensations et des passions en général, et des sens en particulier* (Paris: Vallat-la-Chapelle)

Lehky, Sidney R., and Sejnowski, Terrence J. (1988), 'Network model of shape-from-shading: neural function arises from both receptive and projective fields', *Nature*, 333, 2 June 1988, 452–4

Leibniz, Gottfried Wilhelm [1765], *Nouveaux essais sur l'entendement humain*, ed. Jacques Brunschwig (Paris: Flammarion, 1990)

Leonardo da Vinci (1651), *Traité de la peinture*, trs. R.F.S.D.C. [Roland Fréart de Chambray] (Paris: Langlois)

Leonardo da Vinci (1716), *Traité de la peinture* [trs. Roland Fréart de Chambray] (Paris: Giffart)

Leonardo da Vinci (1956), *Treatise on Painting (Codex Urbinas Latinus 1270)*, ed. and trs. A.P. McMahon, 2 vols, with facsimile (Princeton University Press)

Leonardo da Vinci (1989), *Leonardo on Painting*, ed. Martin Kemp and trs. Martin Kemp and Margaret Walker (New Haven and London: Yale University Press)

Levey, Michael (1993), *Painting and Sculpture in France, 1700–1789* (New Haven and London: Yale University Press)

Lindberg, David C. (1976), *Theories of Vision from Al-Kindi to Kepler* (University of Chicago Press)

Locke, John [1694], *An Essay concerning Human Understanding*, 2nd edn (London: John Churchill and Samuel Manship)

Locke, John (1975), *An Essay concerning Human Understanding*, *The Clarendon Edition of the Works of John Locke*, I, ed. Peter H. Nidditch (Oxford University Press)

MacGregor, William B. (1993), 'Le *Portrait de gentilhomme* de Largillierre: un exercice d'attention', *Revue de l'Art*, 1993, pp. 29–43

Mackie, J.L. (1976), *Problems from Locke* (Oxford University Press)

Macmillan, Duncan (1986), *Painting in Scotland in the Golden Age* (Oxford University Press)

Marcu, E. (1953), 'Un Encyclopédiste oublié: Formey', *Revue d'Histoire Littéraire de la France*, LIII, 1953, pp. 302–5

Mariotte, Edme (1681), *Essais de physique: IV: De la Nature des couleurs* (Paris: E. Michallet)

Markovits, Francine (1984), 'Diderot, Mérian et l'aveugle', in Mérian [1770–80], pp. 193–282

Marr, David (1982), *Vision: A Computational Investigation into the Human Representation and Processing of Visual Information* (San Francisco: W.H. Freeman)

McRae, Robert (1976), *Leibniz: Perception, Apperception and Thought* (Toronto University Press)

Mérian, Jean-Bernard [1770–80], *Sur le Problème de Molyneux*, ed. Francine Markovits (Paris: Flammarion, 1984)

Metzger, Wolfgang (1975), *Gesetzte des Sehens*, 3rd edn (Frankfurt: Waldemar Kramer), chap. 16

Michel, Christian (1987), *Charles-Nicolas Cochin et le livre illustré au XVIIIe siècle* (Geneva: Droz)

Michel, Christian (1993), *Charles-Nicolas Cochin et l'art des lumières* (Rome: École française de Rome)

Mingolla, Ennio, and Todd, James T. (1986), 'Perception of Solid Shape from Shading', *Biological Cybernetics*, LIII, pp. 137–51, also in Horn and Brooks (1989), pp. 409–42

Montesquieu, Charles-Louis de Secondat, Baron [1729], 'Voyage de Gratz à La Haye', in *Oeuvres complètes (l'Intégrale)*, ed. Daniel Oster (Paris: Seuil, 1964), pp. 214–330

Montesquieu, Charles-Louis de Secondat, Baron [1757], *Essai sur le gout*, ed. Charles-Jacques Beyer (Geneva: Droz, 1967)

Morgan, Michael J. (1977), *Molyneux's Question: Vision, Touch and the Philosophy of Perception* (Cambridge University Press)

Newton, Isaac [1704], *Opticks, or a Treatise of the Reflections, Refractions, Inflections and Colours of Light*, ed. I.B. Cohen et al. (New York: Dover, 1952)

Newton, Isaac [1787], *Optique*, trans. Jean-Paul Marat, ed. Michel Blay (Paris: Christian Bourgois, 1989)

Nodine, Calvin F., and Fisher, Dennis F., eds. (1979), *Perception and Pictorial Representation* (New York: Praeger)

Olson, Richard, Yonas, Albert, and Cooper, Robert (1980), 'Development of Pictorial Perception', in Hagen (1980), II, pp. 155–90

Opperman, Hal (1977), *Jean-Baptiste Oudry*, 2 vols (New York: Garland)

Oudry (1983), *Oudry, J.-B., 1686–1755*, exh. cat., ed. Hal Opperman (Fort Worth: Kimbell Art Museum)

Oudry, Jean-Baptiste [1749], 'Réflexions sur la manière d'étudier la couleur, en comparant les objets les uns aux autres', in C.H. Watelet and P.C. Levesque, *Dictionnaire des arts de peinture, sculpture et gravure* (Paris: Prault, 1792), I, pp. 366–96 (also later printings)

Pastore, Nicholas (1971), *Selective History of Theories of Visual Perception 1650–1950* (New York: Oxford University Press)

Piazzetta (1983a), *Piazzetta: A Tercentenary Exhibition of Drawings, Prints and Books*, exh. cat., ed. George Knox (Washington, DC: National Gallery of Art)

Piazzetta (1983b), *Piazzetta: Disegni, Incisioni, Libri, Manoscritti*, exh. cat. (Venice: Fondazione Giorgio Cini)

Piles, Roger de [1708], *Cours de peinture par principes*, ed. Thomas Puttfarken (Paris: Jacqueline Chambon, 1990)

Pinker, Steven, ed. (1985), *Visual Cognition* (Cambridge, MA: MIT), with the editor's 'Visual Cognition: An Introduction', pp. 1–63

Pirenne, Maurice H. (1970), *Optics, Painting and Photography* (Cambridge University Press)

Posner, Michael I., ed. (1989), *Foundations of Cognitive Science* (Cambridge, MA: MIT Press)

Priestley, Joseph (1772), *The History and Present State of Discoveries relating to Vision, Light and Colours* (London: J. Johnson)

Puttfarken, Thomas (1985), *Roger de Piles' Theory of Art* (New Haven and London: Yale University Press)

Ragghianti, Carlo L., and Dalli Regoli, Gigetta (1975), *Firenze 1470–1480: Disegni dal modello* (Università di Pisa)

Ramachandran, Vilayanur S. (1988a), 'Perceiving Shape from Shading', *Scientific American*, CCLV, 2, Aug. 1988, pp. 76–83, also in Rock (1990), pp. 127–38

Ramachandran, Vilayanur S. (1988b), 'Perception of Shape from Shading', *Nature*, 331, 14 Jan. 1988, pp. 163–5

Rawson, Philip (1984), *The Art of Drawing: An Instructional Guide* (Englewood Cliffs, NJ: Prentice-Hall)

Reid, Thomas [1764], *An Inquiry into the Human Mind*, ed. Timothy Duggan (University of Chicago Press, 1970)

Rock, Irvin, ed. (1990), *The Perceptual World: Readings from Scientific American* (New York: W.H. Freeman)

Rosenberg, Pierre (1983), *Tout l'Oeuvre peint de Chardin* (Paris: Flammarion)

Rousseau, Jean-Jacques [1762], *Emile, ou de l'éducation*, in *Oeuvres complètes (l'Intégrale)*, ed. Michel Launay, 3 vols (Paris: Seuil, 1971), III, pp. 7–330

Roy, Alain (1992), *Gérard de Lairesse 1640–1711* (Paris: Arthena)

Sabra, A.I. (1967), *Theories of Light from Descartes to Newton* (London: Oldbourne)

Subleyras (1987), *Subleyras 1699–1749*, exh. cat., ed. Olivier Michel and Pierre Rosenberg (Paris: Musée du Luxembourg/Rome: Académie de France, Villa Médicis)

Taton, René (1951a), *L'Oeuvre mathématique de G. Desargues* (Paris: Presses Universitaires de France)

Taton, René (1951b), *L'Oeuvre scientifique de Monge* (Paris: Presses Universitaires de France)

Taton, René, ed. (1964), *Enseignement et diffusion des sciences en France au XVIIIe siècle* (Paris: Hermann)

Tavernier, Ludwig (1983), *Das Problem der Naturnachahmung in den kunstkritischen Schriften Charles Nicholas Cochins d. J.* (Hildesheim: Olms)

Tiepolo (1970), *Tiepolo: A Bicentenary Exhibition, 1770–1970*, exh. cat., ed. George Knox (Cambridge, MA: Fogg Art Museum, Harvard University)

Tipton, I.C., ed. (1977), *Locke on Human Understanding: Selected Essays* (Oxford University Press)

Todes, Samuel, and Daniels, Charles (1975), 'Beyond the Doubt of a Shadow', in *Dialogues in Phenomenology*, ed. Don Ihde and Richard M. Zaner (The Hague: Martinus Nijhoff)

Veltman, Kim (1986), *Studies on Leonardo da Vinci. I: Linear Perspective and the Visual Dimensions of Science and Art* (Munich: Deutscher Kunstverlag)

Vérin, Hélène (1993), *La Gloire des ingénieurs: l'intelligence technique du XVIe au XVIIIe siècle* (Paris: Albin Michel)

Voltaire, F.-M.A. de [1738], *Eléments de la philosophie de Newton*, in *Oeuvres complètes*, ed. L. Moland, XXII (Paris: Garnier, 1880)

Waltz, David (1975), 'Understanding line drawings of scenes with shadows', in *The Psychology of Computer Vision*, ed. P.H. Winston (New York: McGraw-Hill), pp. 19–91, and see too editor's intro. pp. 3–8

Watt, Roger (1988), *Visual Processing: Computational, Psychophysical and Cognitive Research* (Hove and Hillsdale, NJ.: Lawrence Erlbaum)

Yolton, John W. (1984), *Perceptual Acquaintance from Descartes to Reid* (Oxford: Blackwell)

Yonas, Albert (1979), 'Attached and Cast Shadows', in *Perception and Pictorial Representation*, ed. Calvin F. Nodine and Dennis F. Fisher (New York: Praeger), pp. 100–9

INDEX

Al-Bīrūnī 169n
anisotropic surface 7, 97, 131, pl. IX
astronomy 46, 84, 112
atmosphere 5, 96, 104, 108–109,
 113–117, 123–124, 139,
 152–153, 167–168n
attention 18, 35, 40, 77, 119,
 127–128, 135, 140, 142,
 177–178n

Bartolozzi, Francesco 12–14, fig. 5
Berkeley, George 20–22, 26
Blinn, J.F. fig. 3
Bosse, Abraham 170n
Botticelli 149
Bouguer, Pierre 6, 97–99, 108, 111,
 113, 115–117, 119, fig. 28
Buffon, Georges-Louis Leclerc, comte
 de 26, 29, 112–113, 119, 176n

Caravaggio 95
Cavalieri, Bonaventura 97, 173n
Cennini, Cennino 148–149
Chardin, Jean-Siméon 111, 132, 137,
 139–142, pl. IV, pl. X
Cheselden, William 22–25, 27, 134,
 fig. 8
chiaroscuro/clair-obscur 16, 59,
 76–77, 88, 96, 106–107, 140, 142
Cochin, Charles-Nicolas, the
 Younger 78–79, 104–110, 115,
 119, 121, 123–124, 130–131,
 136–139, 153, 169n, 177n,
 fig. 31, fig. 33, fig. 35
colour 30, 78–79, 81–82, 110–111,
 112–117, 142, 148–149,
 167–168n, 173n, 178n, fig. 25
Condillac, Etienne Bonnet de
 26–28, 30, 56, 119, 177–178n

Dandré-Bardon, Michel-François
 76, 104, 164n, 178–179n
Daniels, Charles 179n
Desargues, Girard 85–86
Diderot, Denis 26, 30, 96–99,
 110–111, 119, 175n
Dowling, J.E. fig. 17

Formey, Jean-Henri-Samuel 81, 85,
 88–91, 119, 169n, 171n
Fréart de Chambray, Roland 113,
 115
Furetière, Antoine 179n

Gautier D'Agoty, Jacques 91, 95,
 172n
Ghirlandaio, Domenico 149
Gibson, James J. 160n
Gilchrist, Alan L. 63, 68–71, 163n,
 fig. 24
Giotto 147, pl. XII
gnomonics 60, 85
'sGravesande, Willem Jacob 88
Gregory, Richard L. 161n, fig. 10
Grimaldi, Francesco Maria 81–84,
 88, 121, fig. 25
Guericke, Otto von 116, 176n

Hills, Paul 147
Hooke, Robert 81
Horn, Berthold K.P. 42–46, 160n,
 fig. 12

Jacob, Hildebrand 29, 158n
James, R.C. fig. 11
Jeaurat, Edme-Sébastien 84, fig. 26
Jombert, Charles-Antoine 77–79,
 81, 84, 110, 115, 119, 130, 133,
 153, 164–169n

Jurin, James 26

Koenderink, Jan J. 56–59, 70, 146, 163n, fig. 20, fig. 21

Lairesse, Gérard de 91–94, 171–172n, fig. 27
Lambert, Johann Heinrich 6, 43, 88, 99–104, 119, 154, 156n, 173n, fig. 28, fig. 29, fig. 30
Lambertian surface 6–7, 43, 59, 99, 146, 148, 161n, 173n, fig. 28
Land, Edwin 116, 176n
Largillierre, Nicolas 96, 104, 131, 136–139, 145, 178n, 179n, pl. VIII
Lecat, Claude-Nicolas 156n
Lehky, Sidney R. 46–47, 160n, fig. 13
Leibniz, Gottfried Wilhelm 20, 26
Leonardo da Vinci 2–4, 15, 77, 103, 107, 110, 113–115, 144, 146, 151–155, 177n, fig. 2, fig. 32, fig. 37, fig. 38, pl. XV, pl. XVI
light:
 ambient 5–6, 68–69, 74–75, 151–152
 artificial 179n
 conceptions of 1–2, 4–7, 80–84, 87–91, 106–107, 151–152
 diffracted 2, 79–84, 86, 91, 169n, fig. 25
 diffused 91–98, 102–103, 107–108, 153–154, fig. 27(a), and see 'universal'
 extended sources 5, 89, 102, 131, 152, 170n, fig. 4, pl. XVI
 global 6, 148, and see ambient
 illumination 5–6, 38, 56–59, 68–70, 73, 131, 140–141, 146, 148, 152, 163n, 173n, fig. 3, fig. 4, fig. 11, fig. 12, fig. 24
 location 2, 5, 15, 29, 60, 74, 99, 131, 144, 146–148, fig. 3, fig. 4, fig. 12(a),(c)
 luminance 5, 7–11, 43, 54–59, 62–63, 70–71, 161–162n, fig. 4, fig. 12, fig. 18, fig. 19
 point sources 86, 102, fig. 4
 reflected 2–7, 14, 15, 18, 25, 29, 43, 63, 68–70, 77–81, 90–98, 103–111, 113, 153–154, 166–168n, 173n, 178–179n,

fig. 3, fig. 24, fig. 27, fig. 28, fig. 31
 refracted 80–82
 terms defined 5–6
 'universal' 91, 95, 96, 102, 152, 154, 155, fig. 27(a), fig. 38
Lippi, Filippino 149, pl. XIV
Locke, John 15, 17–20, 25–27, 56, 157n, 160n, 177n

Mach bands 63, 68, 163n, fig. 23
Maraldi, Giacomo Filippo 88–91, 121, 170–171n
Mariotte, Edme 84, 169n
Marr, David 160n, 161n, fig. 15, fig. 16, fig. 18
Masaccio 147–148, pl. XIII
mental imagery 39, 48–52, 71, 126, 127, 163n, and see vision: top-down
Mérian, Jean-Bernard 25, 157n
Millot, the abbé 29–30, 112, 116
Mingolla, Ennio 160n
Molyneux, William 19–22, 24–27, 36, 157n
Monge, Gaspard 85, 170n
Montesquieu, Charles-Louis de Secondat, baron de 28–29, 119, 158n
Morgan, Michael J. 157n, 177n

Newton, Isaac 80, 82, 84, 88

Olson, Richard 160n
Oudry, Jean-Baptiste 96, 104, 119, 121, 130–134, 136–137, 172n, fig. 33, pl. VI

penumbra 5, 30, 82, 86, 89, 90, 102–103, 173n, fig. 30
Piazzetta, Giovanni Battista 12–14, 15, 119, 146, 156n, fig. 5, fig. 6, pl. II
pictures:
 attention and 28, 29, 76–77, 127–29, 134–135, 137–138, 140, 142, 170n, 177–178n
 drawing 12–14, 48–51, 84–85, 139–143, 149–151, 177n, fig. 26, fig. 35, pl. X
 perception and 24–25, 34–35, 39, 48–52, 59, 76, 77, 84, 99,

129–130, 134–135, 136–139,
149–151, 177–178n
tonal conduct of 12–16, 32–34,
48–51, 76–77, 78–79, 84, 88–91,
104, 110, 130–133, 139–143,
146–155, 156n, 166–169n,
178–179n, fig. 27
Piles, Roger de 76, 77, 164n, 177n,
fig. 7
Pitteri, Marco 12–14, fig. 6
Pollaiuolo, Antonio del 149
Pozzo, Andrea fig. 1
Priestley, Joseph 169n

Ramachandran, Vilayanur S. 160n
Raphael 28–29
Rayleigh scattering 113, 117
Reid, Thomas 124–125, 127–129,
177n
Rembrandt 95, 136–138, 178n
Rigaud, Hyacinthe 137–138, pl. VII
rilievo 59, 146–149, 151, *and see*
shadow: shading
Rousseau, Jean-Jacques 30–31, 119
Rubens 178–179n

sciography 61, 84–88, 91, 99–102,
132, 153, 169–170n, fig. 26,
fig. 30
Sejnowski, Terrence J. 46–47, 160n,
fig. 13
shadow:
'attached' 3–4, 77
cast 3–4, 14–15, 29–30, 60–62,
72–74, 77, 79, 84–91, 99–103,
107–108, 115–117, 121, 123,
132, 140–143, 147, 148,
152–154, 160n, 162n, 167n,
169n, 178n, fig. 22, fig. 26,
fig. 32, fig. 37, pl. XVI
chiaroscuro/clair-obscur 16, 59,
76–77, 88, 96, 106–107, 140, 142
colour in 78–79, 110–111, 168n
colour of 30, 78, 81–82, 112–117,
167–168n, 173n, 178n, fig. 32
'derived' (in Leonardo) 152–154,
fig. 37
edges 74–75, 82, 89–91,
102–103, 153, 162–163n, fig. 18,
fig. 25, fig. 23, fig. 34
intensity, relative 5, 6, 15, 29, 50,
68–70, 76–78, 88, 89–91, 95, 96,
104–110, 123–124, 150,

153–154, 166–168n, 179n,
fig. 12, fig. 24, fig. 27, fig. 31,
fig. 34, fig. 37, fig. 38
microshadow 6–7, 9, 32–33, 97,
125–127, 132, 139, 141–142,
163n, fig. 3
'original' (in Leonardo) 151–153,
fig. 37
penumbra 5, 30, 82, 89–90,
102–103, 173n, fig. 29, fig. 30
projected 4, 6, 7, 14–15, 32, 38,
41, 59–62, 70–74, 80, 84–91, 96,
110, 115, 123, 132–134,
139–140, 143–144, 146–148,
152–154, 161n, 169n, 173n,
179n, fig. 3, fig. 10, fig. 13,
fig. 22, fig. 26, fig. 27, fig. 29,
fig. 32, fig. 37, pl. XVI
rilievo 59, 146–149, 151, pl. XII,
pl. XIII, pl. XIV, pl. XV, *and see*
shading
sciography and 61, 84–88, 91,
99–102, 132, 153, 169–170n,
fig. 26, fig. 30
self-shadow 4, 6, 7, 14, 15, 32,
36–38, 41, 42, 60, 62, 70, 88, 96,
108, 109, 123, 134, 146, 148, 149,
152–154, 178n, fig. 10, fig. 22,
fig. 27, fig. 37
shading 4, 6, 14, 17, 32–34,
36–38, 41–47, 50, 51, 56–59, 63,
69–71, 96, 103, 128, 140,
146–149, 152–154, 160–163n,
178n, fig. 12, fig. 13, fig. 18,
fig. 20, fig. 21, fig. 24, fig. 27,
pl. XVI
sharpness, *see* edges
structure, internal 88–90, fig. 37
types, perceptual fig. 34
types, physical 2–4, 12–15
slant/tilt 4, 7, 36, 41–43, 125, 134,
146, 153
specular surface 7, 33, 75, 131, 133,
141, 146
Subleyras, Pierre 32–35, 119, 159n,
pl. 1

Tiepolo, Giovanni Battista 48–50,
119, 161n, fig. 14, pl. III
Todd, James T. 160n
Todes, Samuel 179n
touch, sense of 19–22, 24, 26–28,
124, 125

Van Doorn, Andrea J.　56–59, 70,
　71, 73, 146, 163n, fig. 20, fig. 21
Verrocchio, Andrea del　149, 151
Vinci, Leonardo da, *see* Leonardo da
　Vinci
vision:
　bottom-up　35, 48, 52, 63
　constancy in　116–117, 125
　contrast and　7, 51, 63, 68–69, 91,
　　109, 115–116, 148, 153, 163n,
　　166n, 167n, 169n, fig. 23
　empiricist theories of　17–28
　eye and　1–2, 5–8, 38, 52–56, 53,
　　71, 78, 124, 150–151, fig. 17
　luminance discontinuities　8, 35,
　　56, 70, 161n, 162n
　machine　36, 42–47, 55–56,

　　59–67, 149–150, 159–162n
　nativist theories of　17, 20
　parallel processing　46–47, 56, 59,
　　71, 128, 160n, fig. 13
　serial processing　44–46, 56, 128,
　　129, 160n, 162n, fig. 12
　spatial frequency　55, 150, 163n,
　　fig. 18, fig. 19
　top-down　35, 39–41, 48, 50, 52,
　　63, 72, fig. 17
Voltaire, François-Marie Arouet　25

Waltz, David　61–66, 70, 71, 163n,
　fig. 22
Watt, Roger　fig. 4, fig. 19

Yonas, Albert　160n

PHOTOGRAPH CREDITS

1 Pierre Subleyras (1699–1749), *Charon*. Oil on canvas, 135 × 83. Musée du Louvre, Paris (Inv. 8007).

11 Giovanni Battista Piazzetta (1683–1754), Figure study. Black chalk, 29.2 ×
20.8, signed. Pierpont Morgan Library, New York (Inv. 1961.12:56).

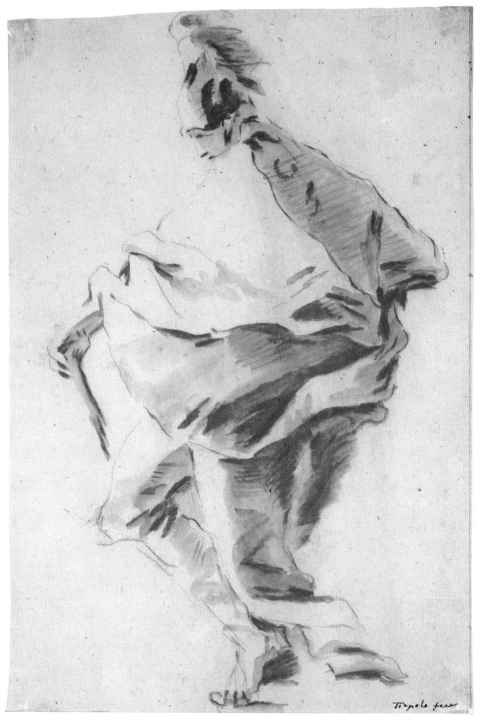

III Giovanni Battista Tiepolo (1696–1770), A Roman Soldier. Red chalk, washed, over black chalk, 26.2 × 18.1. The Art Museum, Princeton University (Inv. 48.842).

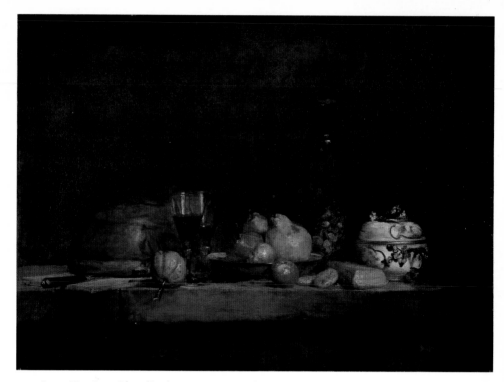

IV Jean Siméon Chardin (1699–1779), *The Olive Jar*, 1760. Oil on canvas, 71 × 98. Musée du Louvre, Paris. (Inv. M.I.1036).

V Detail of pl. IV.

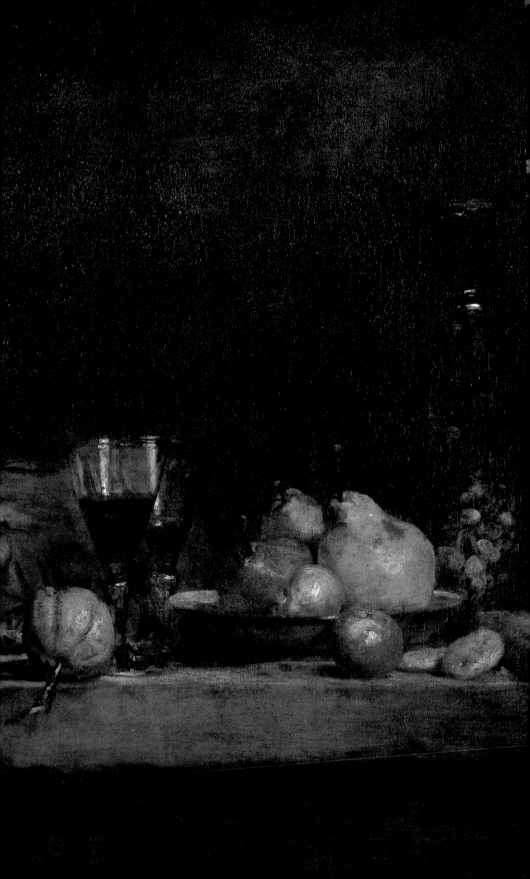

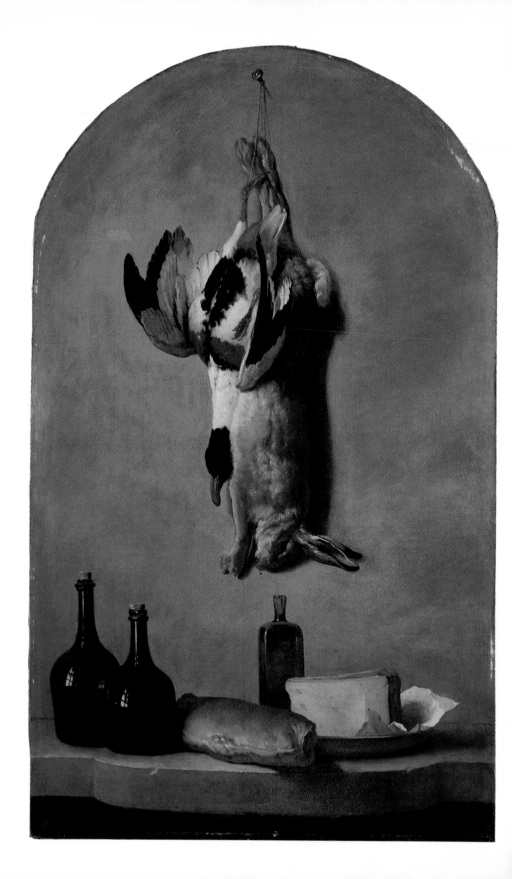

VII Hyacinthe Rigaud (1659–1743), *Président Gaspard de Gueidan*, 1735. Oil on canvas, 146 × 114. Musée Granet, Aix-en-Provence.

VI Jean-Baptiste Oudry (1686–1755), *Hare, Sheldrake, Bottles, Bread and Cheese*, about 1742. 46 × 29. Musée du Louvre, Paris. (Inv. RF 1989–26).

VIII Nicolas Largillierre (1656–1746), *Portrait of a Man*, about 1730. Oil on canvas, 137 × 105. Staatliche Kunsthalle, Karlsruhe.

IX Detail of pl. VIII.

x Jean Siméon Chardin (1699–1779), *The Young Draughtsman*, exhibited 1738. Oil on oak panel, 19.5 × 17.5. Nationalmuseum, Stockholm.

XI Detail (larger than actual size) of pl. X.

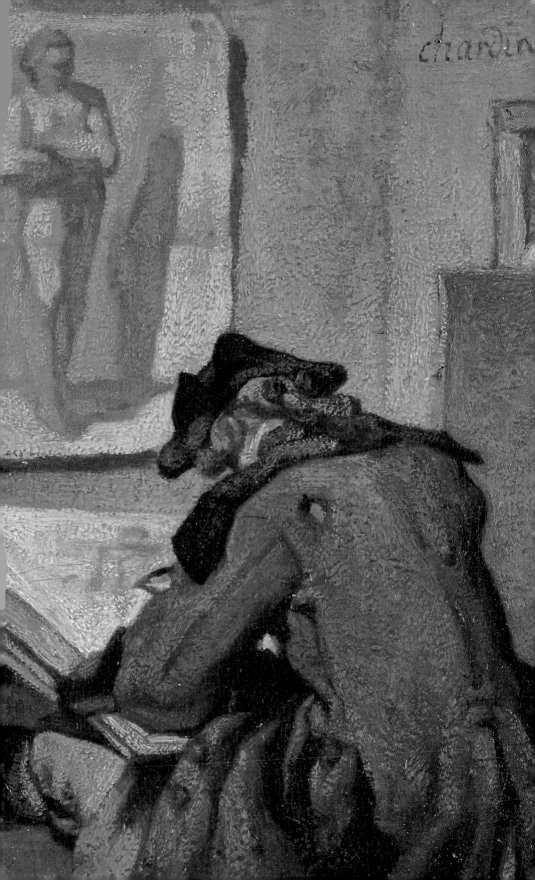

XII Giotto (d.1337), *Joachim and the Shepherds*. Fresco, about 200 × 185. Scrovegni Chapel, Padua.

XIII. Masaccio (1401–28), *Baptism of the Neophytes*, about 1424–27. Fresco, 255 × 162. S. Maria del Carmine, Florence.

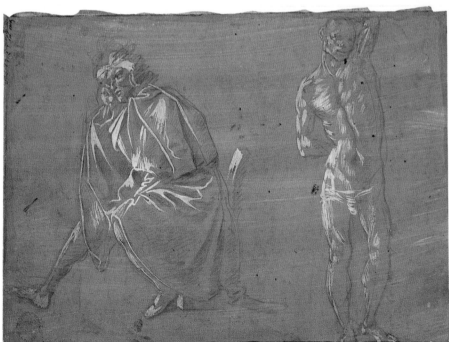

XIV Florentine, second half of the 15th century (workshop of Filippino Lippi?). Recto and verso of a study sheet. Metalpoint and biacca on blue prepared paper, each 20.7 × 29. British Museum, London (Pp. 1–15).

xv Leonardo da Vinci (1452–1519), Drapery study. Brush drawing on brown linen, 28.3 × 19.3. British Museum, London (1895–9–15–489).

XVI Leonardo da Vinci (1452–1519), Light from a window on an umbrous sphere, with (from top) intermediate, primitive, derivative, and (on the surface at the bottom) cast shadow. Pen and wash over metalpoint on paper, 24 × 38. Bibliothèque de l'Institut de France, Paris (Ms. 2185; BN 2038, fol. 14 r.).